OLAF HEINE

LEAVING THE COMFORT ZONE

HATJE
CANTZ

For Lennon and Lia

Teenage Dreams, So Hard to Beat

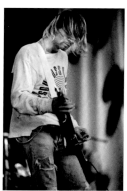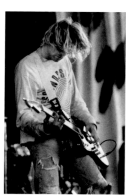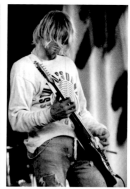

Contents

BORDERLINE

Ralf Grauel

In Olaf Heine's studio there is a wall of framed photographs by fellow photographers. There are also a few original Heines: In the middle is a self-portrait from the period when his girlfriend at the time had just broken up with him. With a shaved head and wearing a black suit, Heine stands there dirty, and possibly beaten up. He holds his jacket open, and in the place of his heart is a target painted on his chest in blood. "I originally wanted to do a triptych," says Heine "but after that photograph it was over. I was done and didn't feel anything anymore."

The way Heine deals with himself is the same way he treats the artists he portrays. For Heine the staging of the image is a form of therapy; the artists he photographs grow through these kinds of situations. Musician Blixa Bargeld described them as follows: "The more vulnerable, the more tangible you make yourself, the more untouchable you in fact become. You can show the greatest and most wounded fragility, but because of the very fact that you show it to the world, you become all the more invulnerable." *Leaving the Comfort Zone* reveals these very moments.

It is Olaf Heine's job to supply a market crazed for perfection and glamour with photographs. Heine takes a close look at the artist, studies his or her work, reads texts, watches his or her films, listens to his or her music, and then waits for images to come to him. He devises cinematic scenarios, organizes props and lighting and then acts as the director on the set. Usually, he somehow turns the image of the artist on its head: the person whose portrait is being taken becomes an actor in the role of reinterpreting his or her own image. The film, however, is pure Olaf Heine.

The mood on the set is almost always playful and relaxed, and it is Heine himself who is the most playful. He makes art out of chance circumstances, reacts with lightning speed to unexpected details and uses them for his purposes. His intensive preparation makes the production run smoothly. The person in front of the camera clearly feels comfortable—but from his team, Heine demands a lot.

Heine's films noticeably often lead into vast spaces. In cities, he searches out a sense of expanse, often choosing views over rooftops. His scenarios play with architecture, line, and structure and almost always follow a strict, formal aesthetic and clear composition. Regardless of what the many stories in Heine's images are about, the segments he selects often show moments of failure. His themes are loss, loneliness, and emptiness. Singer Sting, for example was photographed in a swimming pool, tied up and gaged (ill. pp. 88–89).

Heine staged androgynous British singer Brian Molko lost in thought as a possibly impotent dandy sitting in a wheelchair with a female playmate (ill. pp. 66–67). A painful image, especially because it has grown tragically quiet around his band Placebo since their 2006 album *Meds*. But even if the photos are not shot in quite such a dark mood, Heine gives them an uncanny twist. Take, for example, the photograph of Thomas Kretschmann, which was taken during the production of the movie *Seewolf* (ill. pp. 138–39). The actor had called Heine up and said, "I have a beard. Let's take some photos." Every actor knows the value of a new look in their portfolio, since there is nothing worse than always being pegged as the same type. Olaf Heine had an intersection blocked off in Berlin's Karl-Marx-Allee, got hold of a lamb and an old Ford. The stage directions were: "Imagine you have lost everything in a fire. Wife, children, the farm. The lamb was the only thing you could save."

Years ago, Heine photographed Mark Spoon, the excess-driven techno and dance DJ, in front of a pressure pot with the needle pointing to zero. Seven years later time did run out on Mark Spoon; his heart gave out. Mark Löffel, so his given name, died

in Berlin in 2006. For Heine, the old image, which was already very minimal, was not enough. A year after Mark Spoon's death he took a print, set it out in the desert, and burned it: Heine's own way of saying good-bye (ill. pp. 52–53).

And finally the photograph of Herbert Grönemeyer*: "I wanted to create a Berlin picture," explained Heine, "I wanted it to be dreary and have an element of *film noir*." Heine tied up Gröne-meyer, blindfolded his eyes, and staged an execution. At the time the photograph was taken, Grönemeyer had lost his wife and his brother just six months earlier. This photograph may only be shown in exhibitions and on Olaf Heine's web site. Heine is not permitted to publish it in magazines, on posters, let alone on advertising banners. This image may not be used to sell anything, for it shows too clearly an individual's true pain.

One could criticize the lack of scruples in having someone play the victim of an execution just after such great personal losses. However, just before the photo was taken, Grönemeyer had released his most successful album by far, *Mensch* (Human), in which he himself tells of his sad fight to simply keep on going. Is there a difference between a sufferer working through his pain by making it into a performance and this pain as the basis for a drama staged by someone else?

Heine might have overstepped a boundary with Herbert Gröne-meyer. However, more than any portrait photograph, the stag-ing of the image enables us to see Grönemeyer as human, which is what the musician wanted to achieve with his album title *Mensch* (Human). One also has to acknowledge Heine's courage and strength in convincing the person in front of the camera to go that far. Heine usually stages photographs with extremely strong personalities. People who are so famous that that most viewers have some association with them—and who in this sense are more like brands than real people: globalized

public figures. They are accustomed to playing with their arti-ficial image. Olaf Heine persuades these celebrities, who are almost always the "decision-makers," to follow him on his path. Heine loves friction, but he also enjoys engaging his subjects. It does not always work. But when it does, it is a euphoric sensa-tion. For actors, slipping into a role is an everyday experience. To involve others, however, is hard work, regardless of whether the photograph is commissioned or an independent project.

However tragic the stories behind his scenarios are, the result-ing snapshots are sensational, archaic, and beautiful. Icons emerge from the place where archetype and perfection meet. And naturally the photographs are a joint product, created by Heine and his subjects.

"Vicarious lives" are lives lived in place of other people. Many re-porters, photographers, and actors experience these moments incessantly: they experience themselves through other figures and expand their own existence in the process.

Heine's personal theme has to do with suffering and with death. It goes beyond the many stage directions that he gives to actors and pop stars—bringing about their downfall in a small form of death from which they are then resurrected. For Heine himself death holds a certain fascination. He frequently visits historical medical collections, from which he borrows exhibits for his works (ills. pp. 83 and 162). He visits cemeteries and finds within them a mirror image of life. The cemeteries in Hawaii, he claims, are like paradisiacal palm gardens. The graves of Hollywood are miniature celebrity shrines with gilded actors's names (ill. p. 37), while the cramped stone cemeteries of New York form long alleyways. Ac-cording to Heine, "the cities of the dead reflect those of the living."

Authors write when they need to come to terms with something. Photographers take photographs. Many years ago, before Heine

knew that he would become a photographer, he completed his mandatory civil service in a hospital. He witnessed several births including a caesarian (ill. p. 164). During this period, Heine's nephew was born and his grandfather died. "At that time I became an adult," he says. This book concludes with the image of his grandfather in an open casket. "Strange," says Heine, "in contrast to birth, which is the entry into life, I experienced death as something very quiet. Death is peaceful, but birth is a painful fight. You are torn out of the security of the womb." From this perspective, life begins with a departure from this *Comfort Zone* and ends with a return.

Olaf Heine's photographs are at their best, when he challenges his subjects's personal limits. "At its best moments my work confronts archaic feelings such as euphoria, helplessness— and death." During his civil service work, Heine held the hand of an older woman who was dying. "The caretaker said that I should tell her when she was dead, and I asked how I would know. 'By the gasping breaths. The intervals get longer,' she said and left." The intervals did get longer. The woman held him in her gaze and did not let go. Heine described the experience as immersive, "At some point I felt a hand on my shoulder. It was the attending doctor." Deeply moved, Heine left the room.

As so often, Heine found a way to embrace his own and other people's lives.

*Unfortunately, Herbert Grönemeyer has not given permission to reproduce this image. It can only be viewed at www.olafheine.com.

LET THE MUSIC PLAY

Matthias Harder

"I photograph famous people." With this simple statement Olaf Heine describes the main subject of his multifaceted work—unusual images of some of the most famous individuals in the international pop music scene. His portraits seem familiar to us, even if many of the photographs collected here have remained unpublished until now. Heine, an avid traveler, has set his photographic stories on all continents of the globe. Each photograph is based on an encounter, with people or cities. Some are first-time meetings, others repeat engagements. Heine's prerequisites for creating these intensive portraits are his talent for communication and his intuitive touch.

Heine alternates between commissioned photographs and independent projects. Good photographers are able to assert their stylistic mark in collaboration with their patrons and operate to a certain extent *carte blanche*. Heine has undoubtedly developed his own portrait style: clear and insightful, ironic, and enigmatic. Sometimes we seem to hear the music through the two-dimensional image, as in his portraits of Lou Reed and Nick Cave (ills. pp. 26 and 74–75). When actors like James Woods step in front of his camera, the resulting images pass in front of the mental eye like film stills (ills. pp. 131–34). Heine lives in Los Angeles, where entertainment industry celebrities live and work, and opens the door to this American world for Europeans. However, the industry is changing at incredible speed; the distribution of images is moving at an increasingly faster pace, and most photographs only appear on the Internet—and not in printed magazines.

The people in Heine's portraits have been photographed numerous times, both with their approval and without, and are media professionals. For actors and musicians, celebrity portraits serve as a medium for transmitting their latest image to their fans, again and again—with distribution running in the millions. Star portraits were and are a means of presenting oneself for people to identify with. Is it possible to create a new image given this kind of medial inflation?

For most photographers, whether paparazzi or hired photographers, the goal is not a perfect image but an iconic one. This is also true for Heine: he aims to create images that will outlast him, as he says. This has been the traditional, genuine idea of the portrait since the pioneering era of photography. With the rise of the middle class, the official portraits previously reserved for rulers became available to anyone who could afford to sit for a portrait in a photographic studio. Portraits of pop culture celebrities, often in the form of autograph photos or photos in illustrated newspapers, were introduced as early as the late nineteenth century for a constantly growing number of fans with an insatiable hunger for images of their idols. Since then, this tradition has basically gone unchanged. Only the number of images, means of distribution, rapid shifts in interests, and personae are new.

In the first half and second half of the twentieth century Hugo Erfurth and Stefan Moses respectively photographed the cultural scene of their times, now largely forgotten. Their conservative and consistent concept of the image has been transformed into a fast-paced, spinning global spiral of hot news and innovation. Novelty is what counts, visually and in terms of content—also in the field of portraiture. At the same time, we are beginning to lose our overview in our increasingly globalized world. It is no longer possible to know every musician or actor who is being promoted, especially since casting agencies and picture editors will have new names on their lists tomorrow. When figures like Madonna or Mick Jagger manage to remain interesting to the media for decades, it is also due—beyond musical talent—to an ingenious PR concept.

Behind the media façade, authenticity has become an elastic concept. Olaf Heine is interested in the private people underneath the disguise. In 2001, he photographed Iggy Pop in Miami: The

singer stands bare-chested and well-toned, like a boxer after a fight (ill. pp. 158–59). Only his suit pants add a puzzling touch to the image. This photograph, fitting content for the cover of *Leaving the Comfort Zone,* will certainly become an iconic portrait. The direct and cool gaze into the camera is atypical of Heine's work; he is usually inclined to contemplative or emotional settings. Here, in the encounter with Iggy Pop, a confrontational tension developed between the star and Heine. Another time, he transformed the rapper Snoop Dogg into a Shaolin monk with a sword (ills. pp. 15 and 144–45). Above and beyond the martial gesture of carrying a sword, associations with an ascetic, spiritual element are also palpable. In contrast, he photographed the German singer Phillip Boa standing on the craggy cliffs of Teneriffa's coastline with his back to the viewer (ill. pp. 180–81). Slightly bent over, fighting against the wind and the elements, Boa's image is an exceptional character study. The way nature is used as a background suggests a development away from a romantic citation of painter Caspar David Friedrich towards the stylistic principles of contemporary fashion photography.

This level of drama is also visible in Sting's portrait, which shows the singer tied up, with his mouth taped shut, and standing half under water (ill. pp. 88–89). Sting can neither move nor sing. But the scene is also humorous, because the eyes of the singer reflect Heine's provocative staging with props. The photographer always managed to find allies among the famous—creative spirits that are open to an unusual concept for a photograph. Heine individualizes whoever poses for his camera—giving the person a private persona for us to rediscover. In the process, Heine stages his scenes in closed spaces, even when working in public space, much like a play and unlike "real" life. He leaves the *Comfort Zone* in favor of a stylized reality.

Sometimes Heine studies preexisting photographs of his subjects, but he consciously does not model his work on such images. The ideas for the takes come to him independently. However, in this selection of his work, one does find one or the other tip of the hat to famous colleagues, for example in the portrait of Sven Regener, whom Heine placed unusually close to the left edge of the image, thus cropping the figure (ill. p. 82). The strip of negative film calls to mind a typical stylistic trademark of Richard Avedon—a conscious homage to the New York photographer who died in 2004.

There are not many fellow photographers in this field working on the same level. Anton Corbijn tends to crop his images more closely than Heine, but focuses more exclusively on people. By contrast, Heine's photographic spaces are filled with people, but he includes a number of props thus developing associations between the people and the objects. Olaf Heine nevertheless remains committed to representative photography; he does not follow radical formal experiments or utilize abstraction in his work. His photographs of people are based on the clear compositional principles of line, surface, and figure—an expression of his deep connection with architecture, which he studied for a brief period before he focused on photography. What remains is his openness towards other forms of art, which enhance his visual vocabulary.

Heine is both a director and an observer; he usually conceives of his images in advance, so he can then direct the action and react within the scene. In the dialogue between the camera and the gaze, his photographs sometimes develop intuitively, and he becomes conscious of certain ideas for an image only after the fact, as he himself admits: for instance, with regards to the portrait of Thomas Kretschmann, who carries a lamb in his arms as he poses for the photograph (ill. pp. 138–39). At the time the photograph was taken, during the Berlinale 2008, the actor had grown a full beard for his role in *Seewolf,* and he appears like a wandering, confused shepherd or, if one

interprets the lamb religiously, a Saint Christopher, a bearer of the Christ child. There are many possible interpretations, but Heine is not didactic. Regardless of the interpretation we choose, the image remains ambiguous due to the strange urban setting: a car stands with a door open in the middle of the street, and the traffic on this multi-lane street seems to have come to a halt in the middle of the day. Everything is at a standstill, as if after a catastrophic event.

Heine works with utmost concentration and seldom leaves anything to chance; nevertheless the coincidence of an unexpected encounter can lead to a powerful photograph. This occurred in Havana, where he saw an old man sitting in a bar looking into the camera lost in thought but with an intense gaze (ill. pp. 170–71). One could not compose a better image, and it would be difficult to stage the visual and atmospheric depth of the setting.

Olaf Heine sees himself as a storyteller. He makes visual propositions, as when he photographed Strausberger Platz in Berlin in black and white: with the shift of the image to the sky above Berlin, the site is void of people (ill. pp. 140–41). The view automatically evokes memories of Wim Wenders's classic film Wings of Desire.

Ultimately, Heine is most interested in the grand themes of life and death. One photograph is an exception, as it is an authentic scene with a dramatic background, which Heine reincorporated into his work and placed within a sequence of images. Cornered by the police, a young criminal shot himself in front of the photographer years ago. While others sought cover underneath tables and behind doors, Heine intuitively grabbed his camera, went to the window and photographed the suicide victim who killed himself with a gunshot to the head. The body of the dead man lies slightly askew on the asphalt, and a huge pool of blood flows into the drain next to him (ill. pp. 96–97). The event seemed like a nightmarish drama and haunted Heine for months. Only after years

did he develop the film and enlarge this photograph for the book project Leaving the Comfort Zone.

This book, a summation of his work up to this point, comes at a turning point in Heine's life and work, which often carried him beyond familiar territory. Something is going to change, even if the photographer himself does no know where the journey is taking him—or does not want to give it away. Maybe sports will take on greater significance; up to this point the theme has only played a marginal role in his work. Heine's interest in sports is deeply personal. We could certainly use new ways of presenting athletes in the media.

The cosmopolitan photographer paused to experience the birth of his son, son, to whom, among others, this book is dedicated. Heine bears witness to the past one and a half decades; this book tells his story. We encounter people whom Heine accompanied in Germany, America, and other places and who accompanied him, captured individually on film. Images came about as a result of these encounters. "You are as porous as a sponge and soak things up—that's the artistic process," says Heine in an interview.

Formally, different representations of people coexist next to one another. The photographs range from the birth of a child—photographed during his civil service in a hospital—to the death of his grandfather at the end of the book (ills. pp. 164 and 182–83), though most photographs are portraits of musicians. However, life's existential moments can also include a celebration or experiences made traveling. Heine's intensive gaze within and into the world becomes a very unique autobiography through this collection of images, a polyphonic portrait of himself and his work, which includes characteristic traits like contemplation and melancholy as much as assertiveness and initiative. "The most important thing," says Heine about his photography "is the dialogue with people."

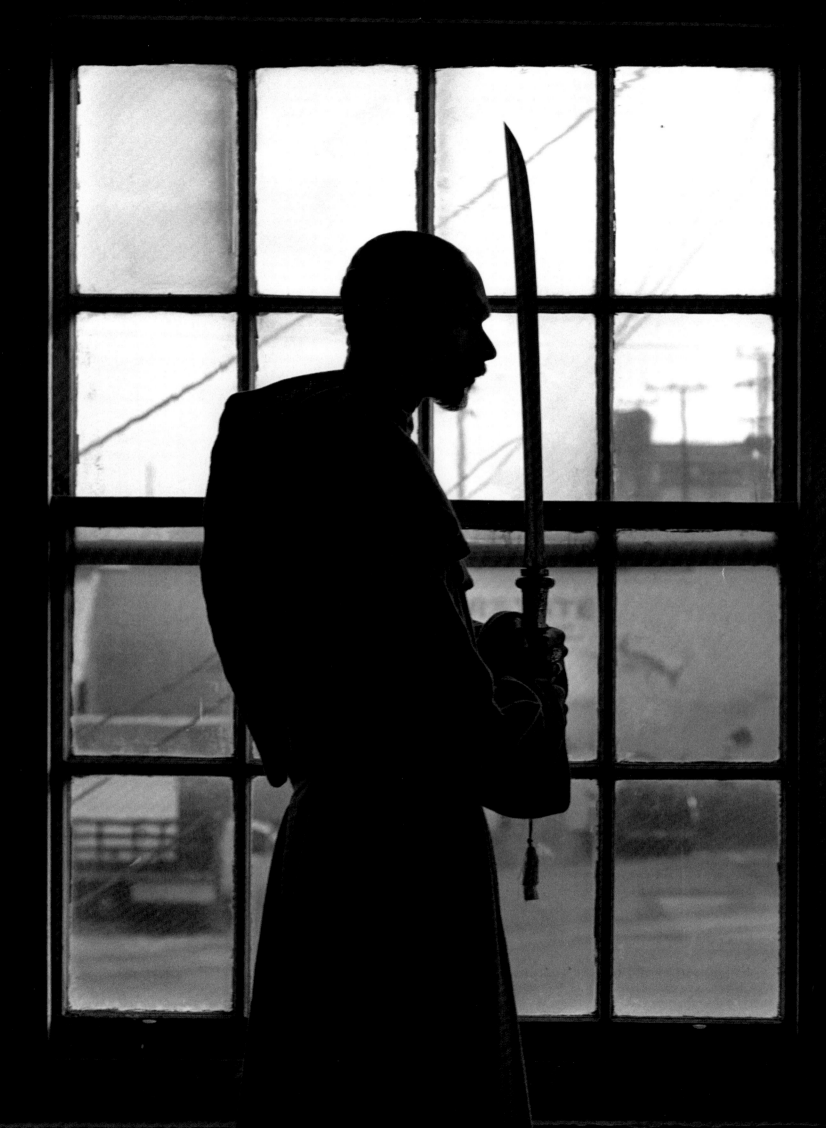

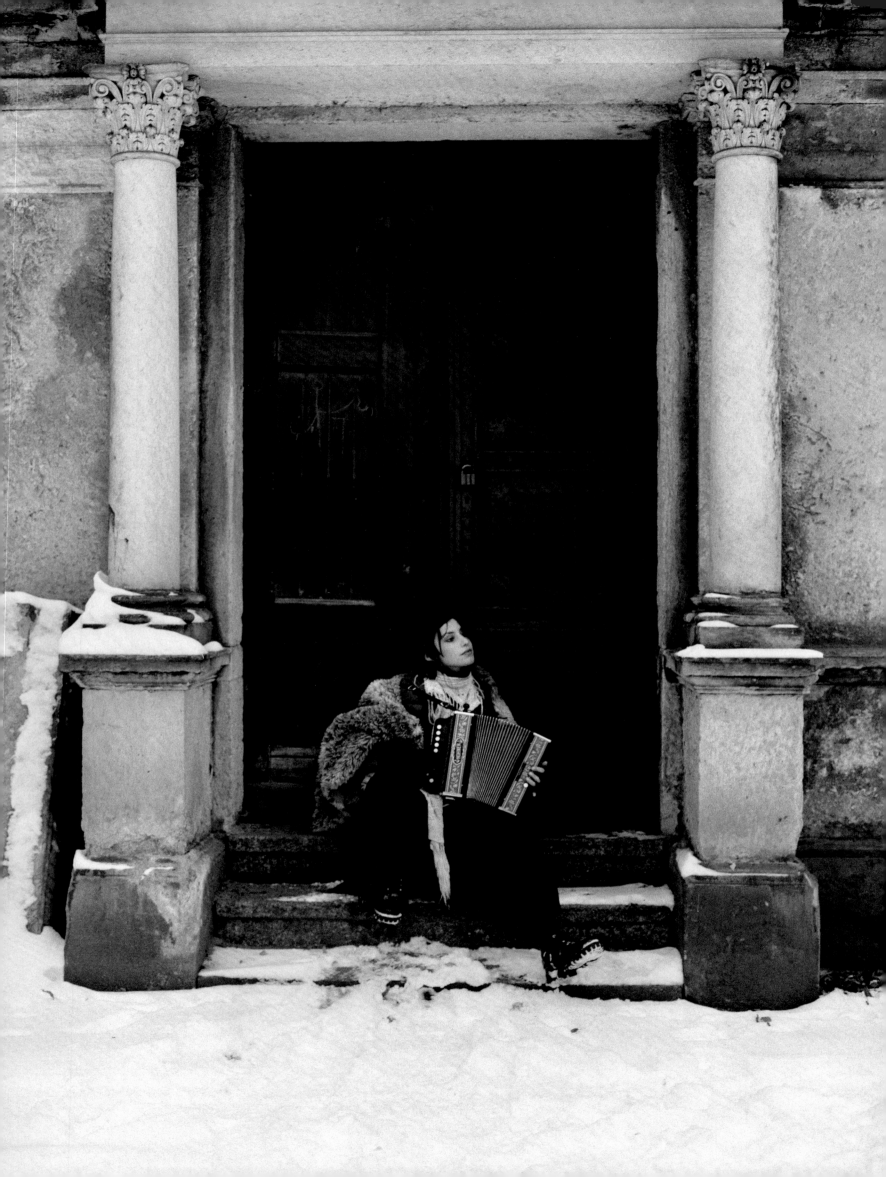

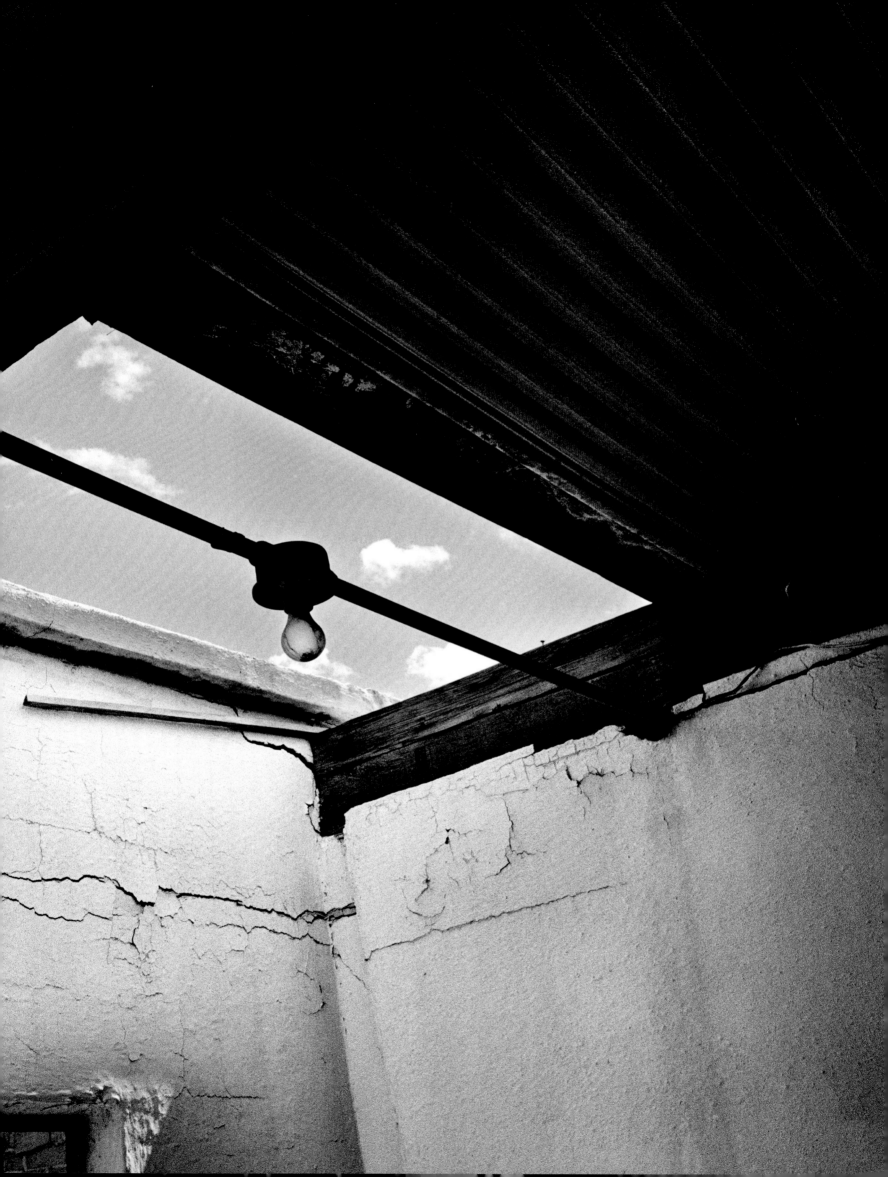

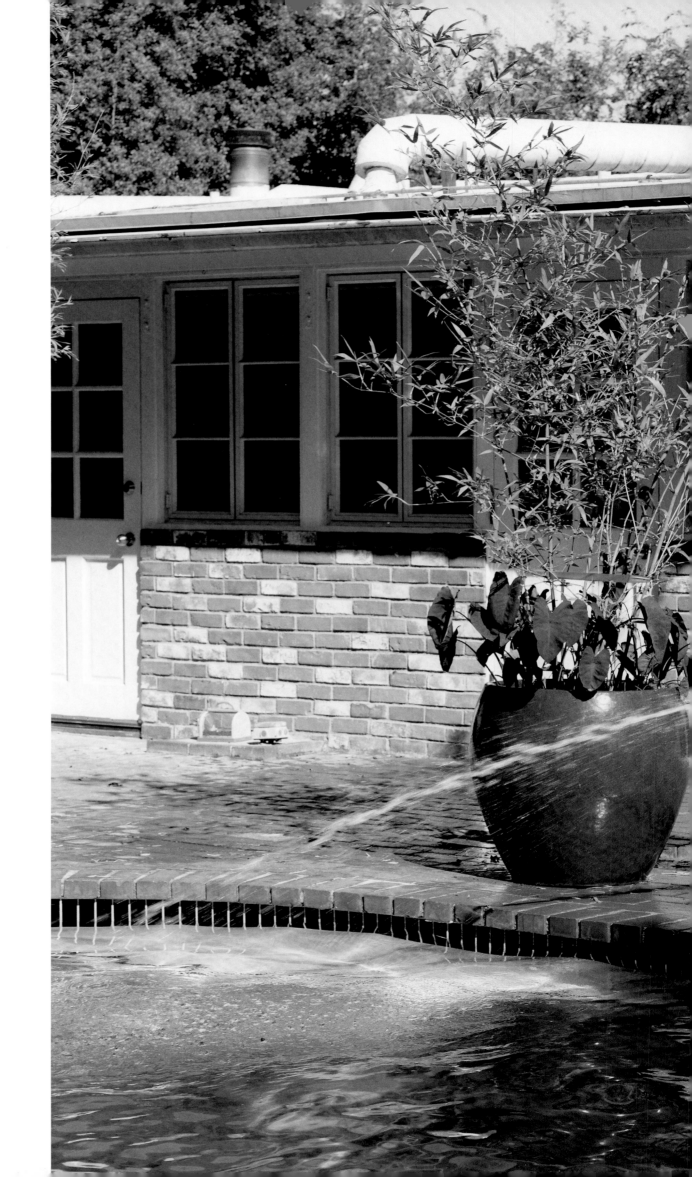

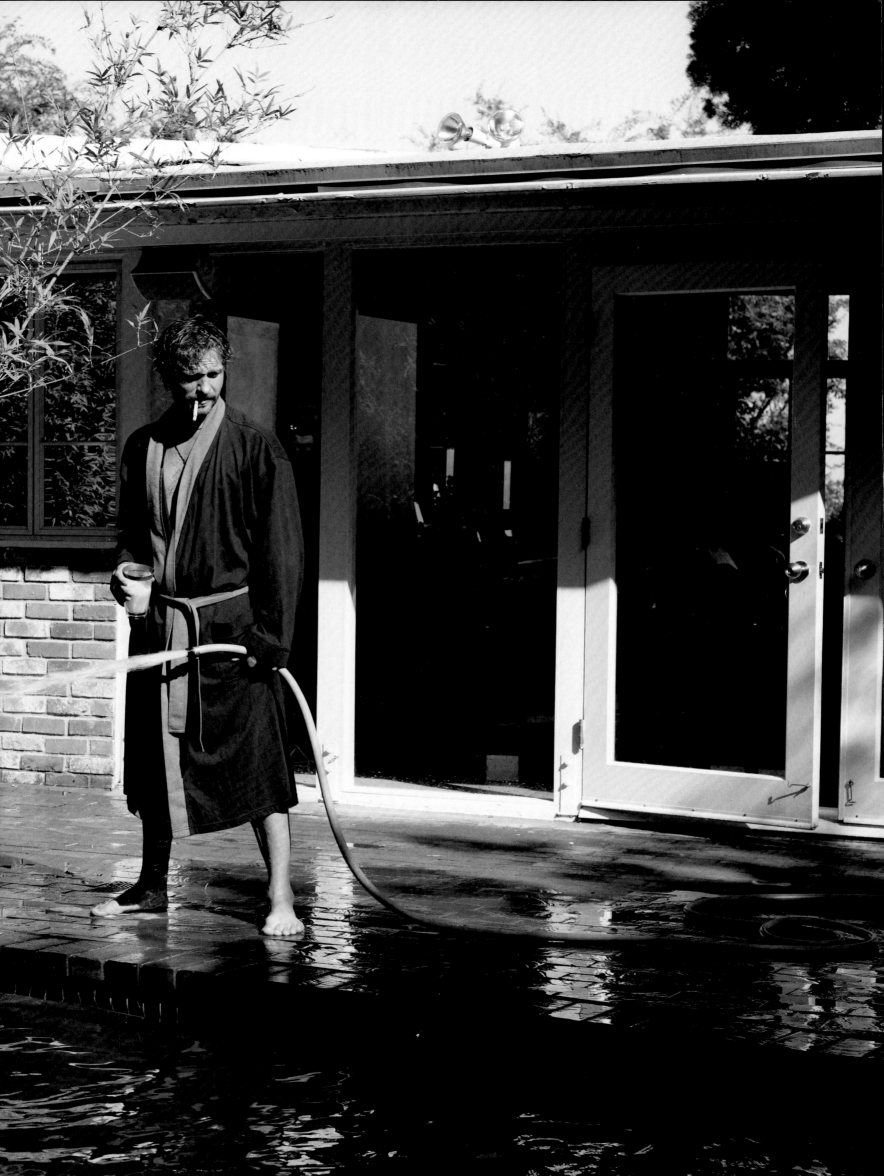

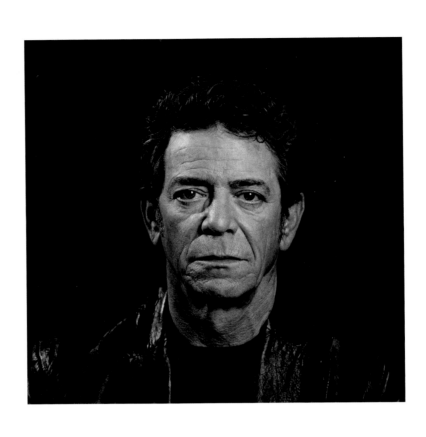

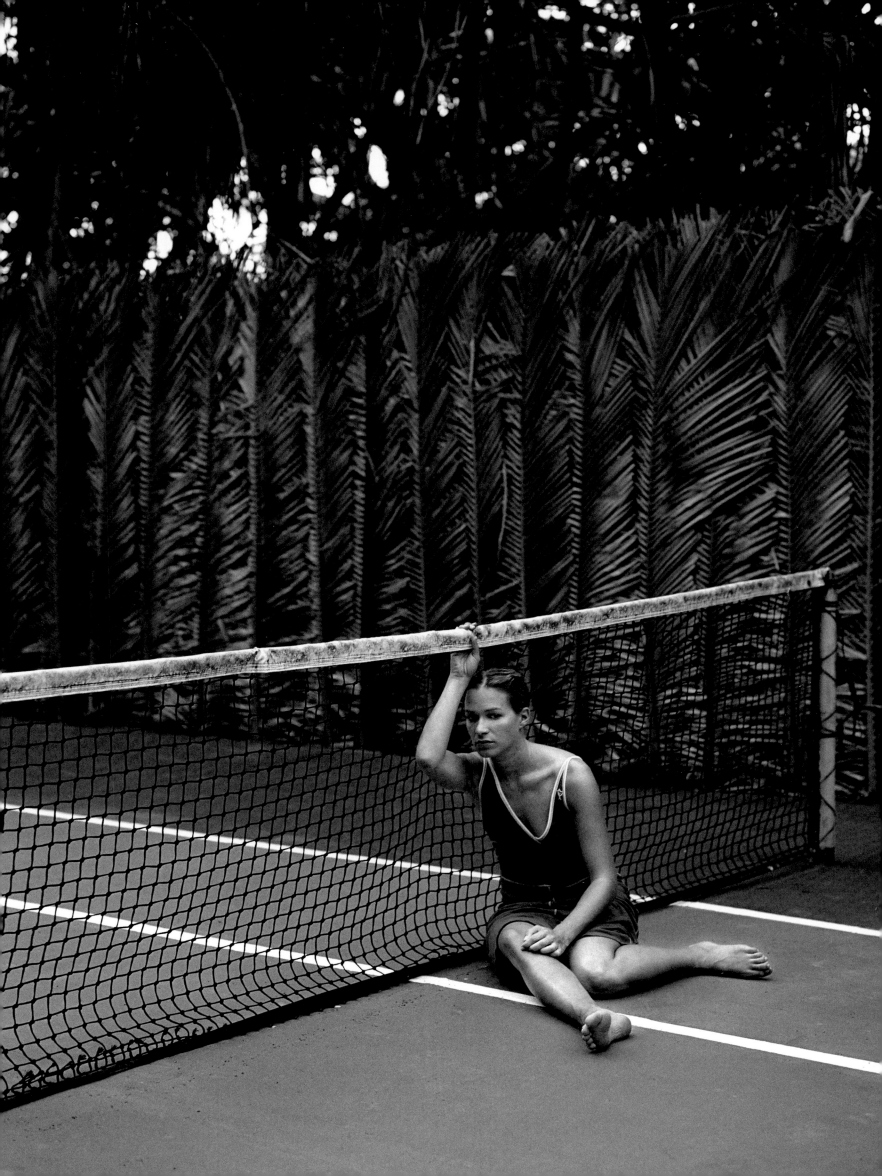

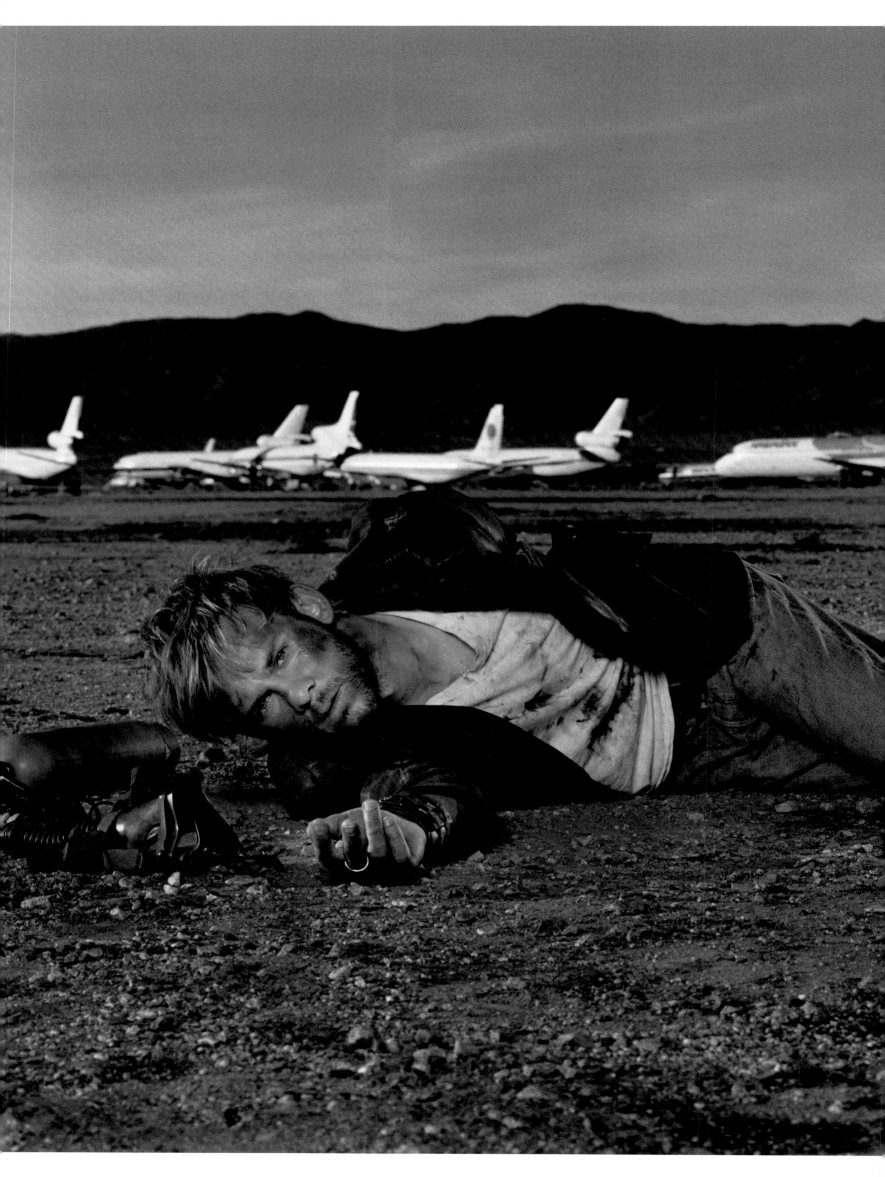

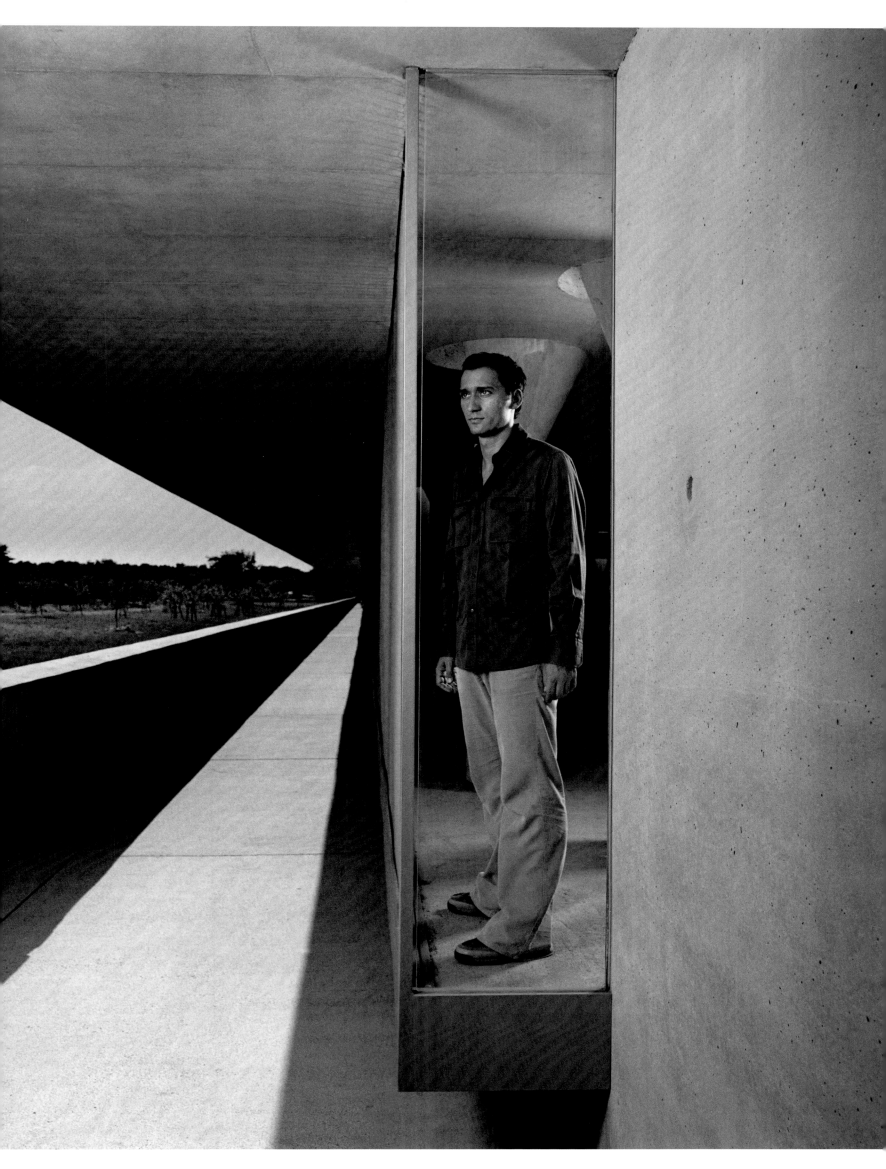

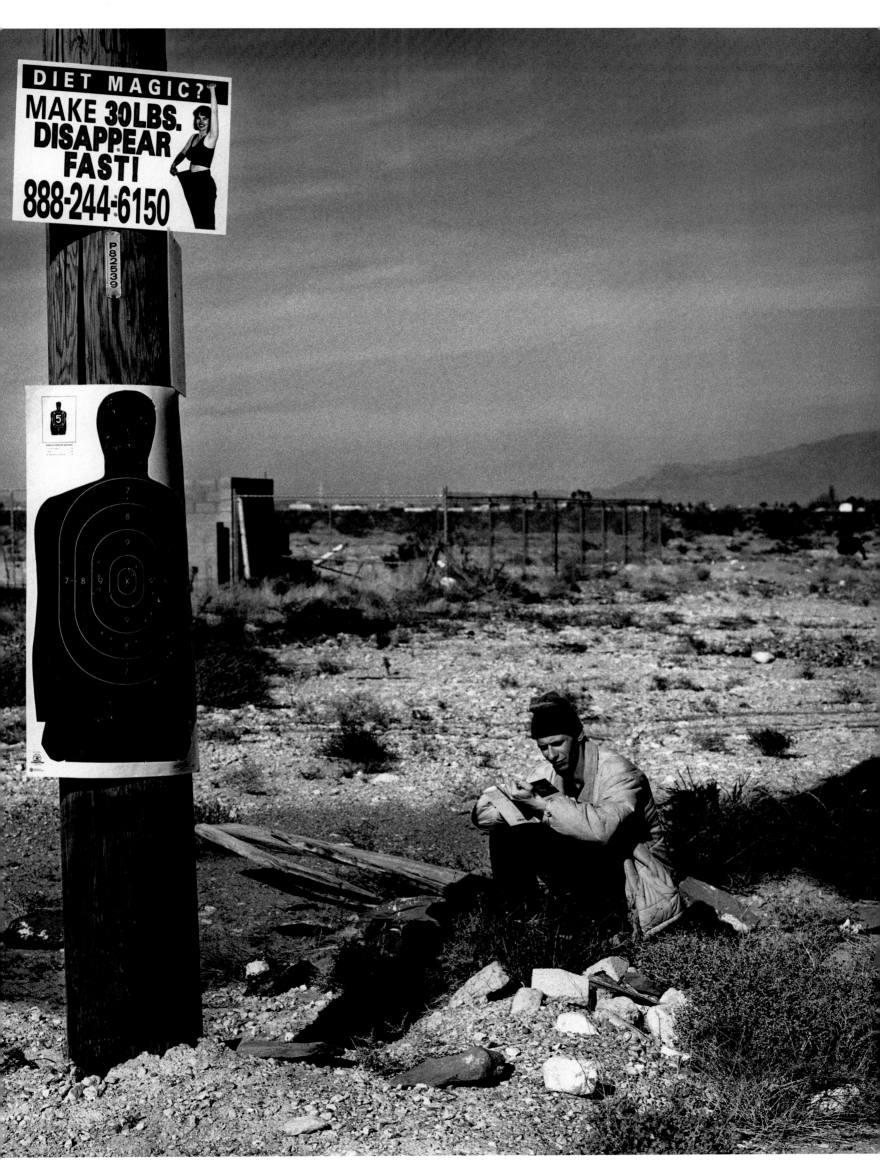

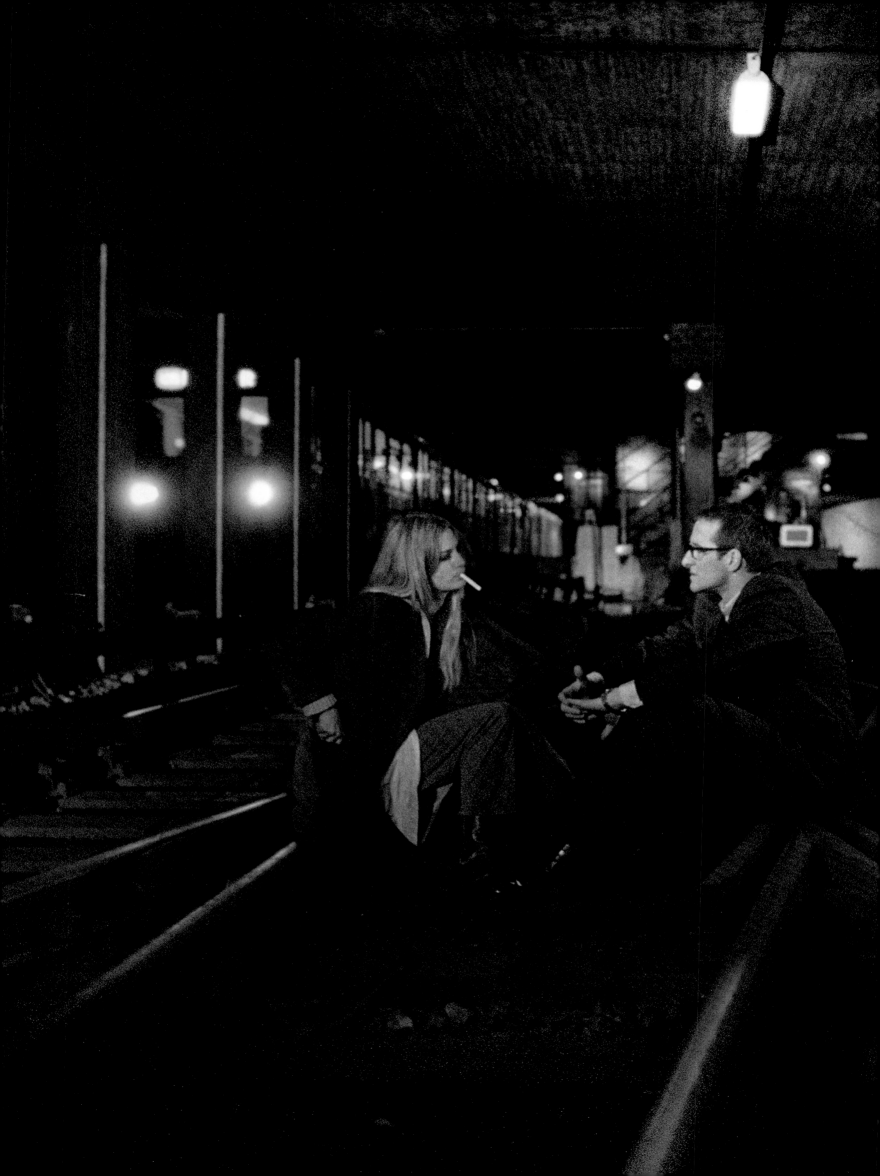

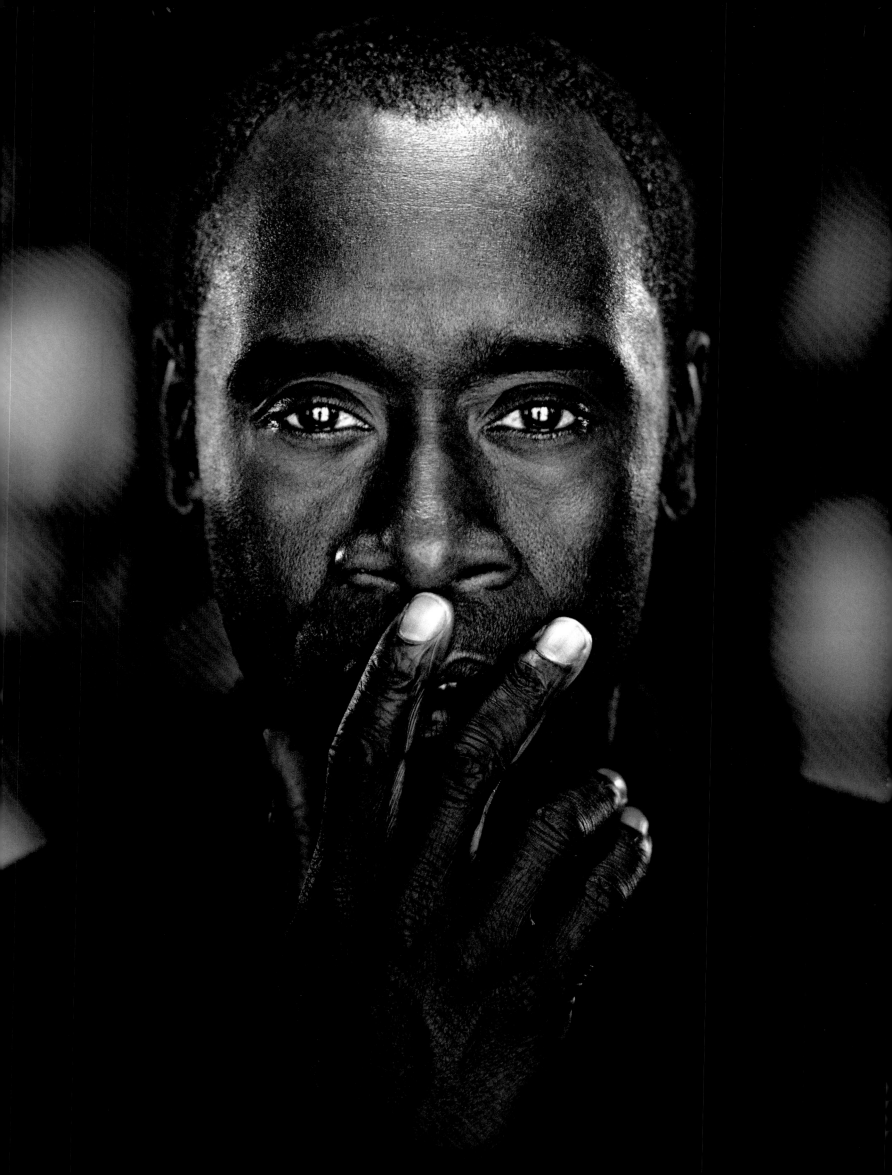

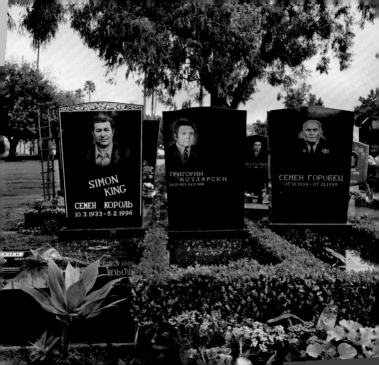

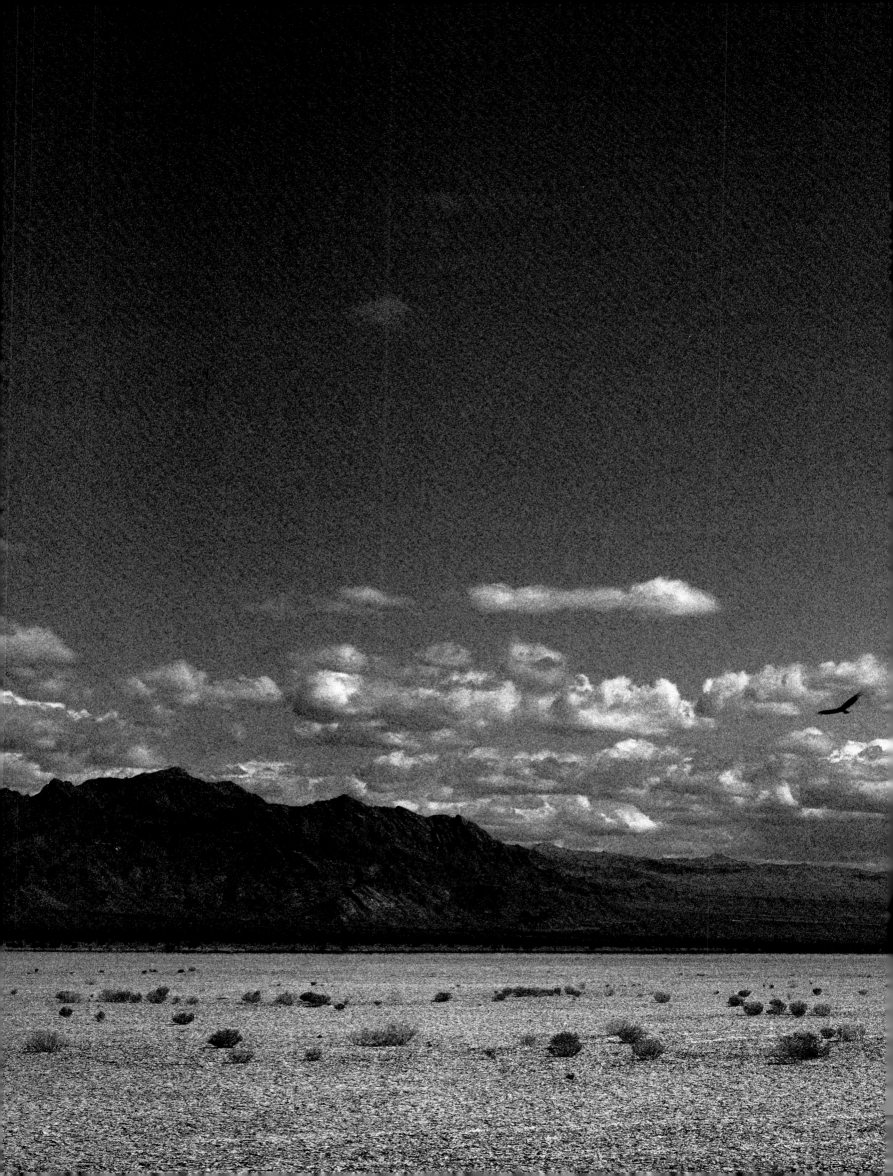

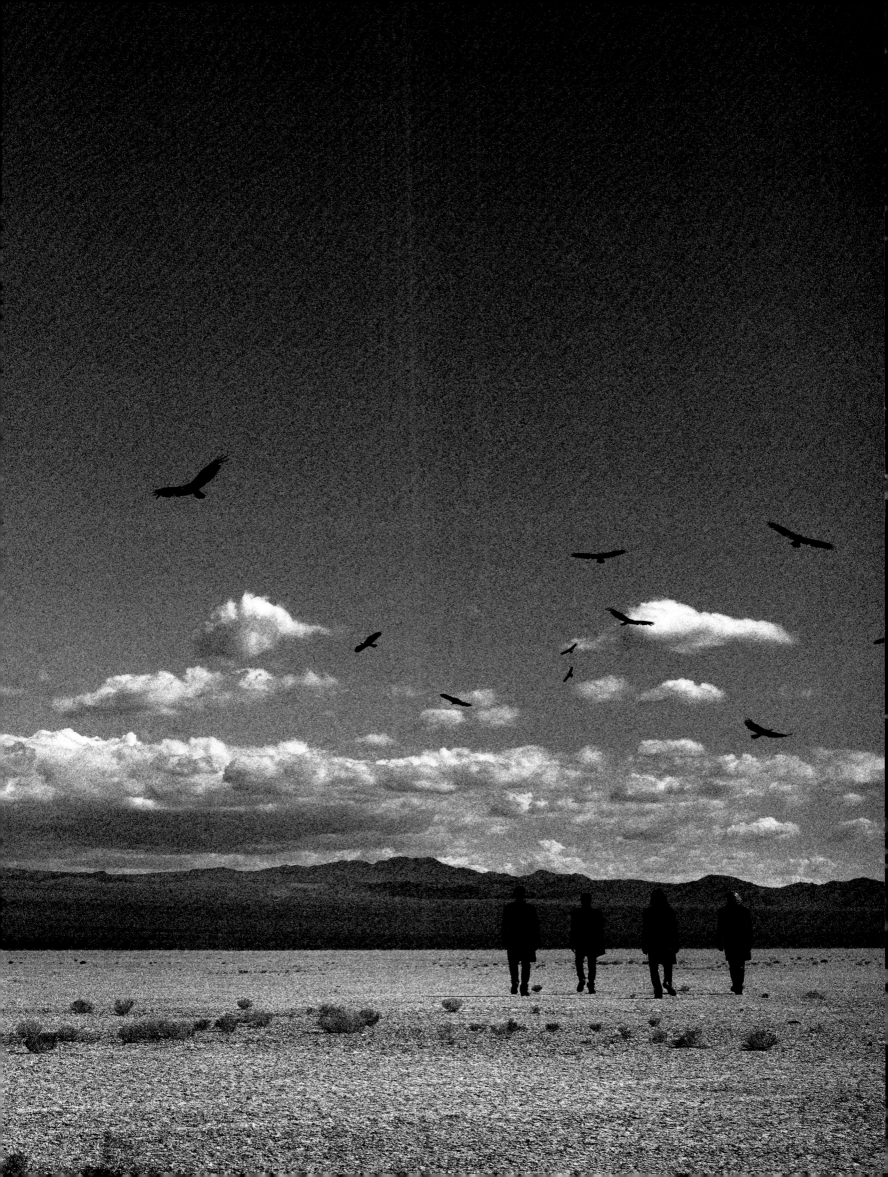

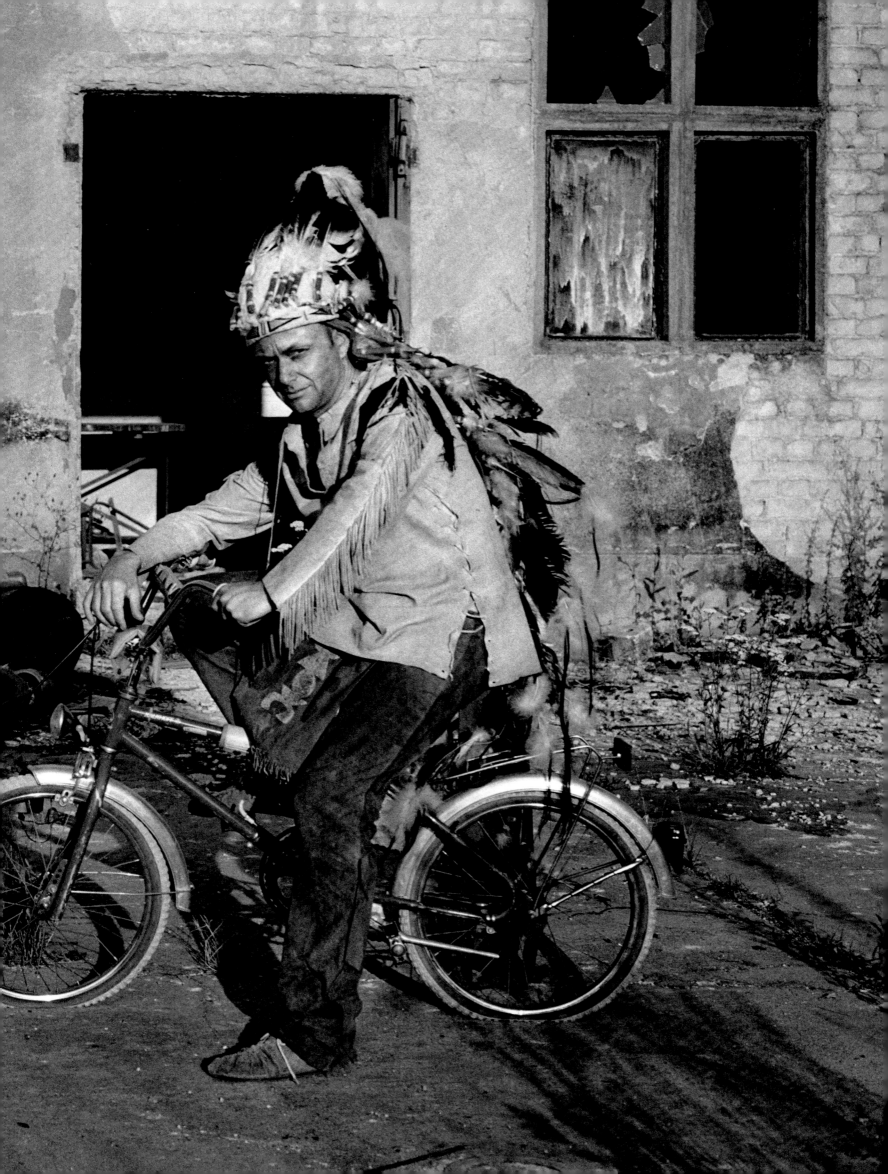

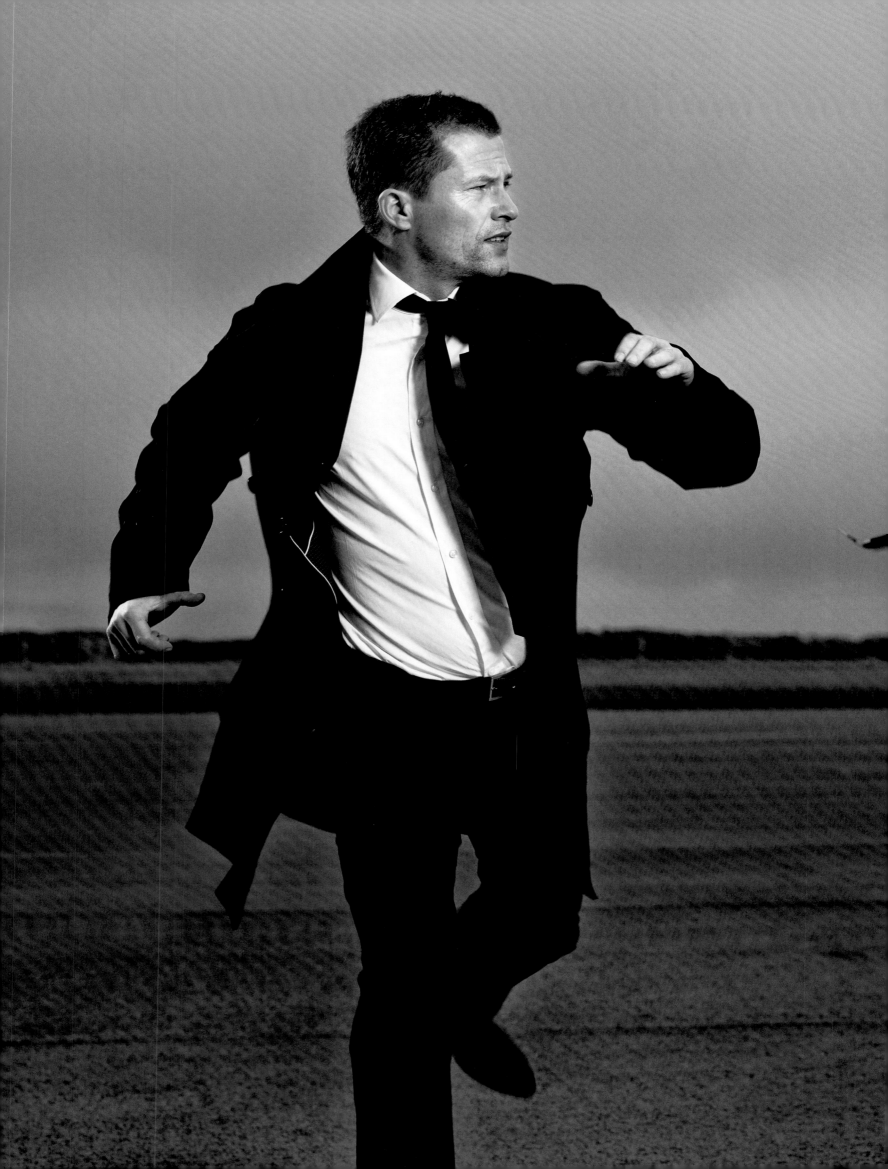

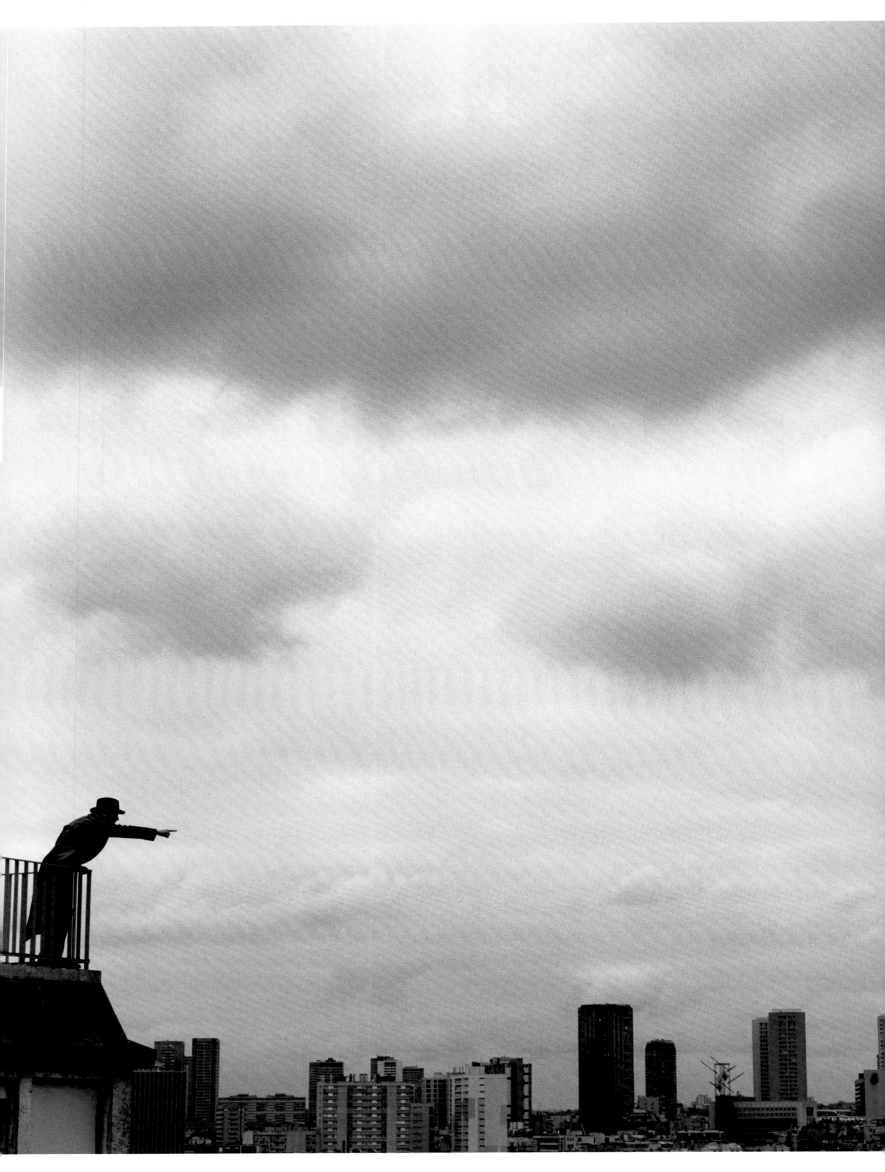

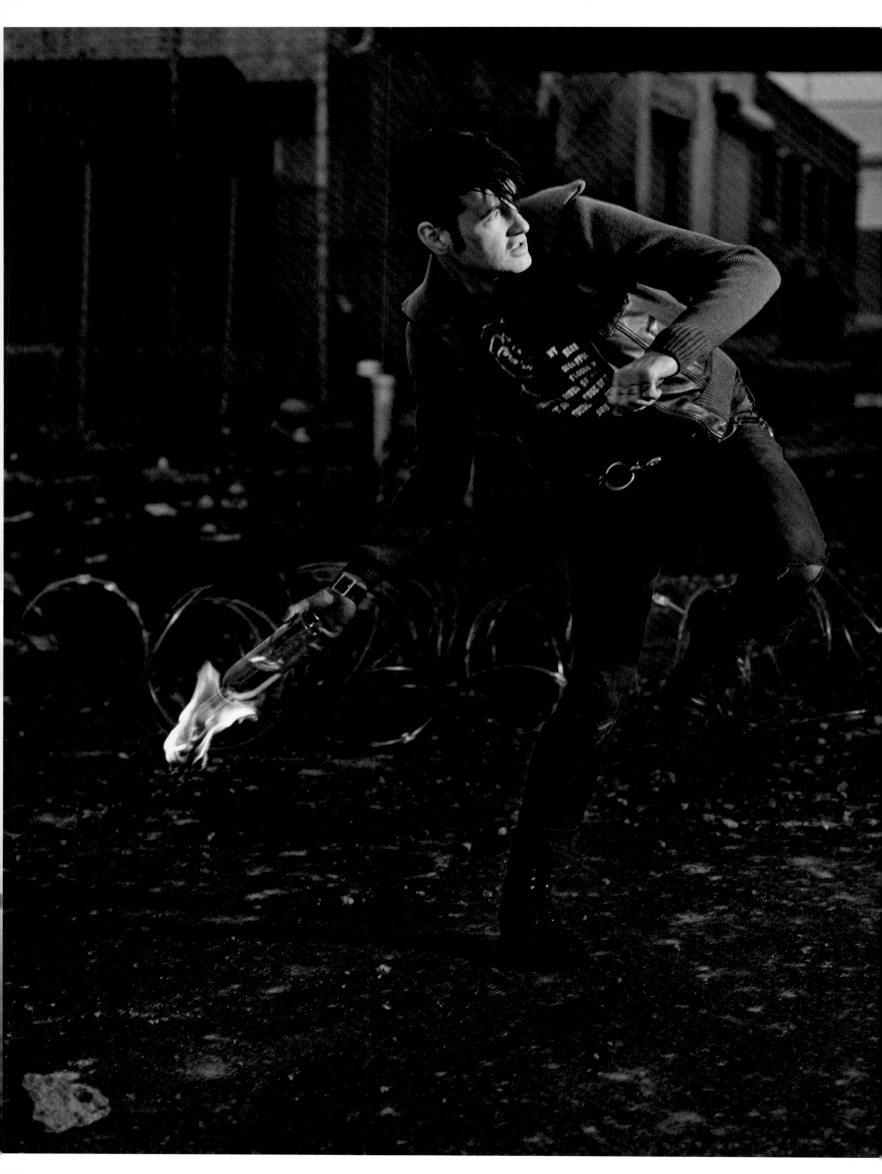

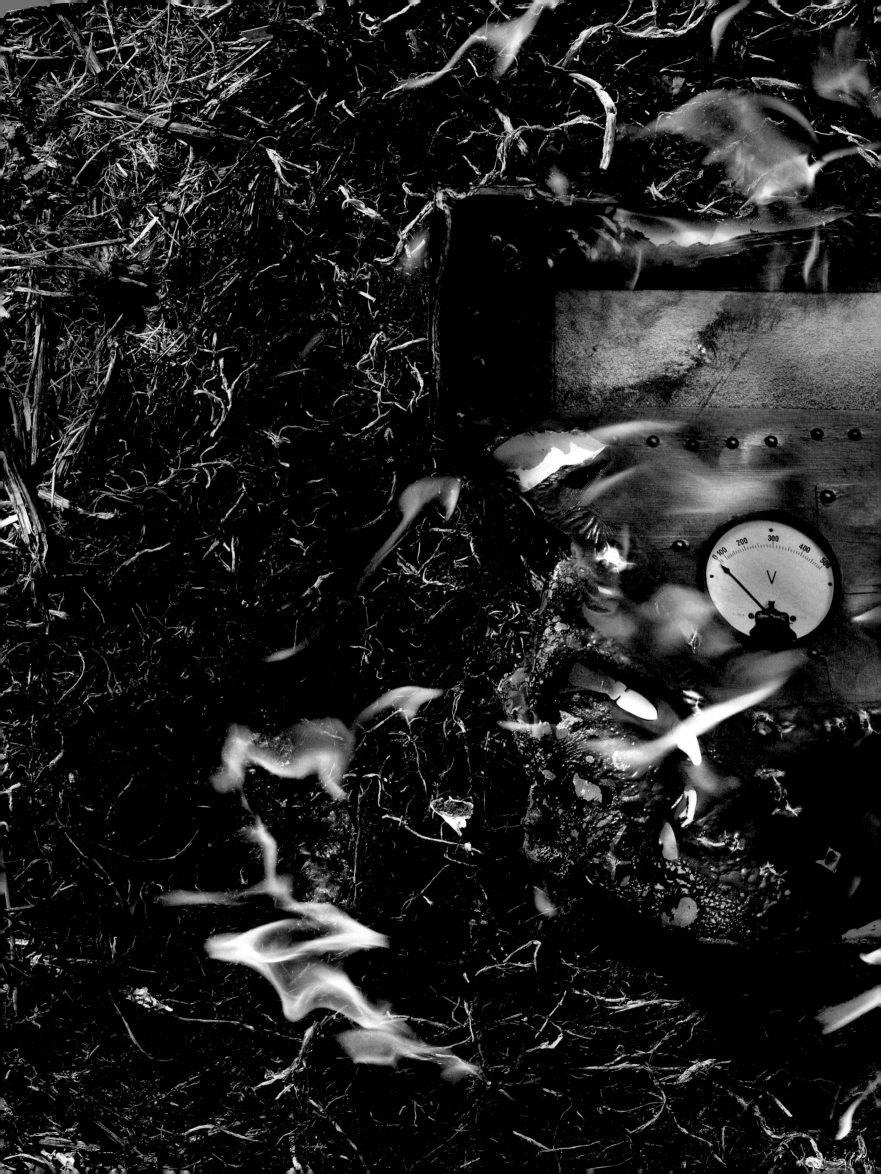

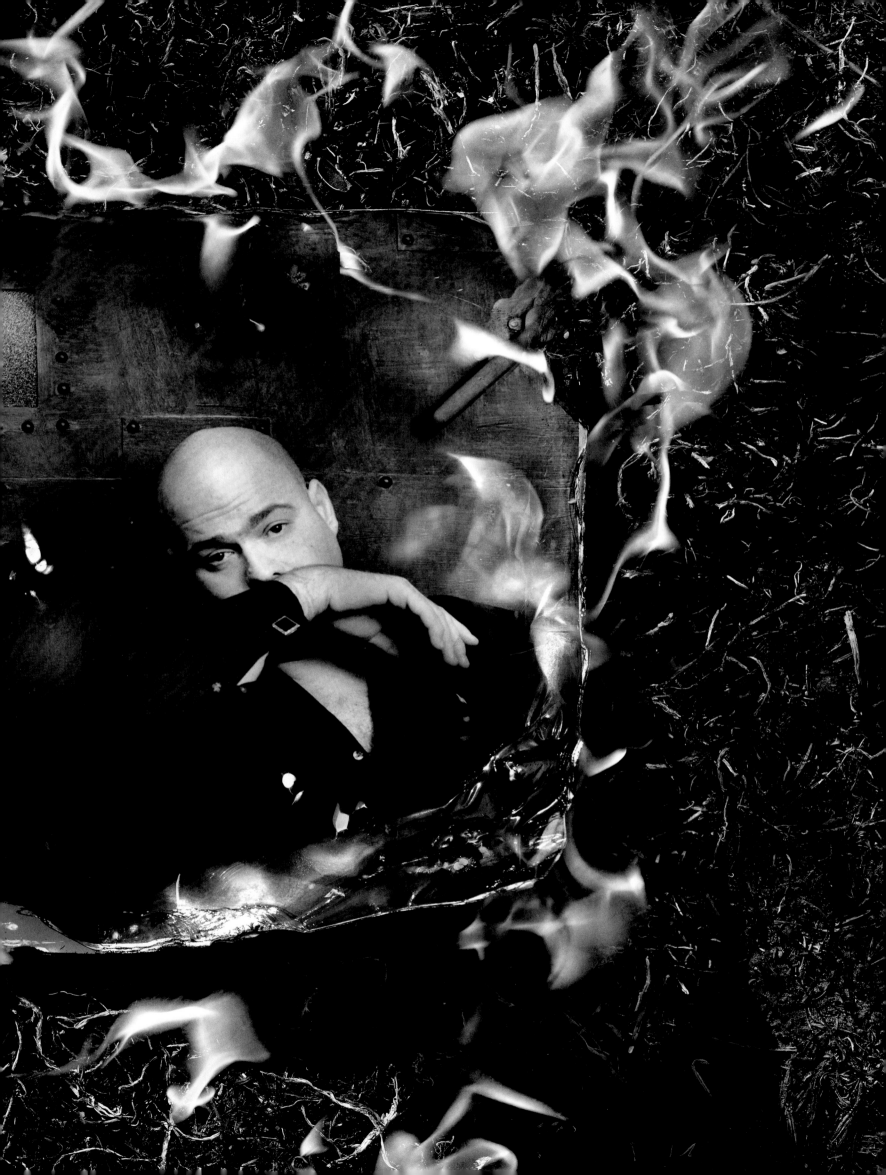

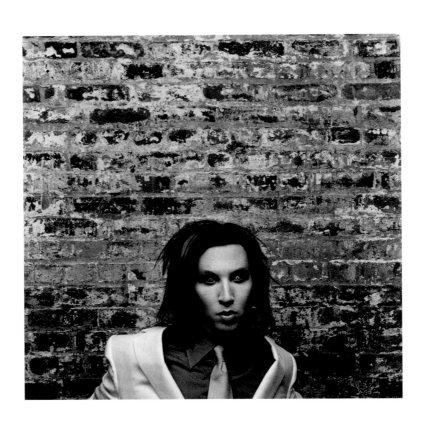

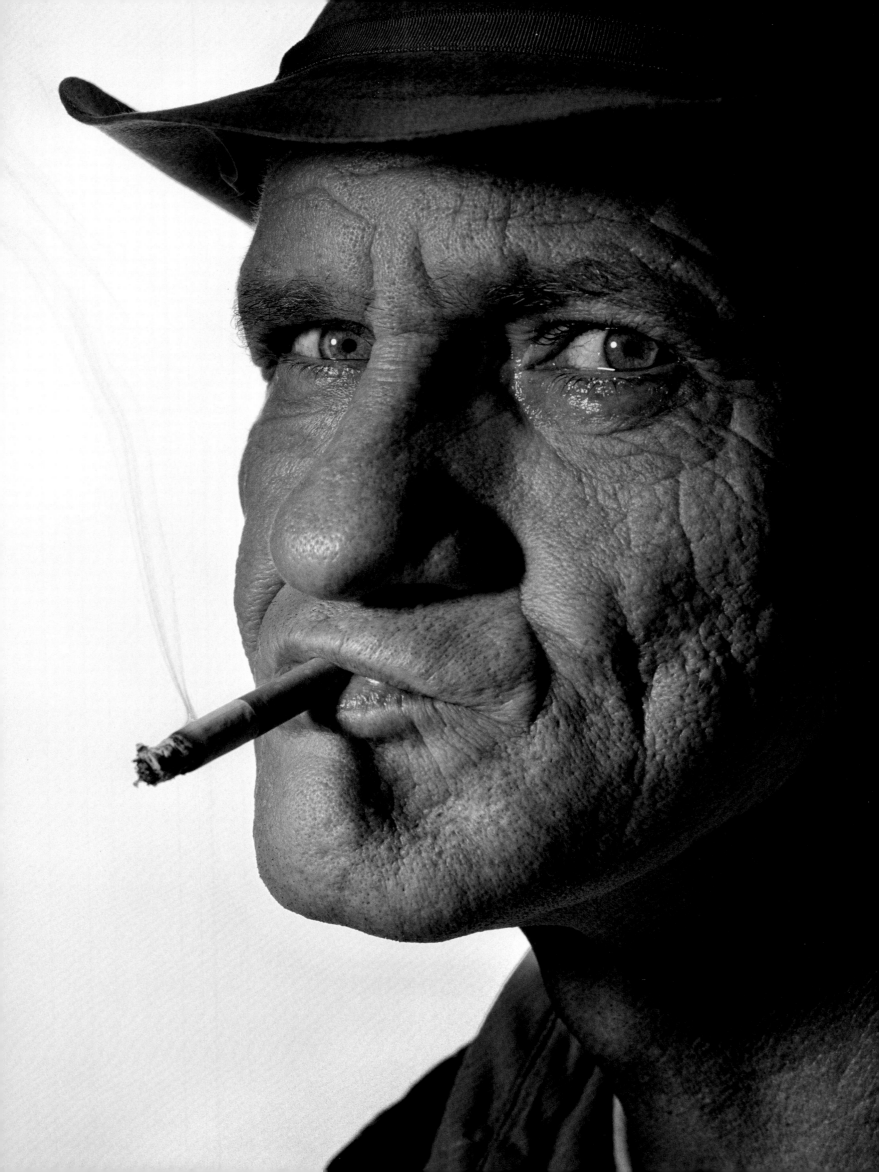

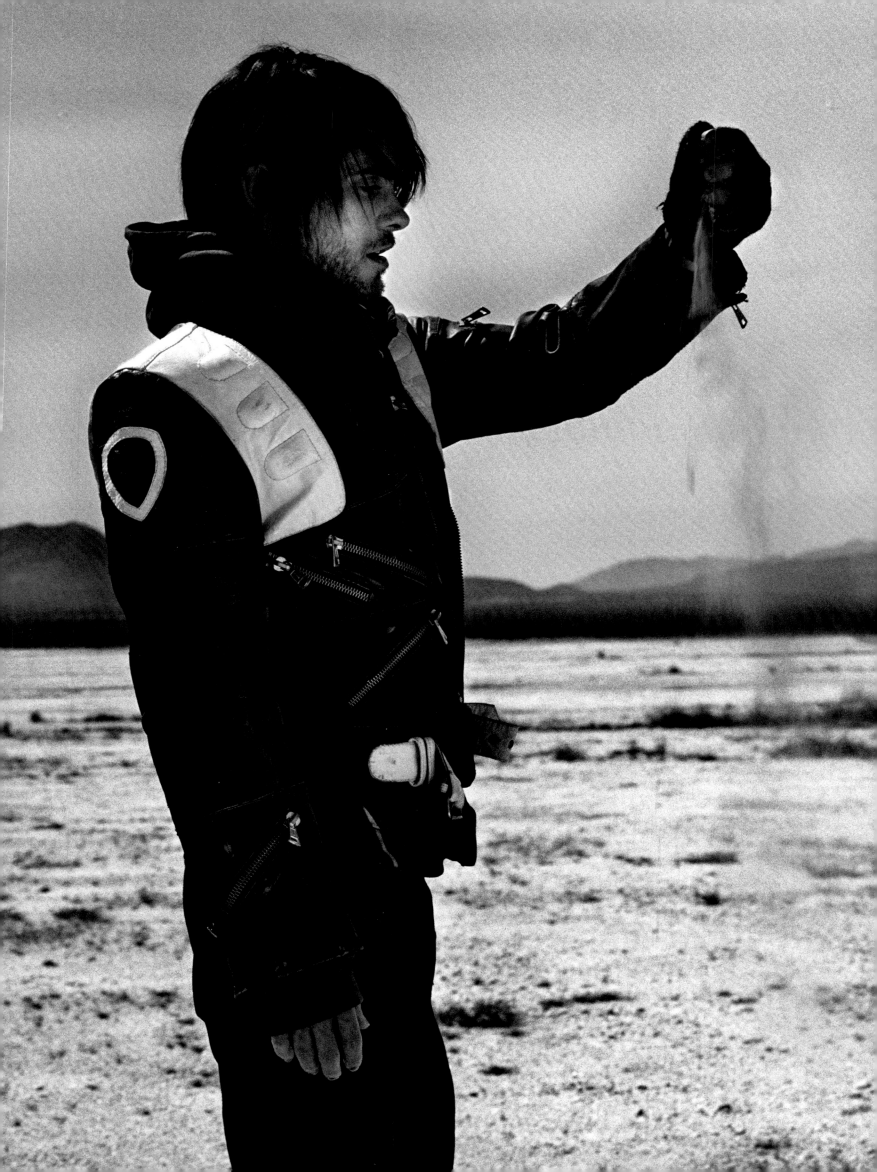

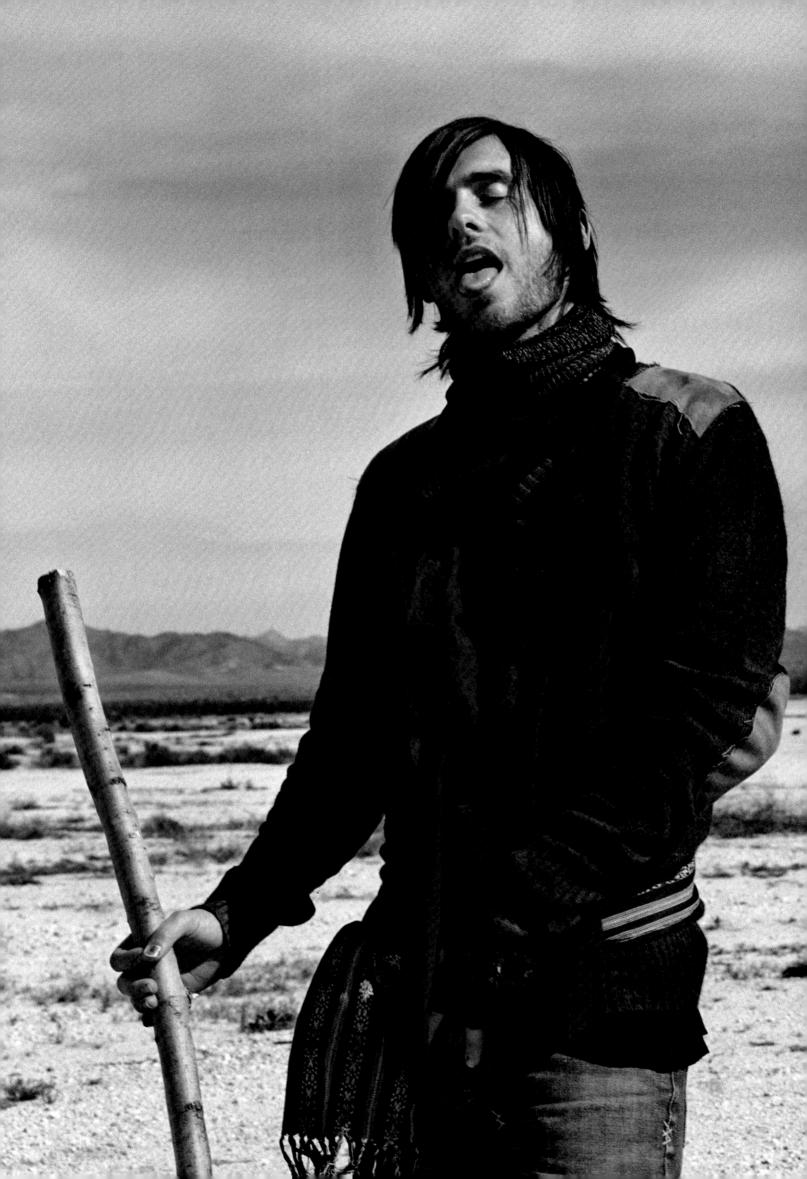

There is a certain something that I have encountered in young male artists from Berlin. A kind of inner toughness and a dogged determination to complete fully whatever it is they're doing—to go all the way. So when I met Olaf, I thought: here comes another one. Olaf has this quality. It's never easy spending time with one of these guys because they're so fucking heavy, but the quality of their work is very high.

Although the occasion for these photos was a commercial shoot the images far transcended that and showed a true picture of who I was and where I was at: slightly irritated, fairly desperate, and somewhere in the middle of an escape from the prison of my life. Olaf is blessed with a clear and inescapable German eye. You'd better run, or fight back.

Iggy Pop

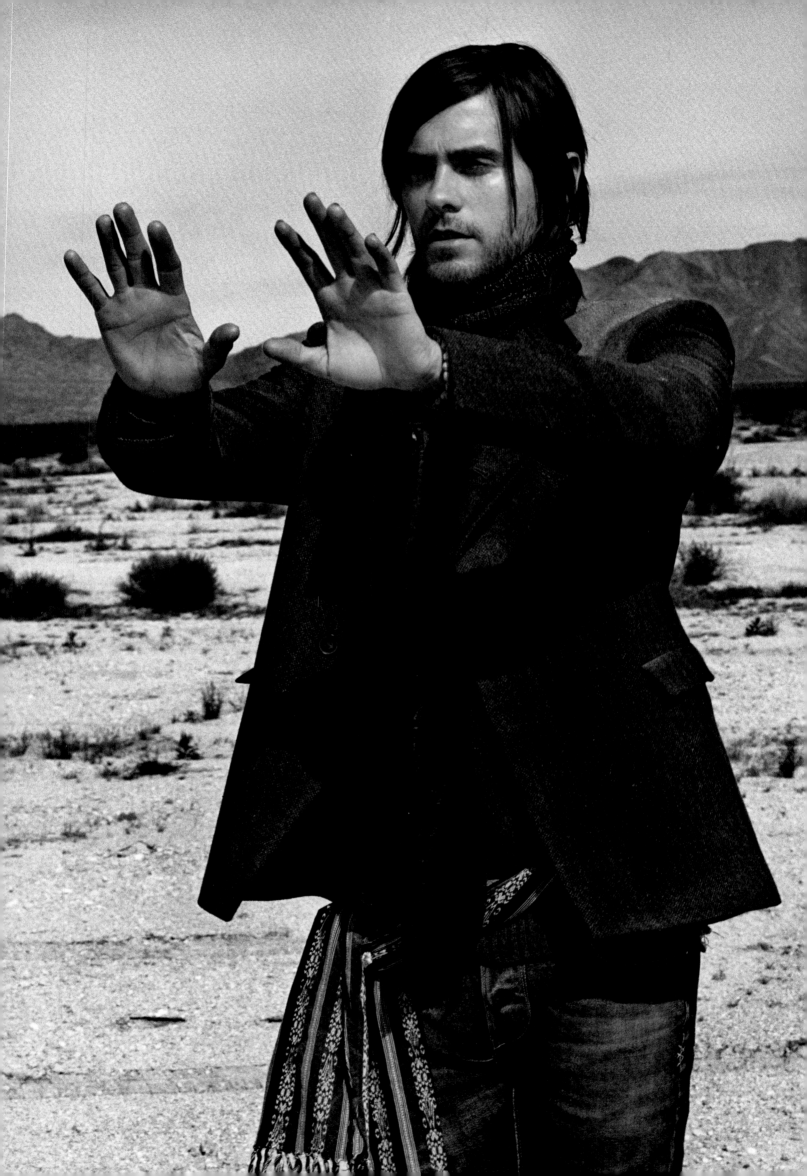

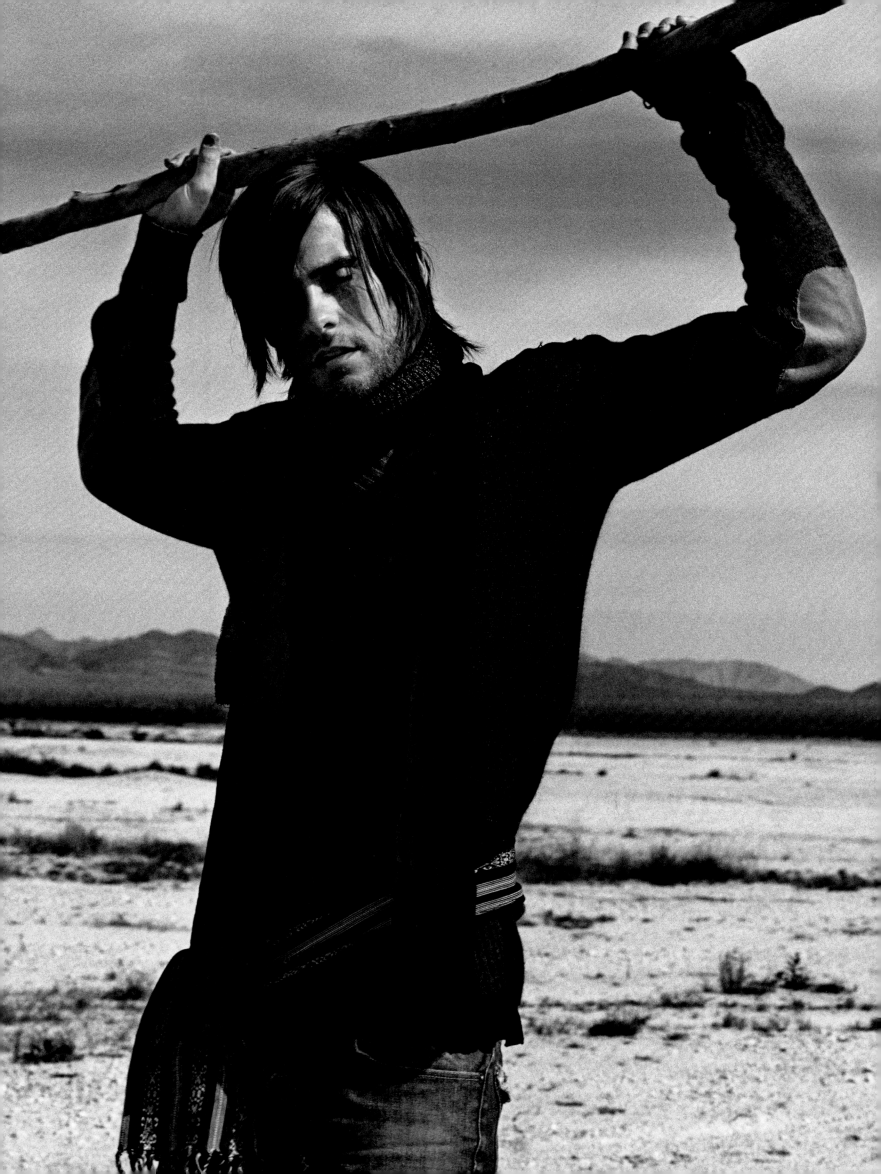

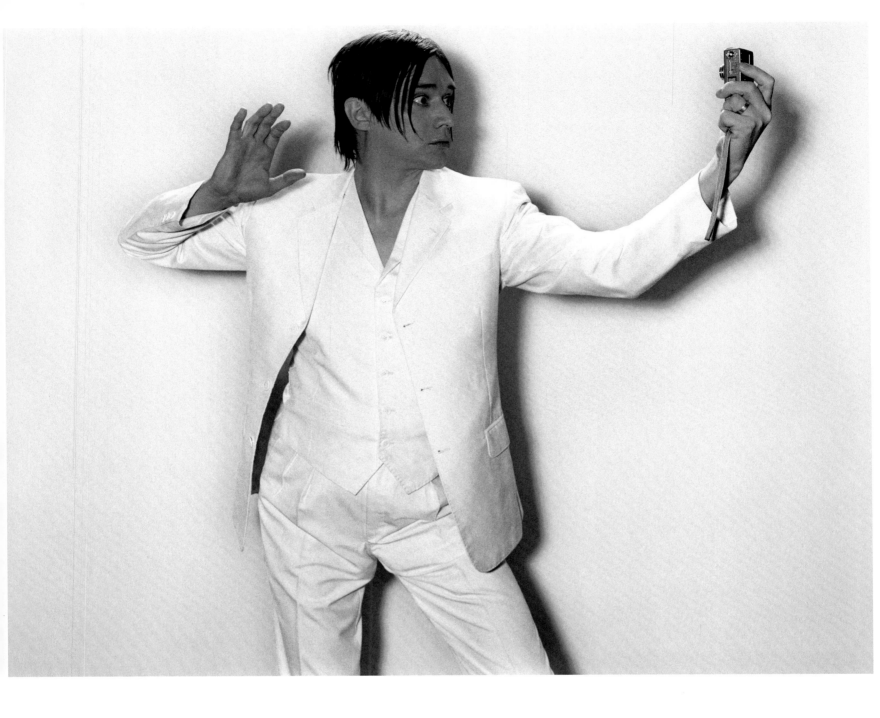

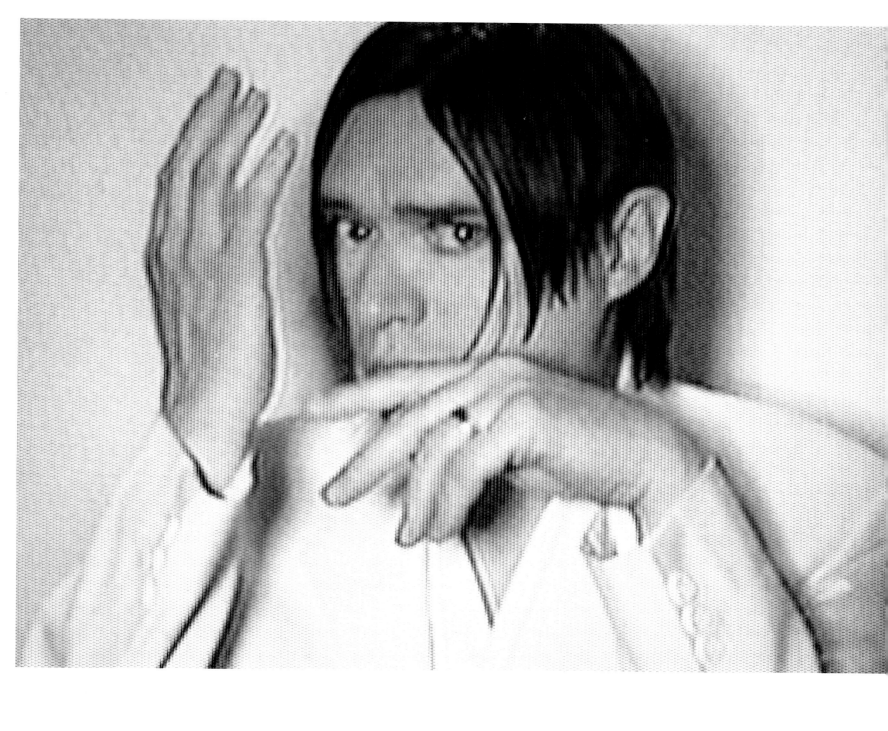

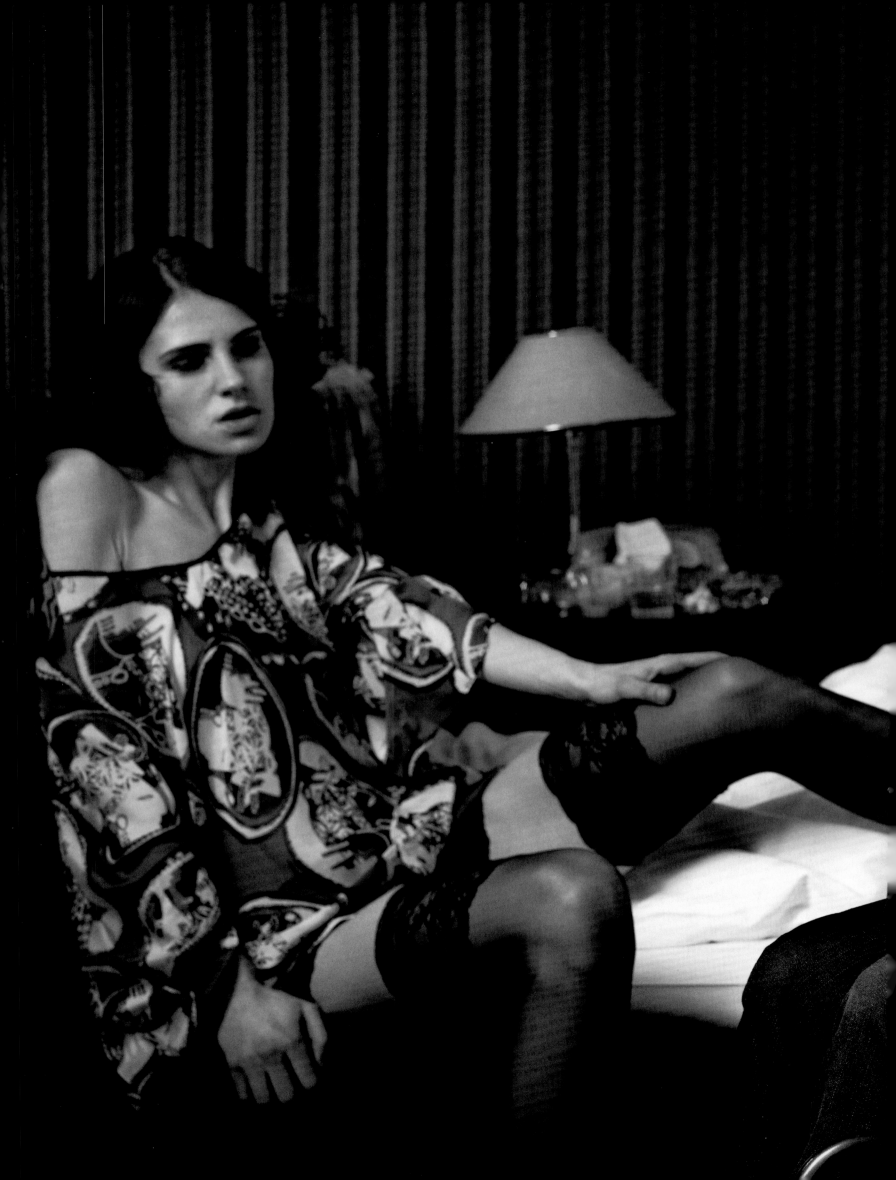

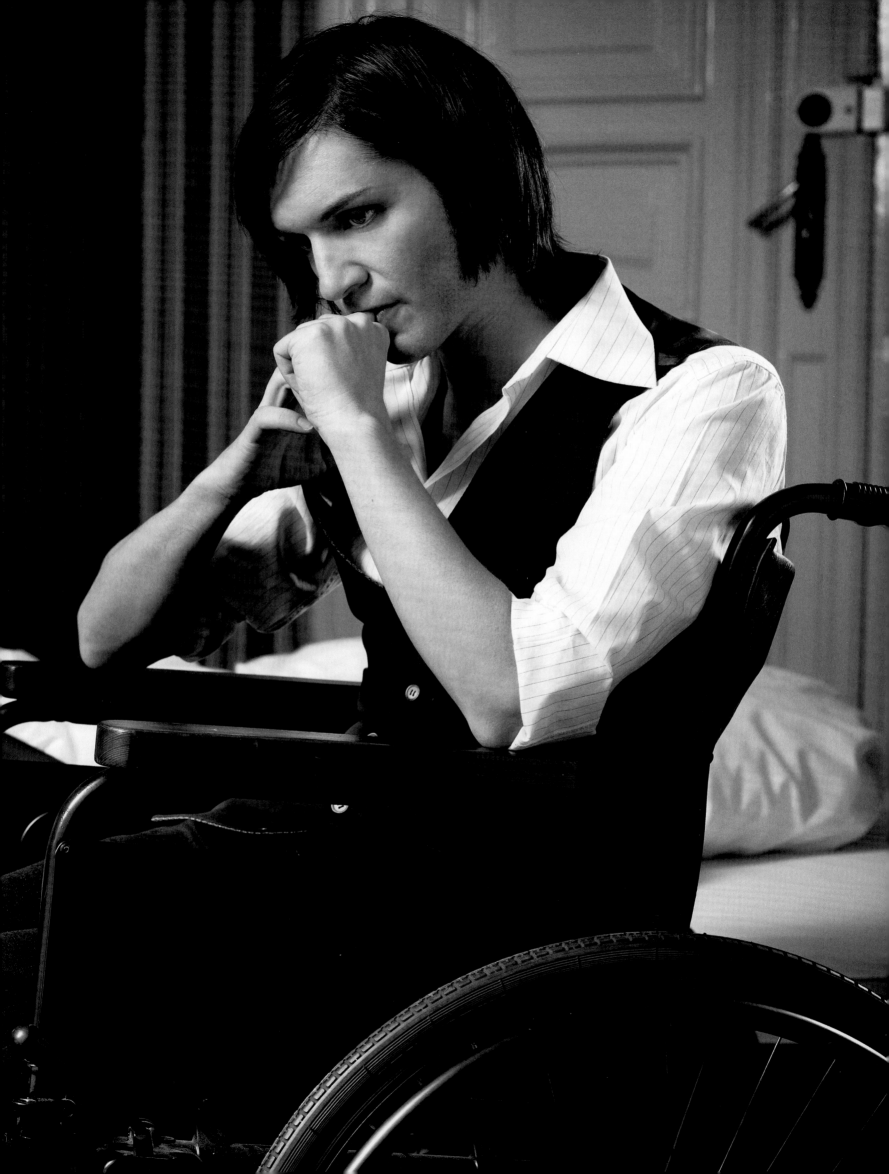

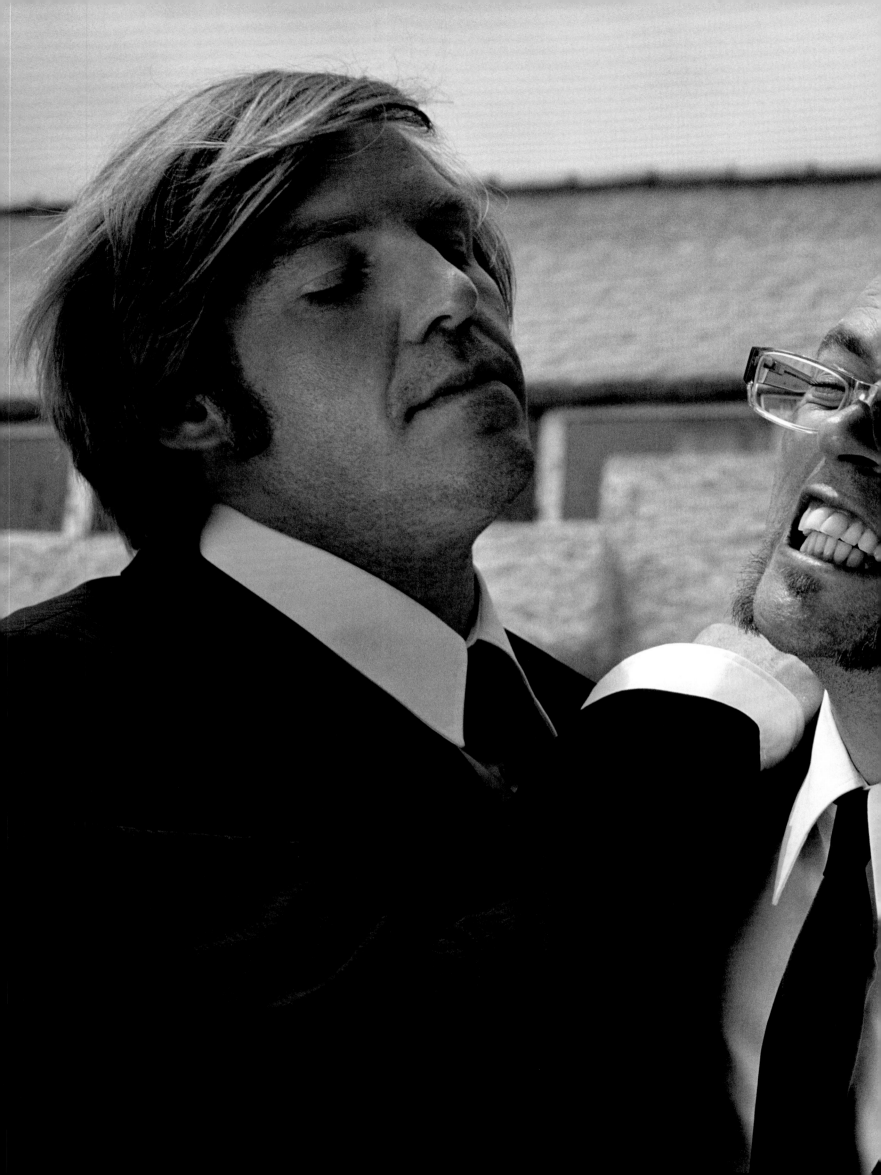

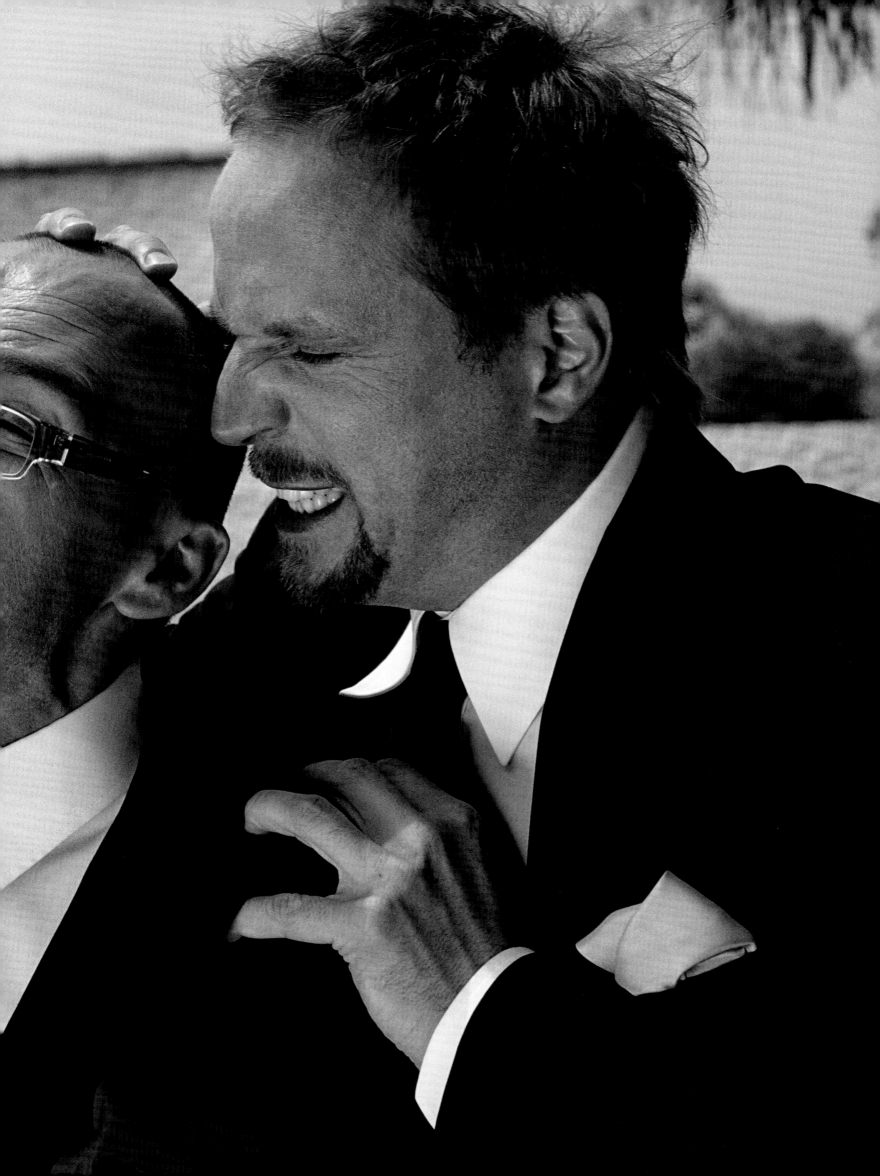

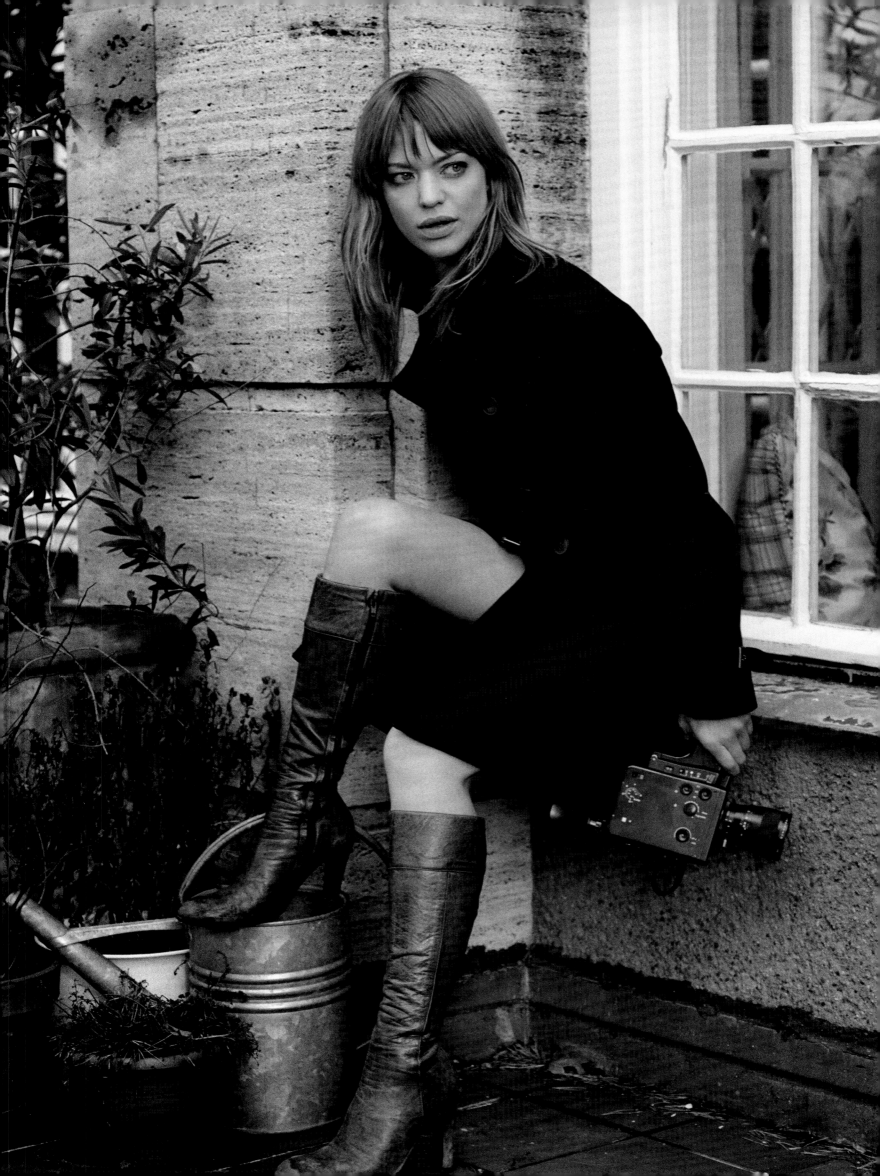

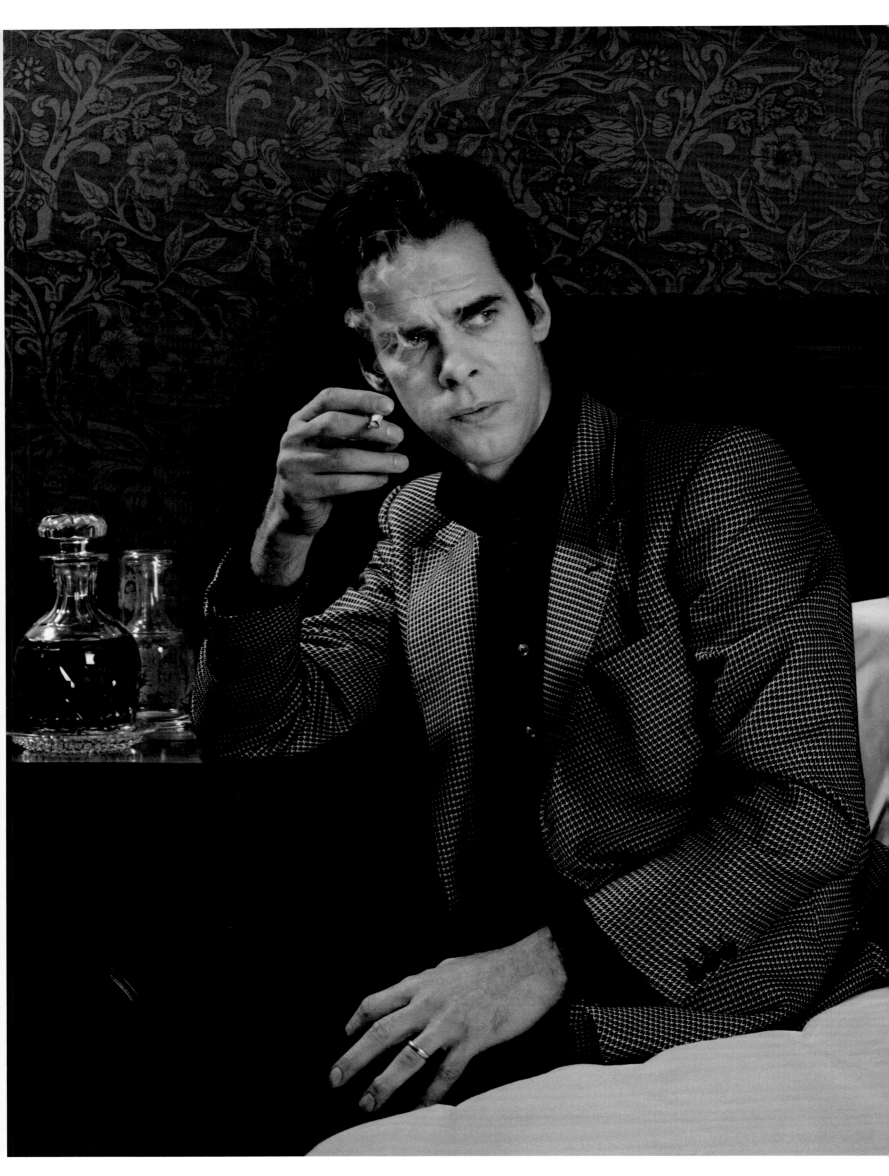

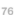

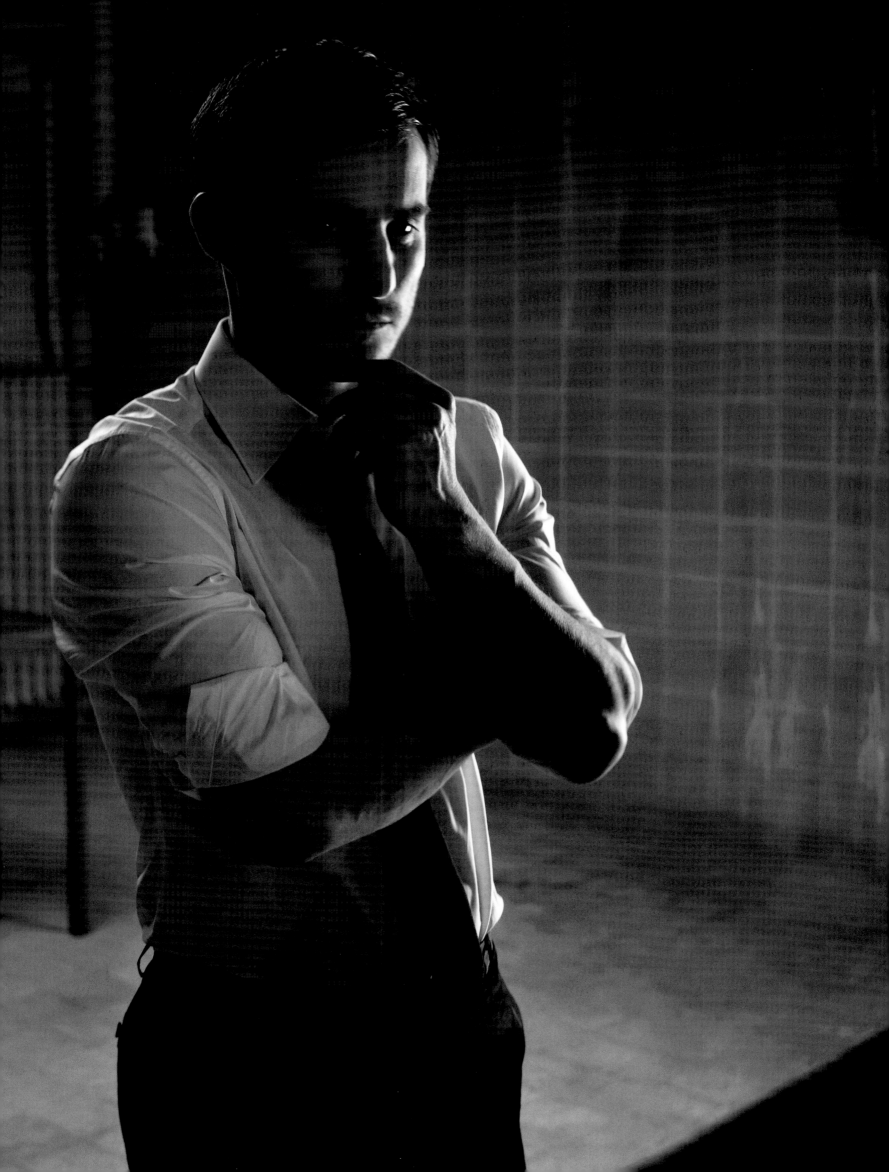

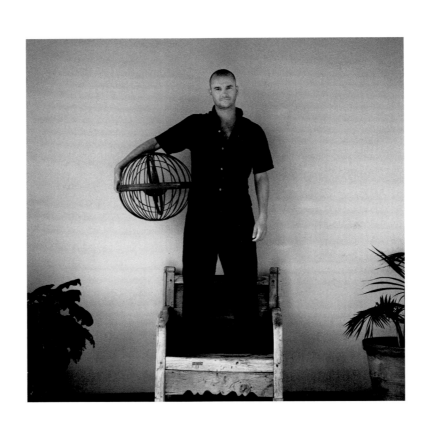

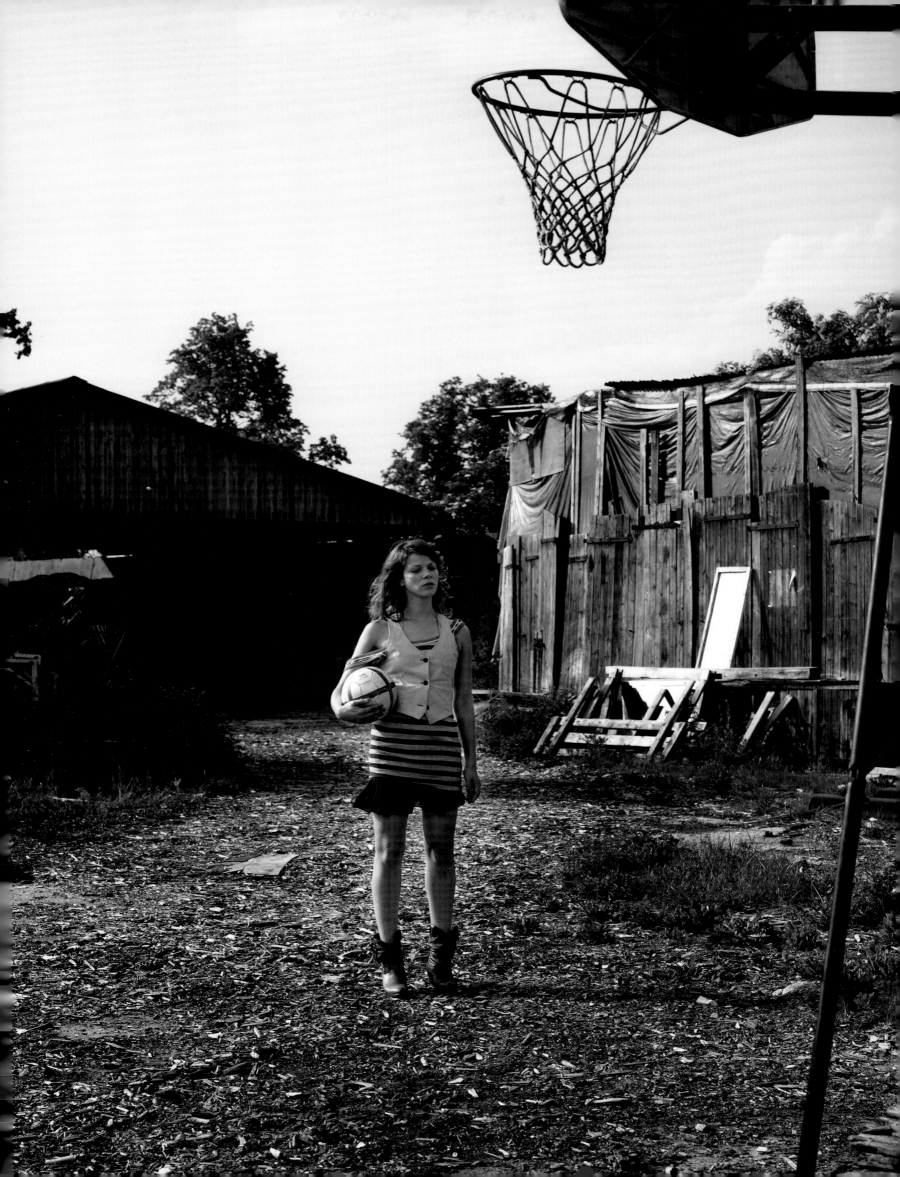

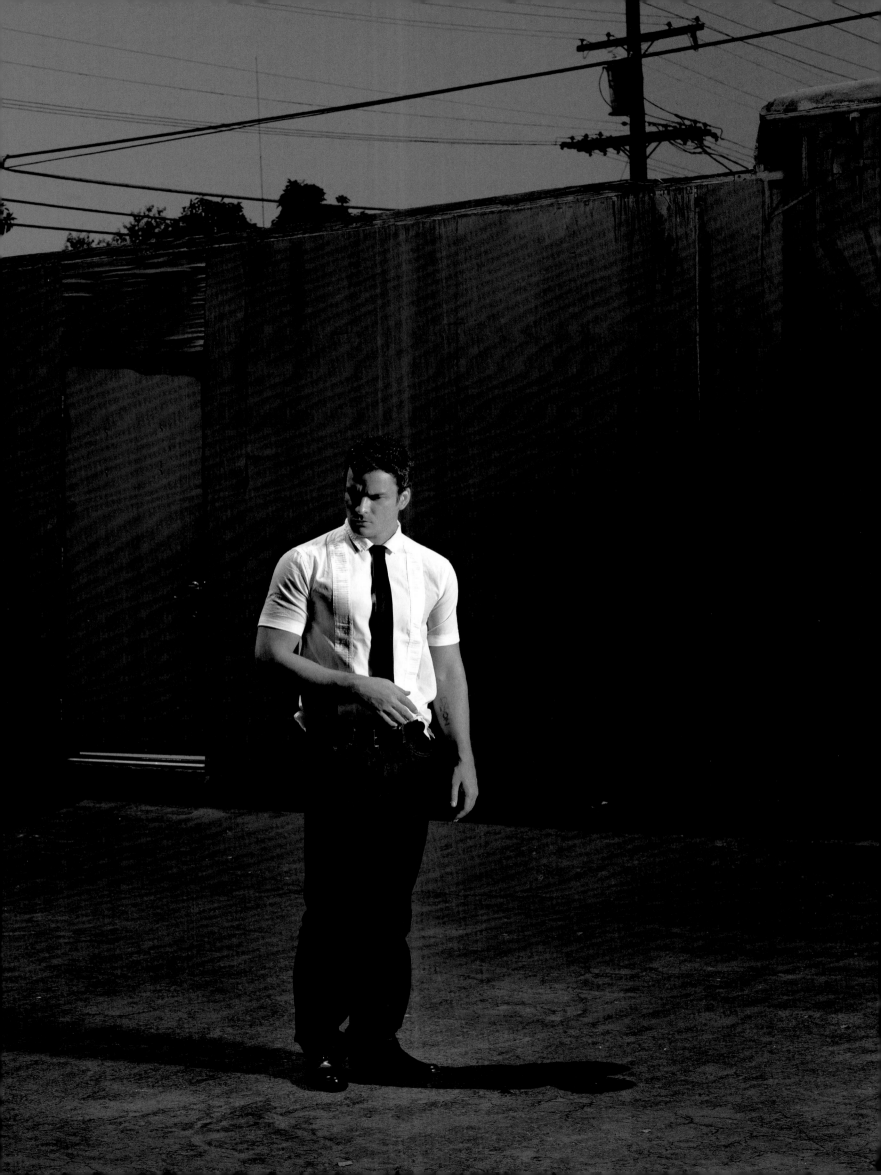

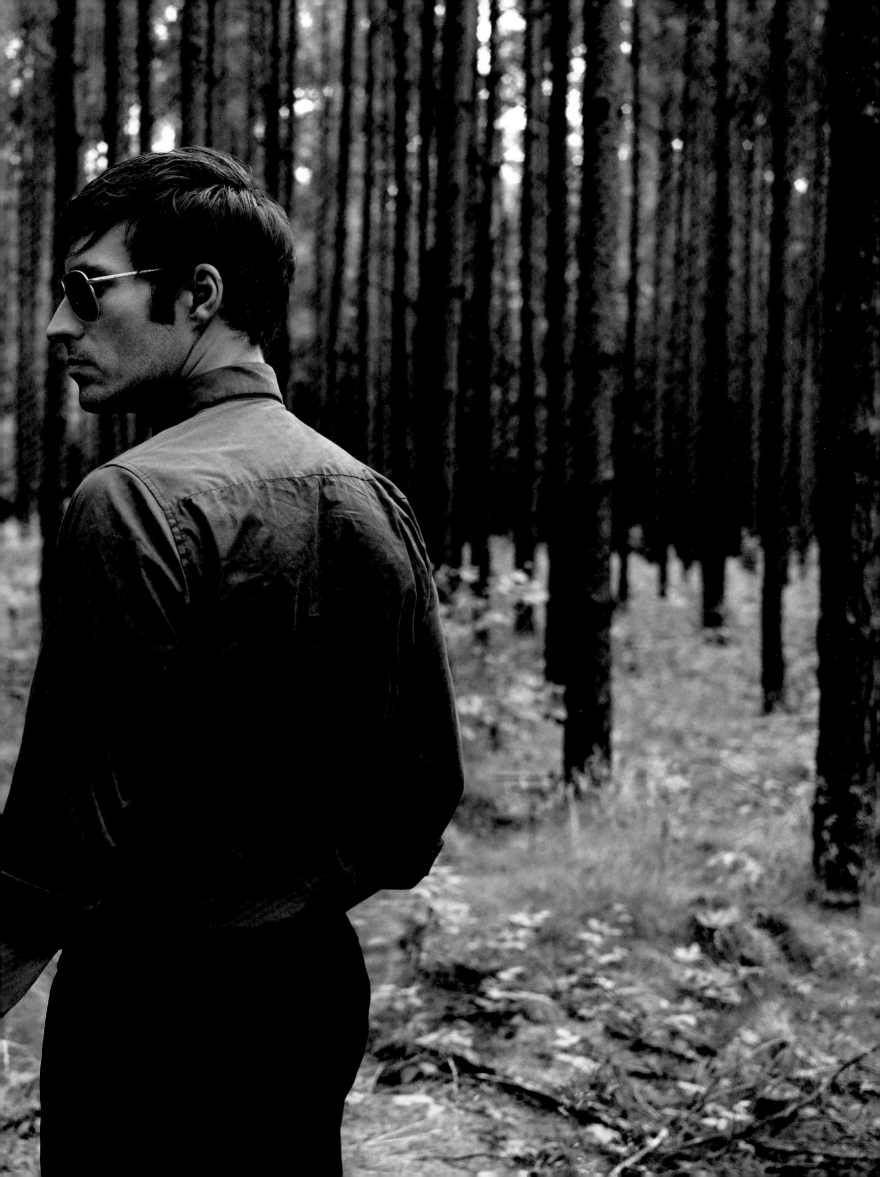

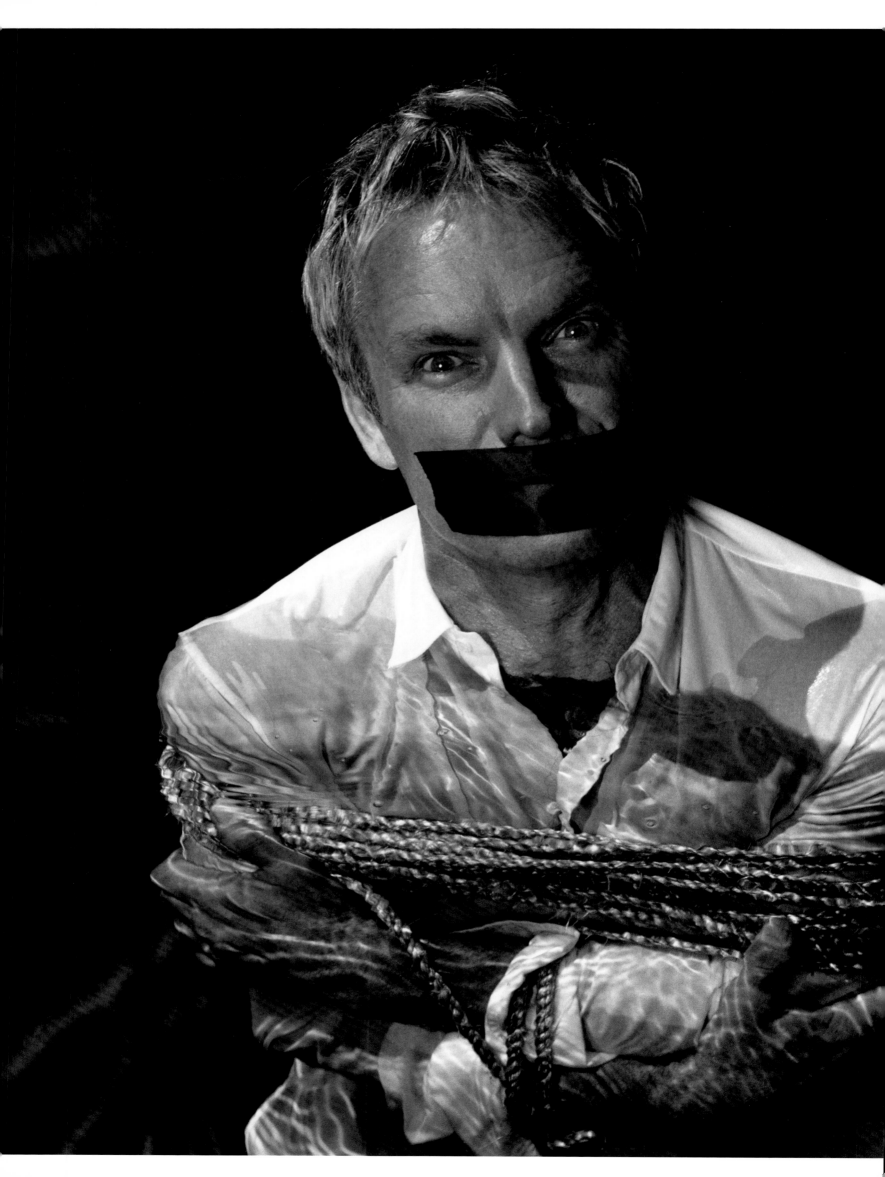

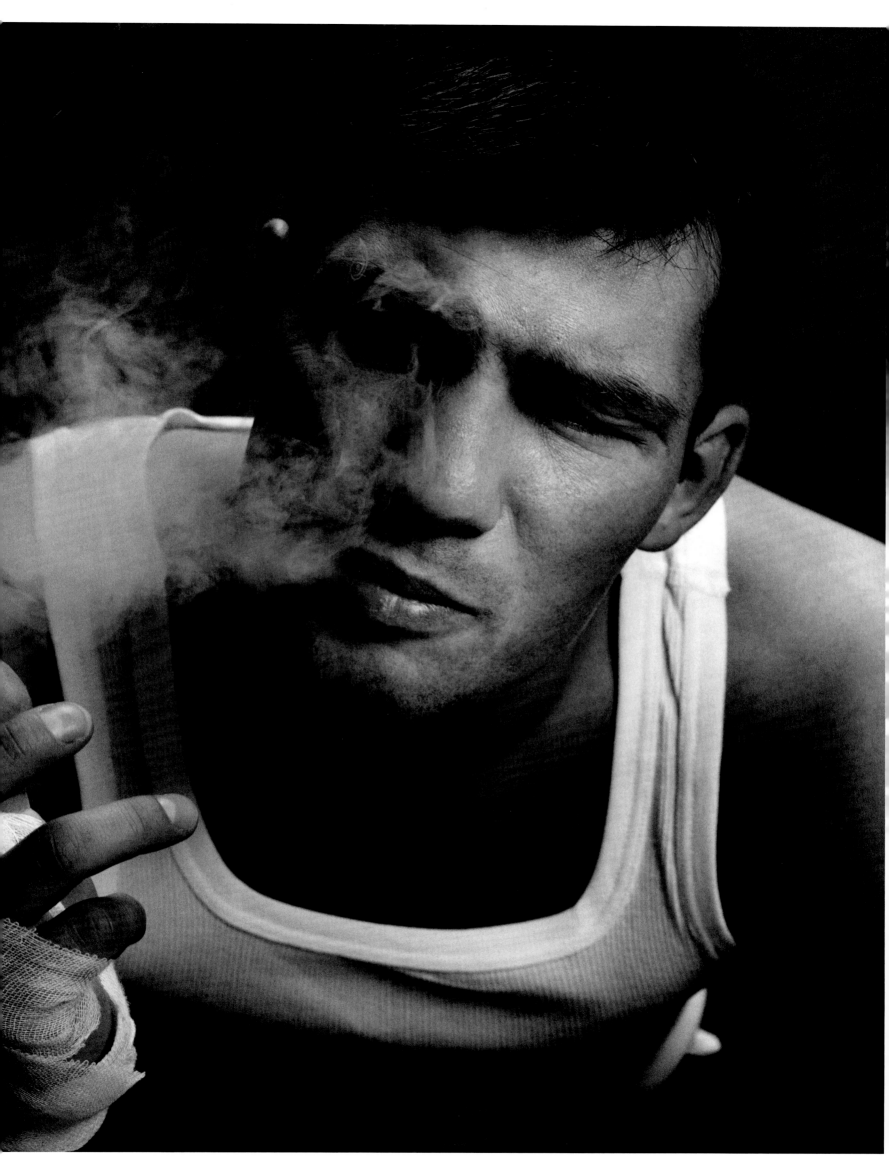

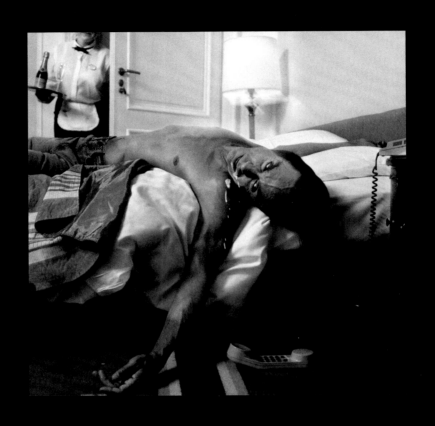

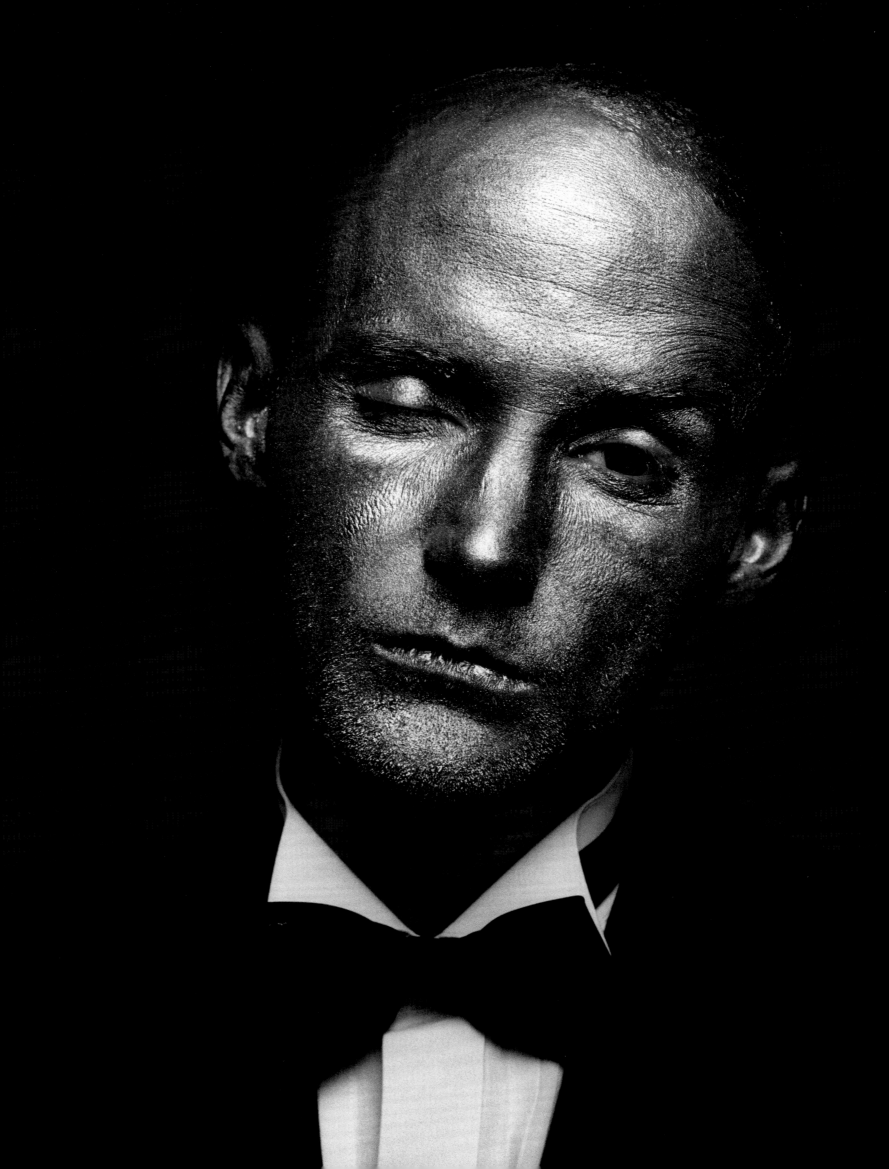

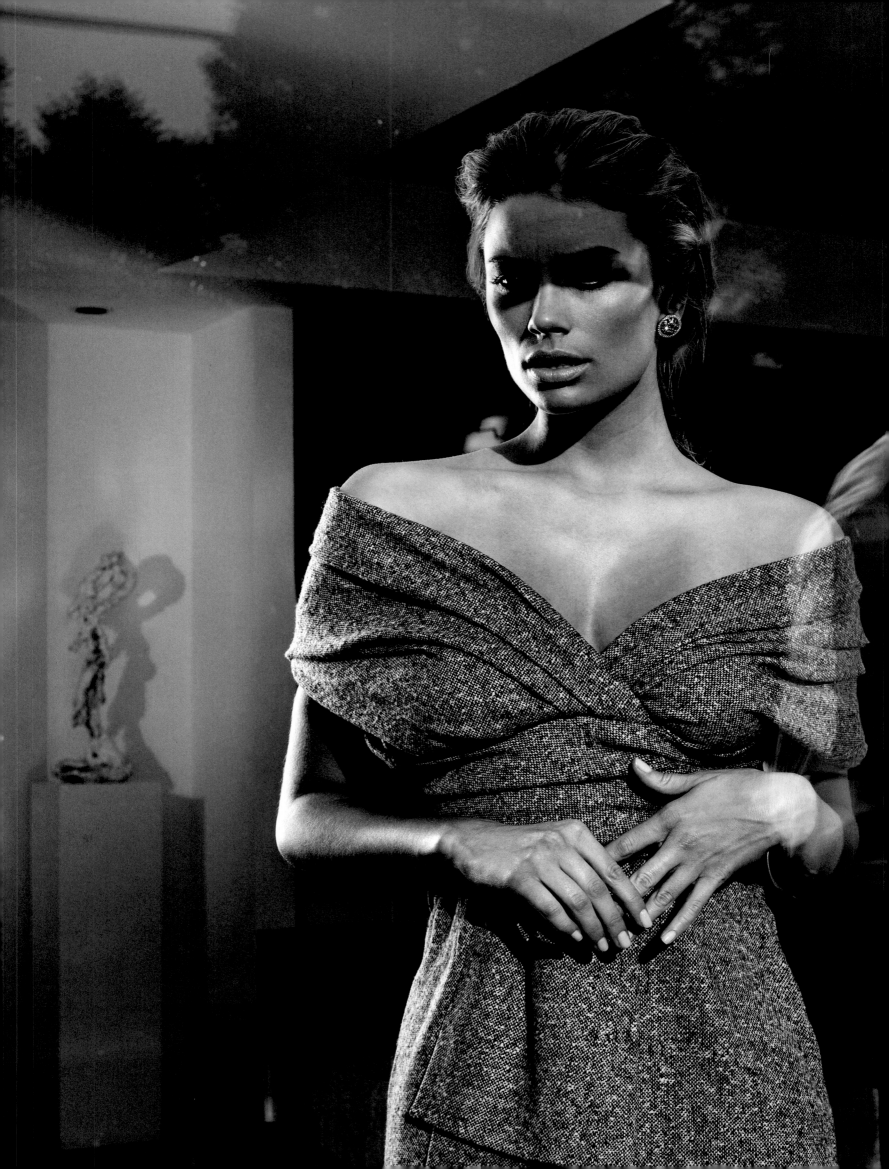

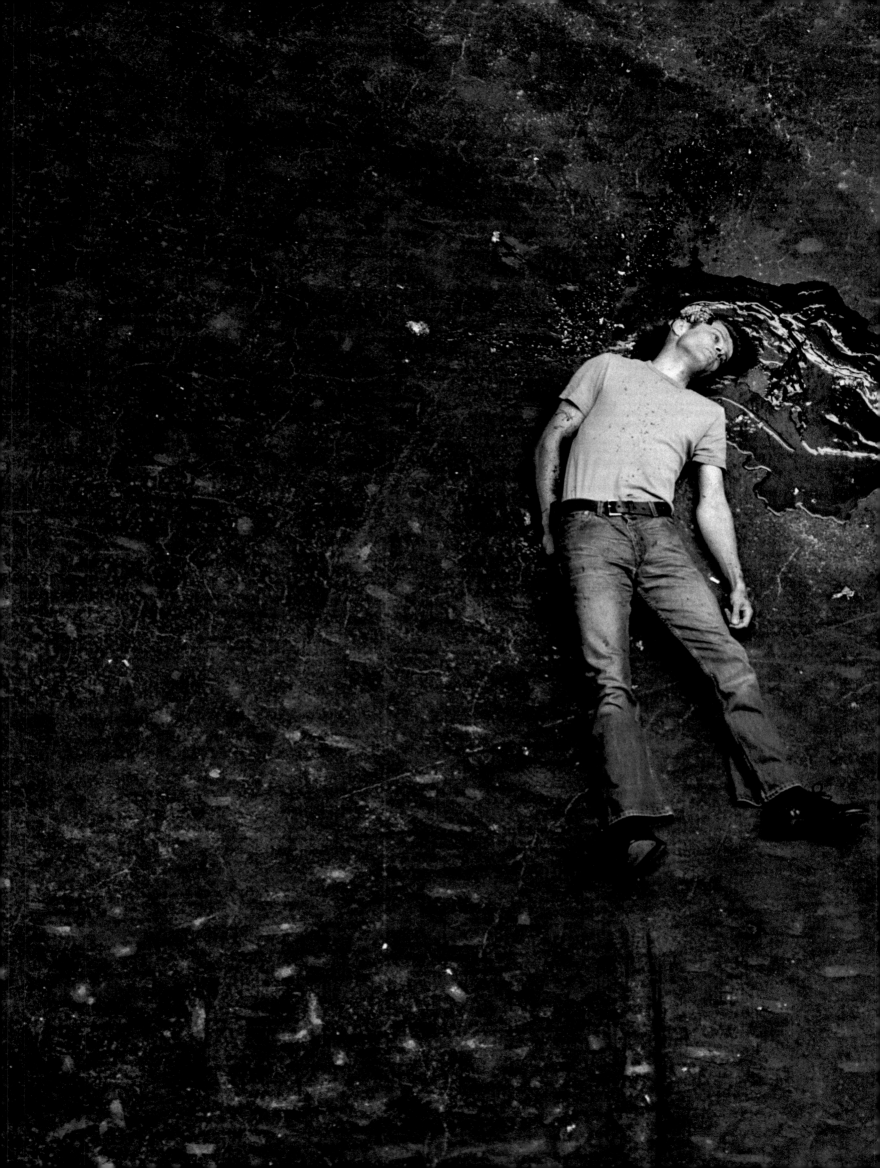

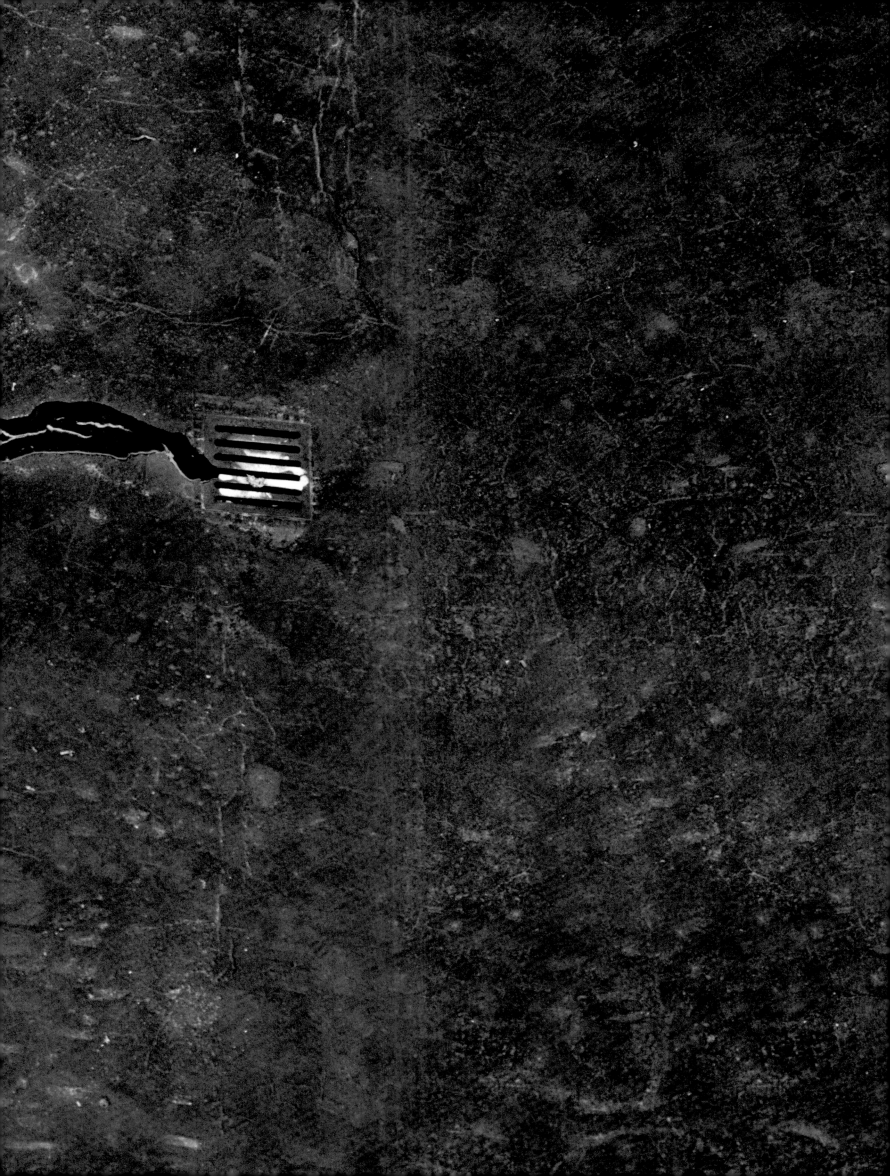

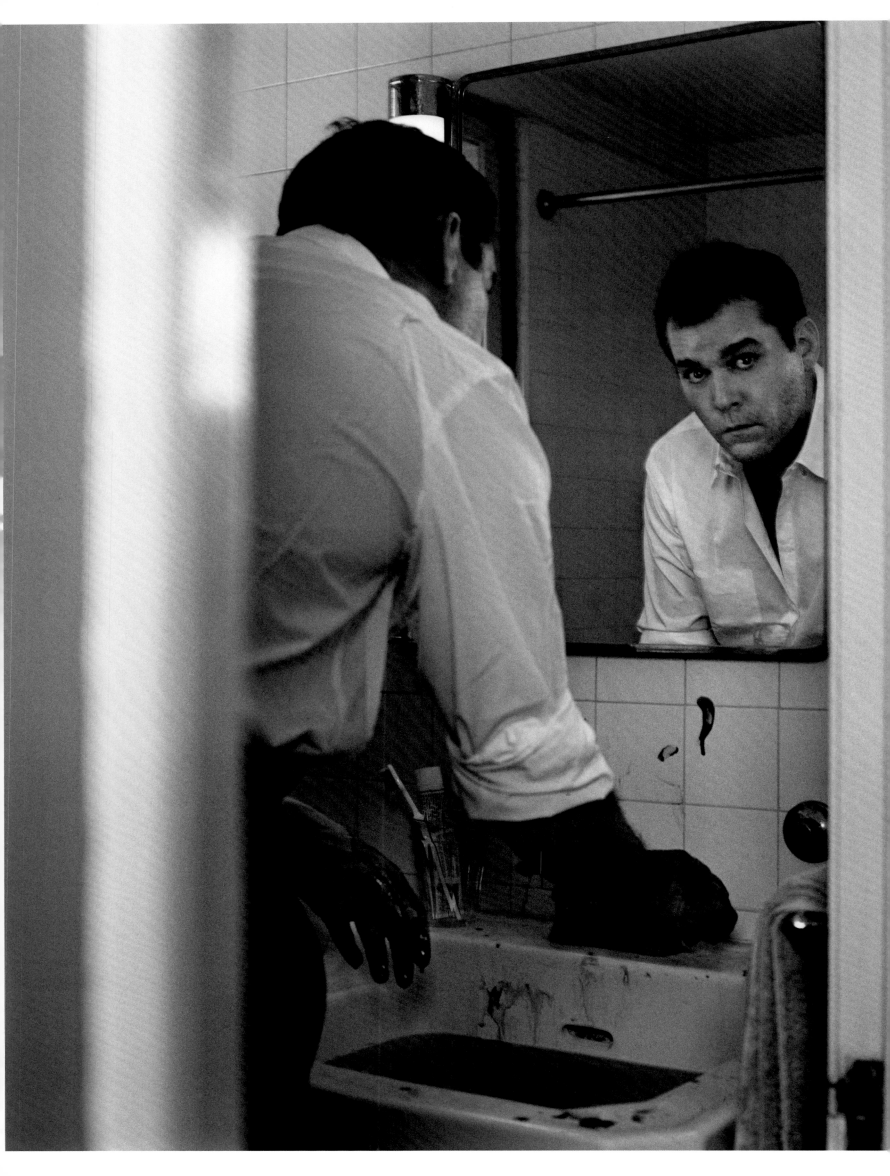

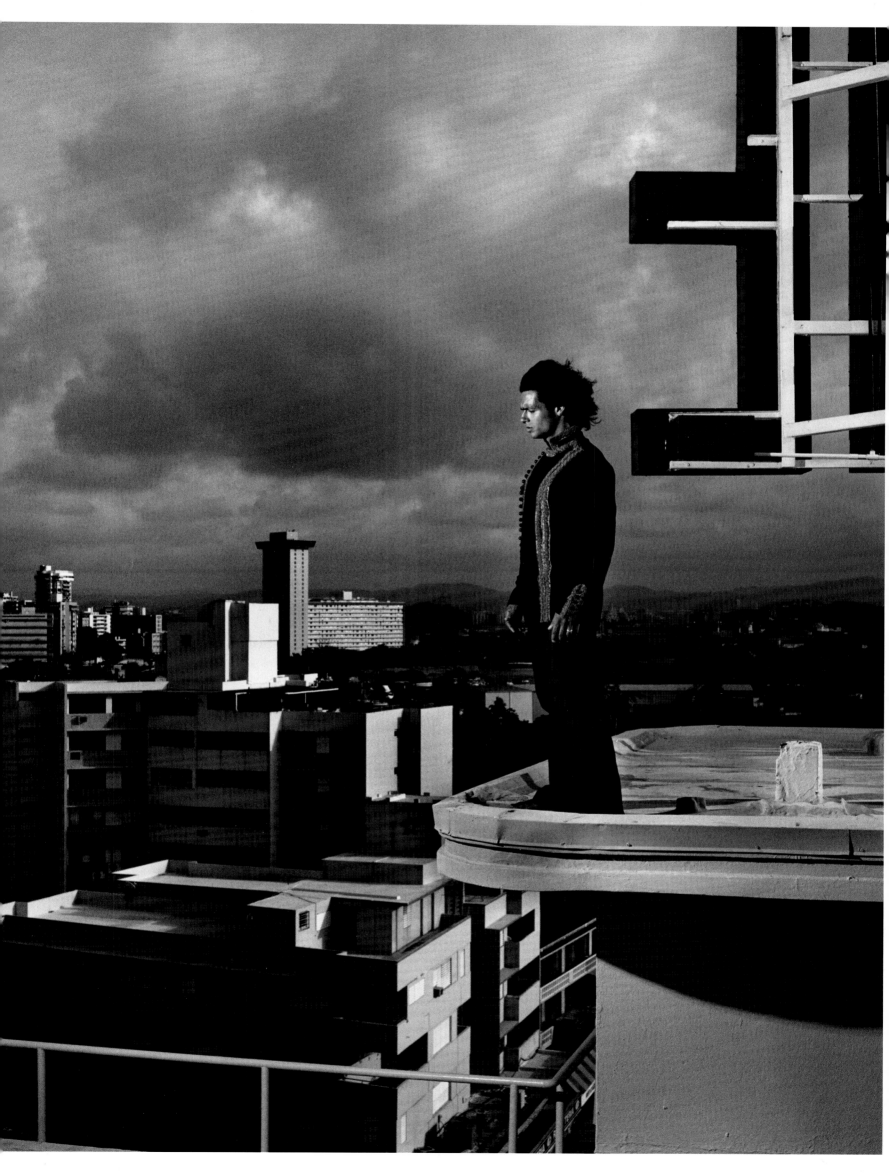

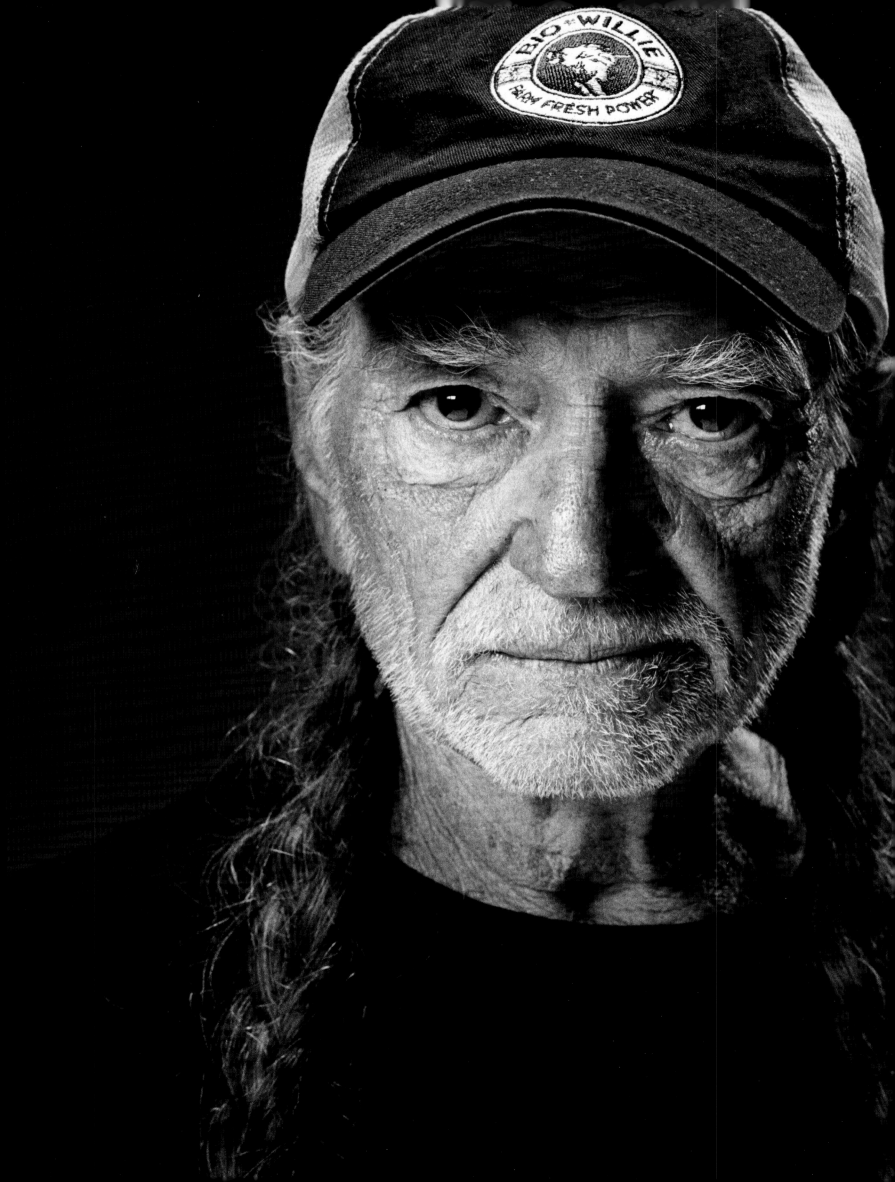

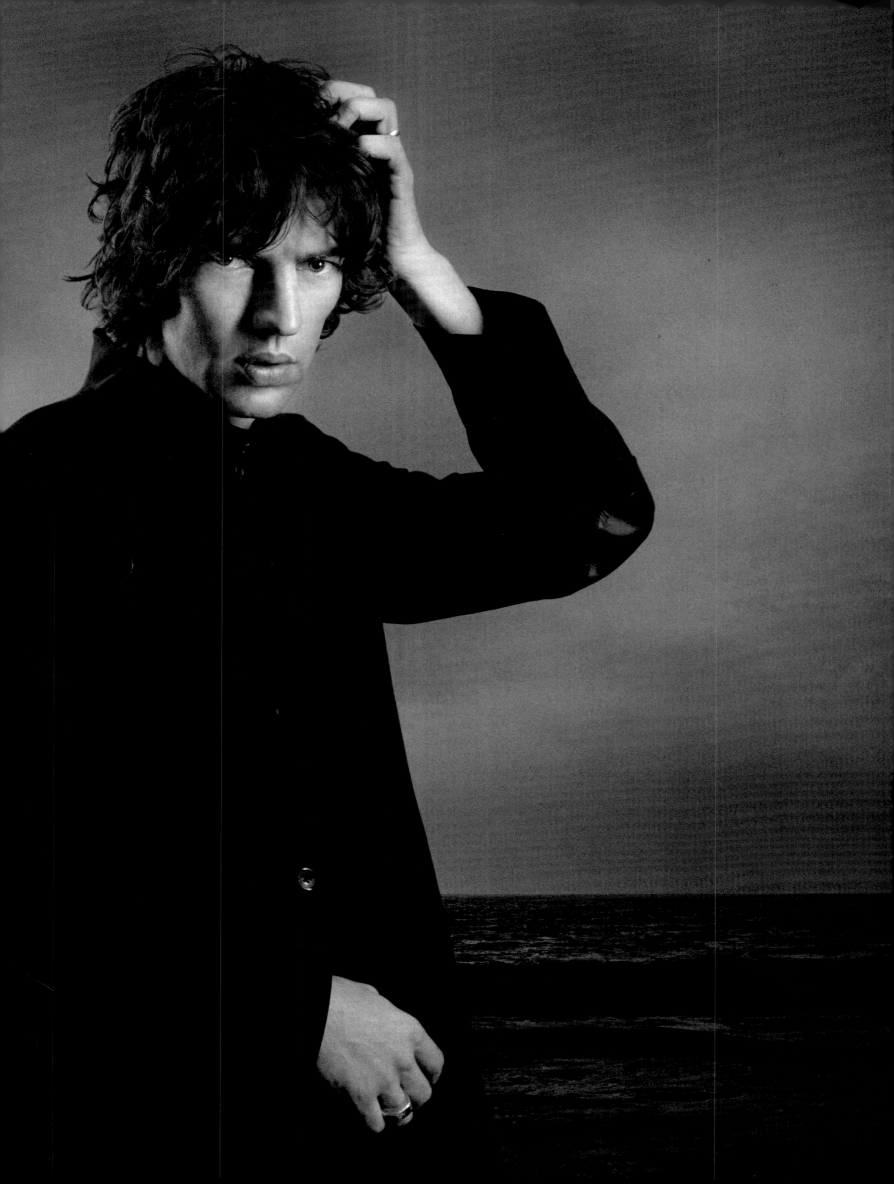

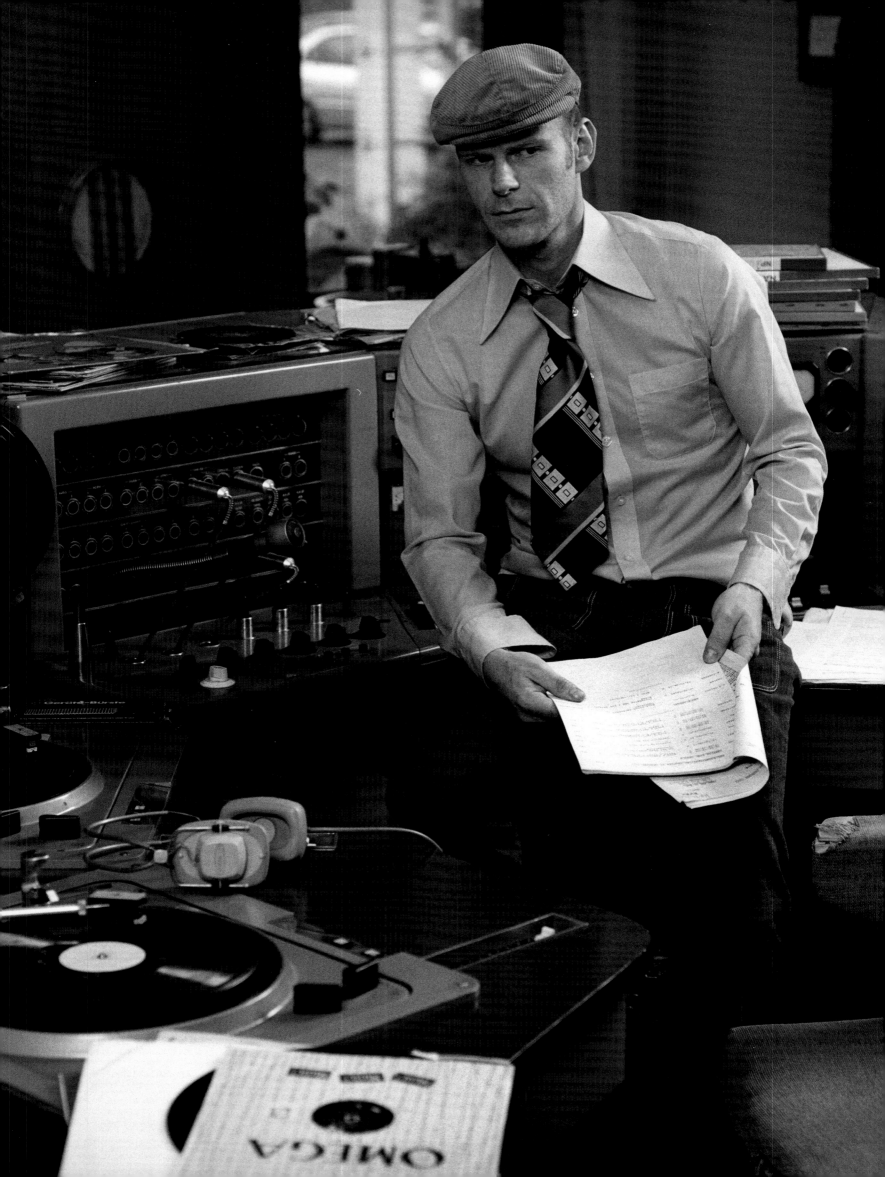

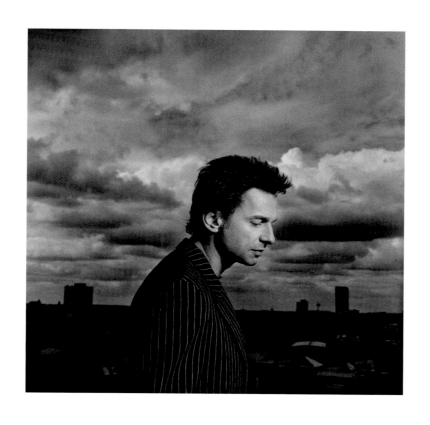

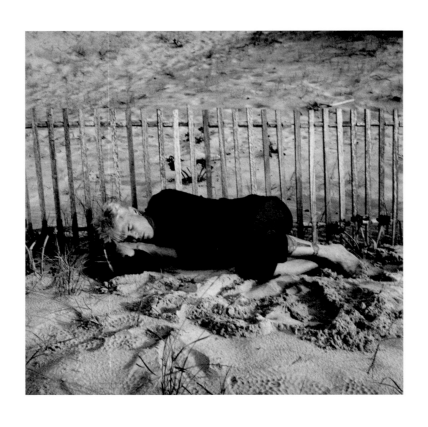

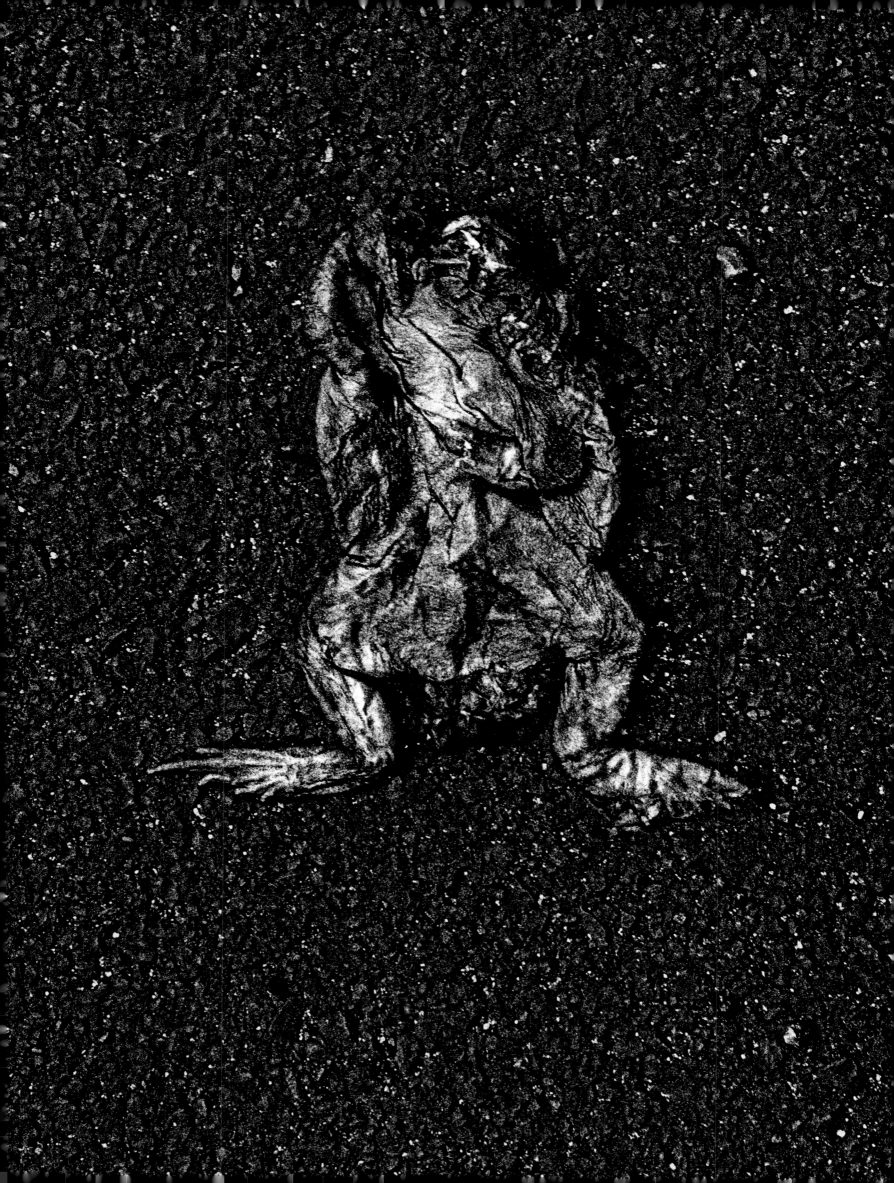

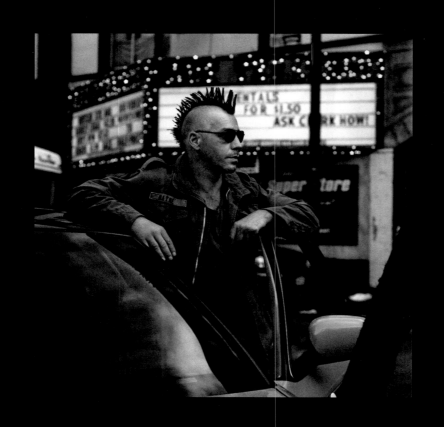

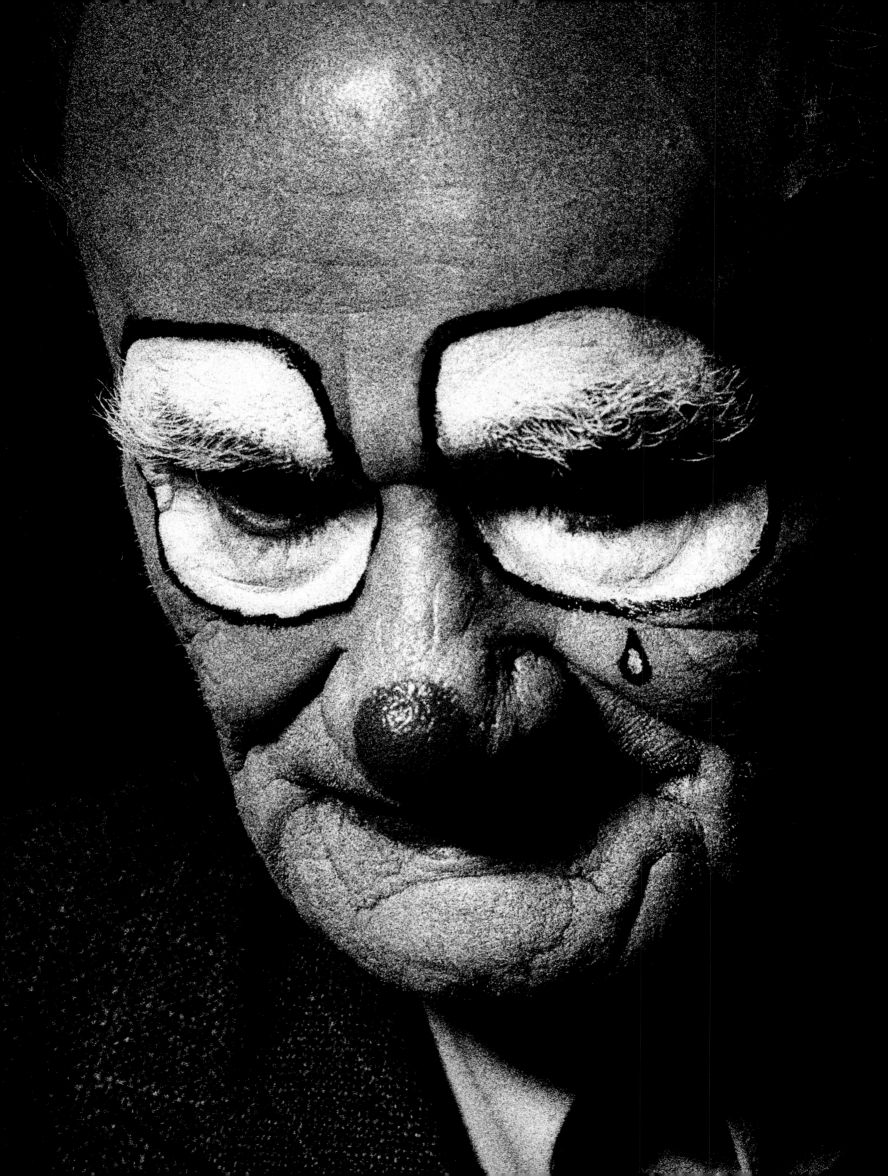

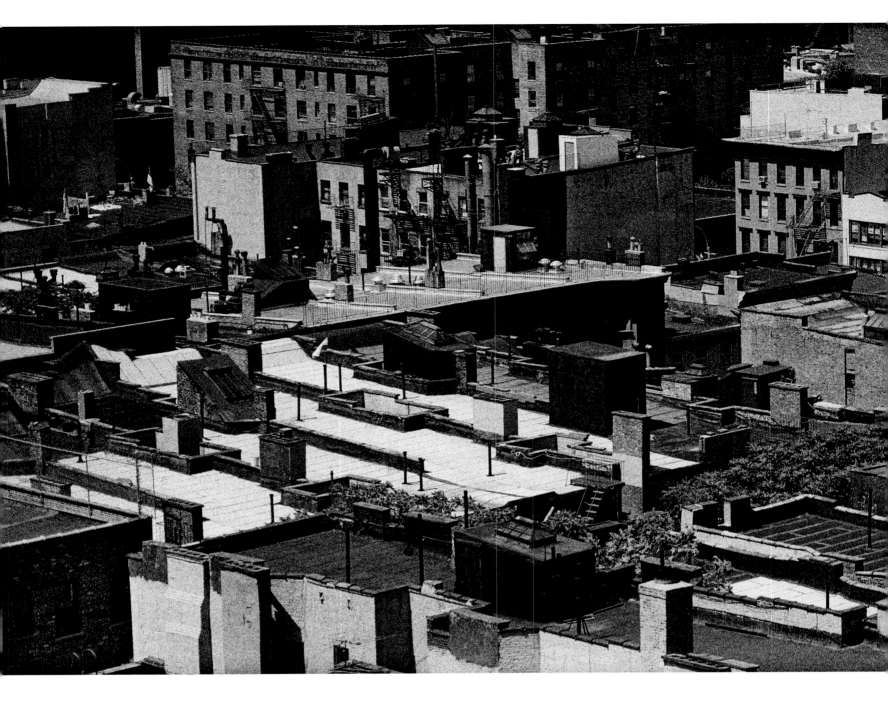

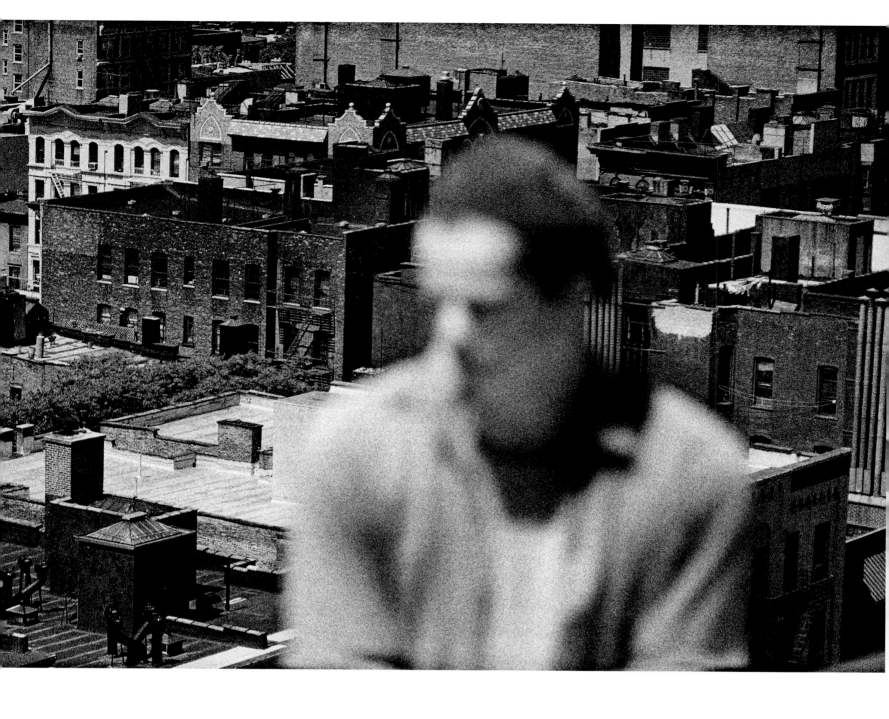

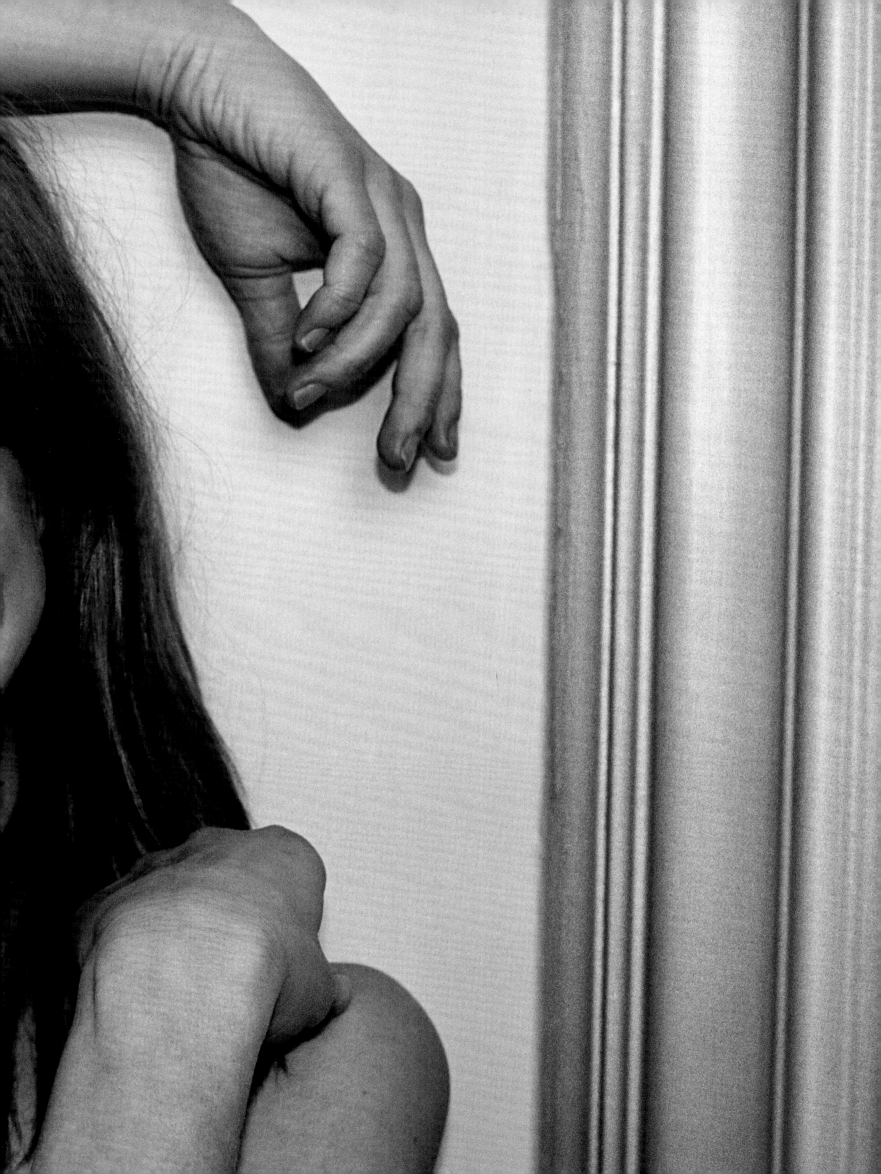

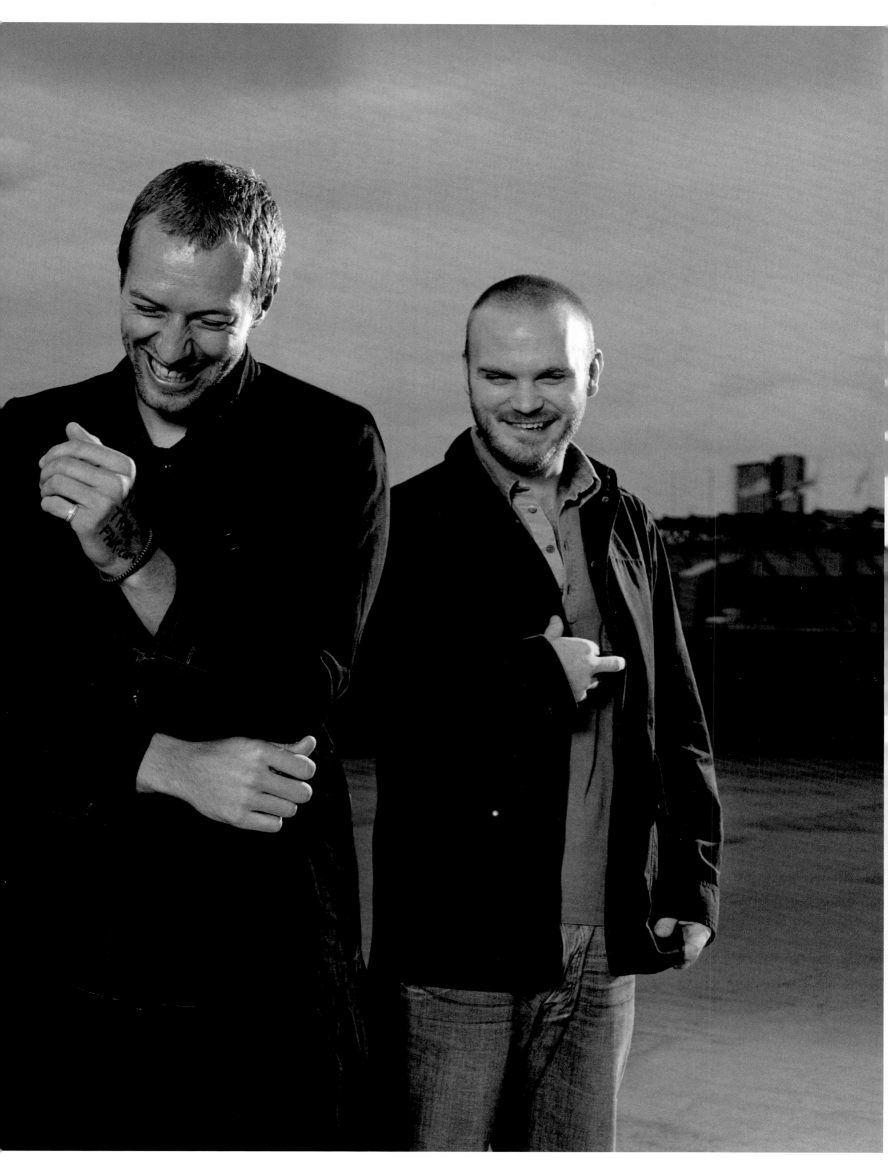

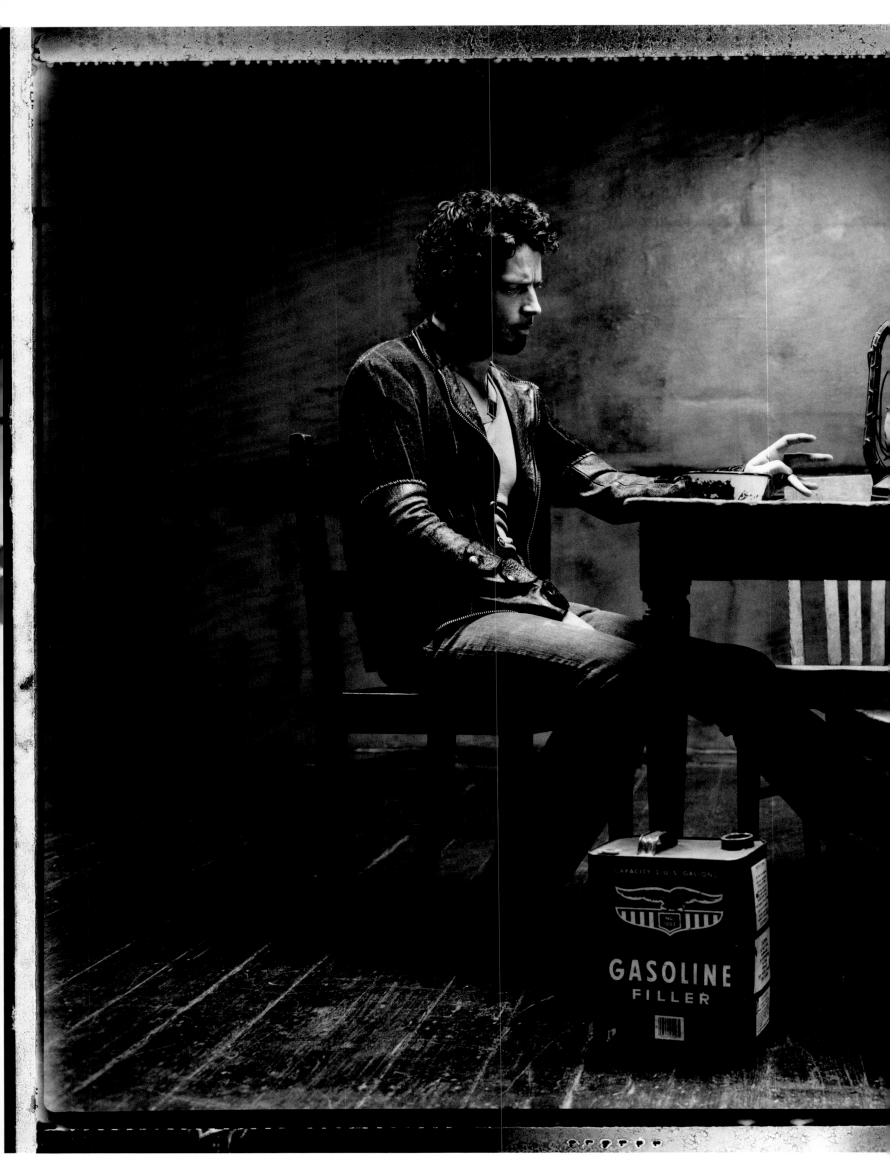

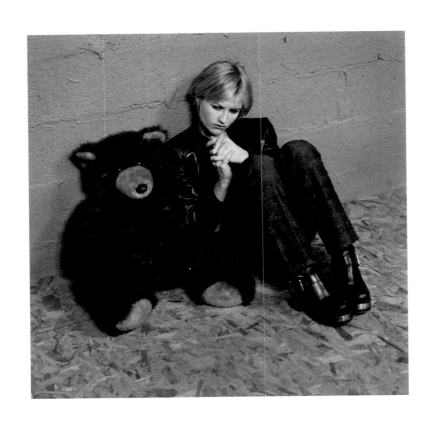

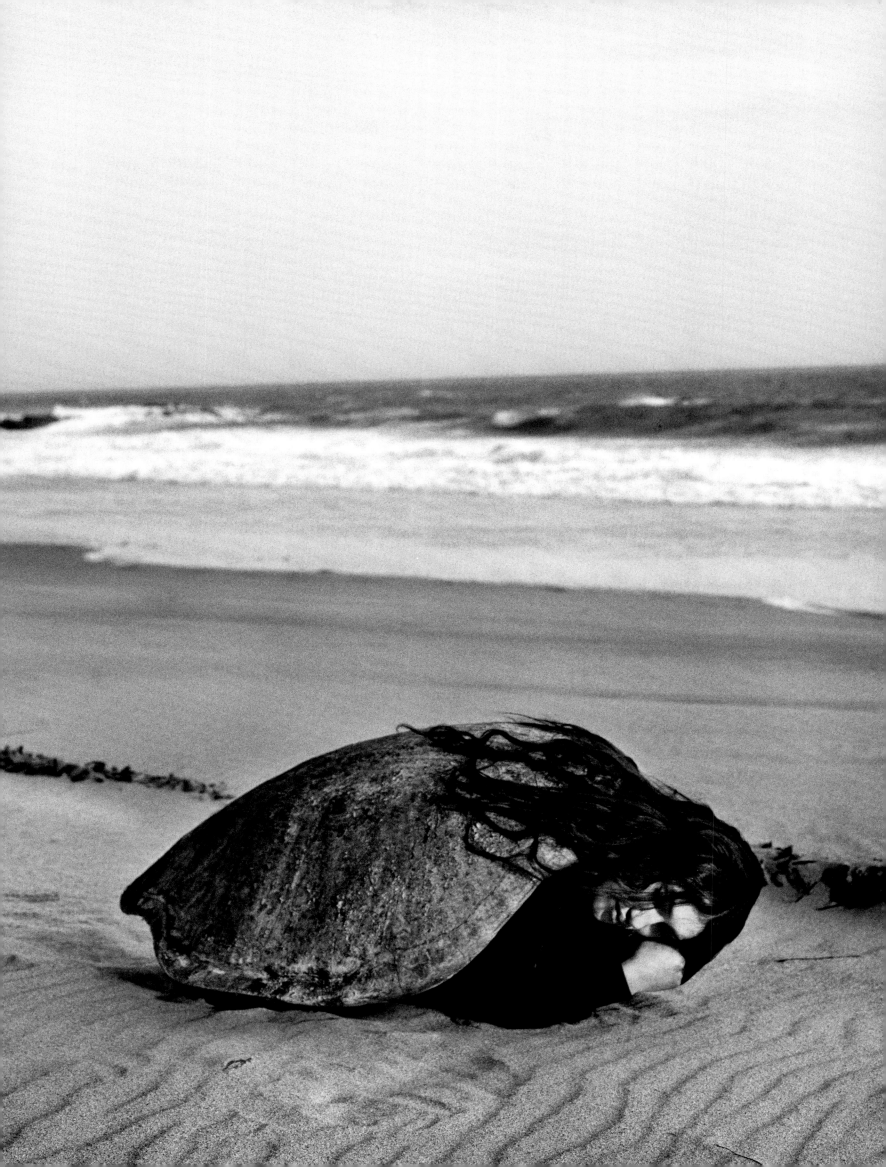

124

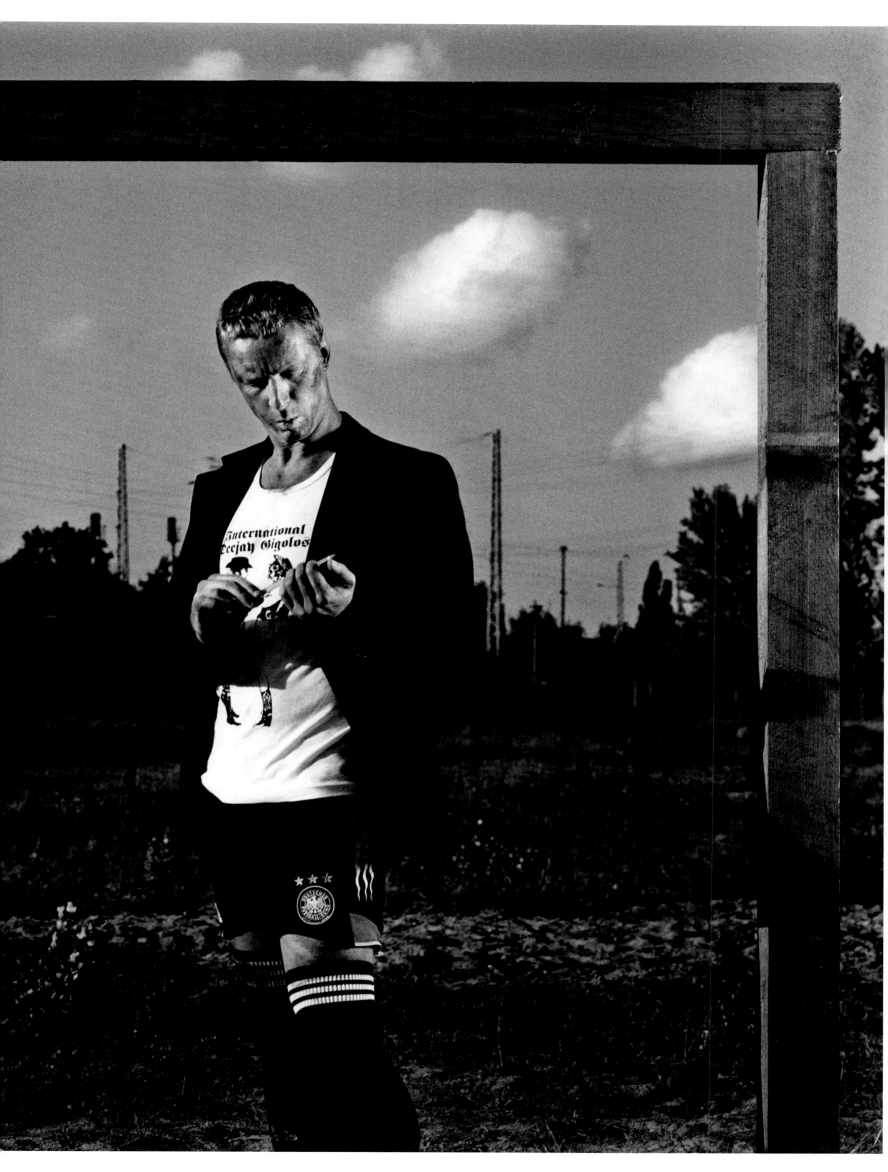

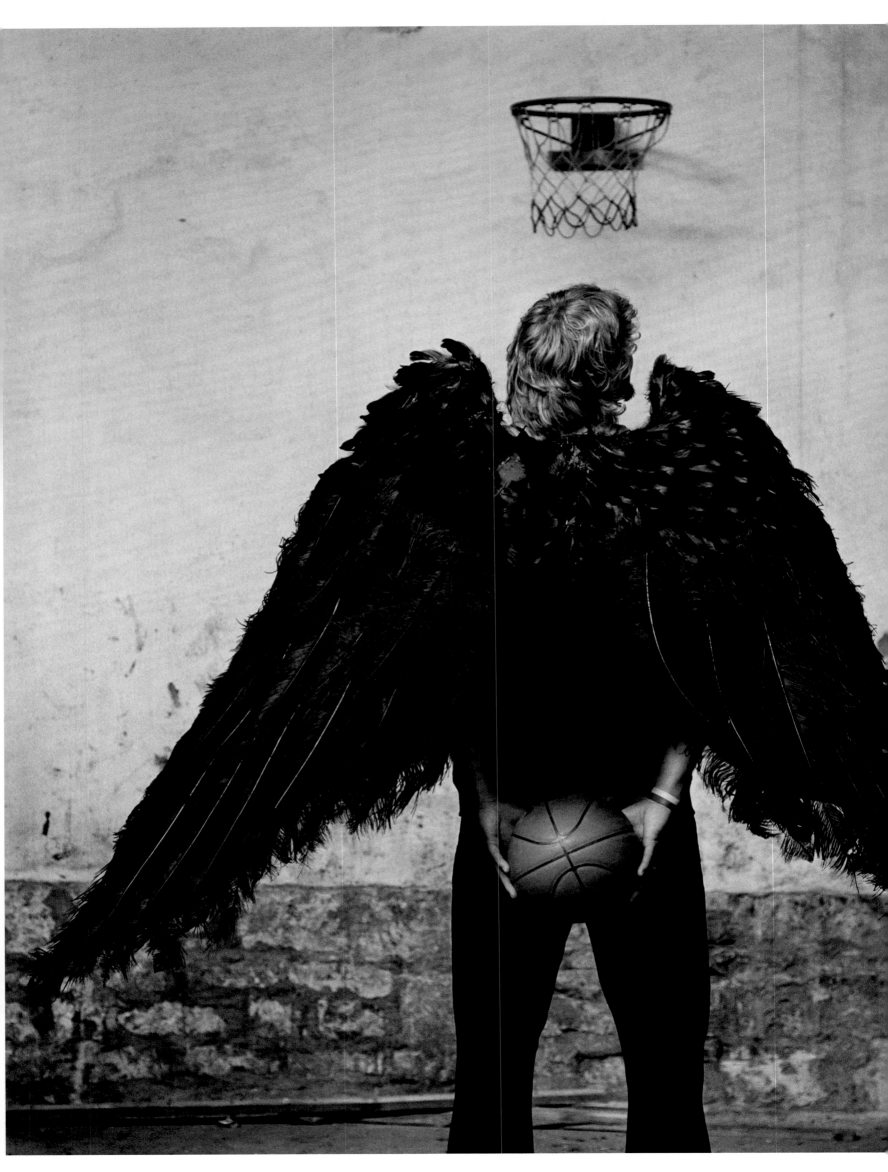

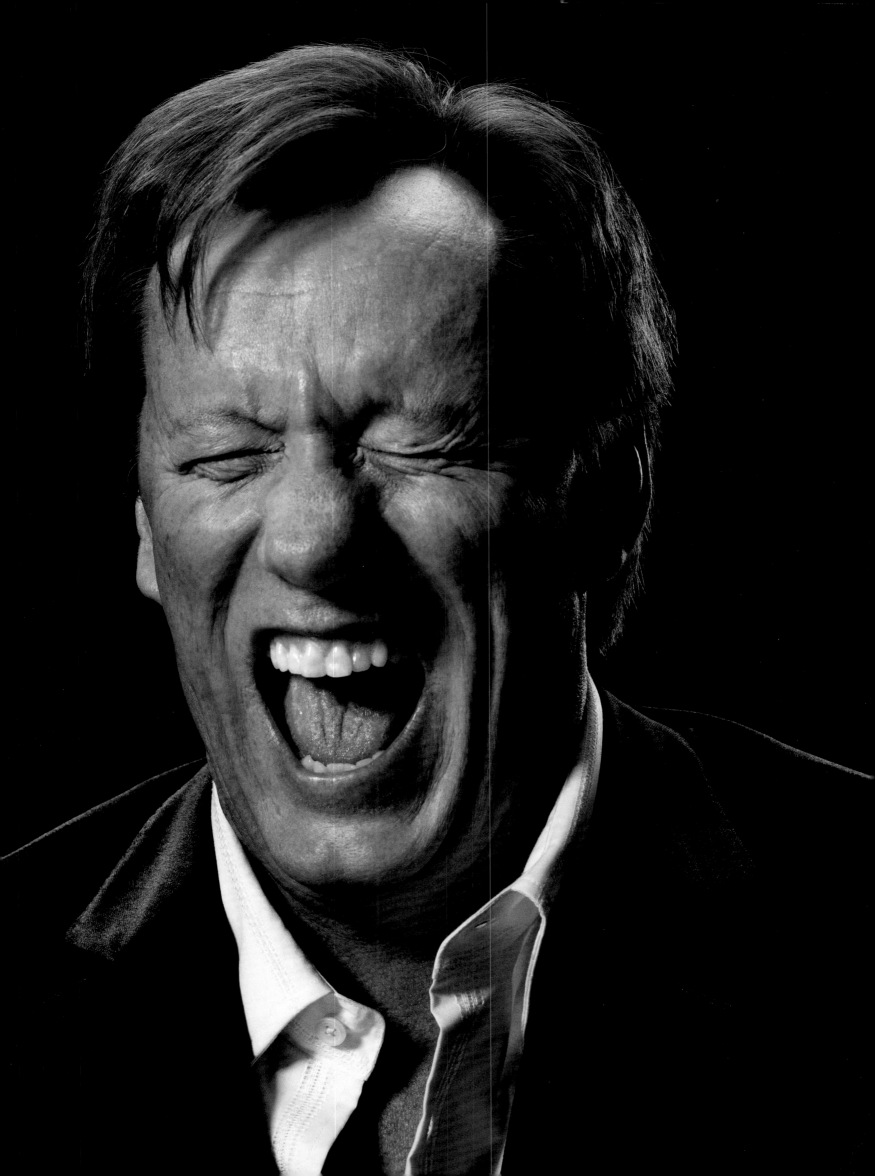

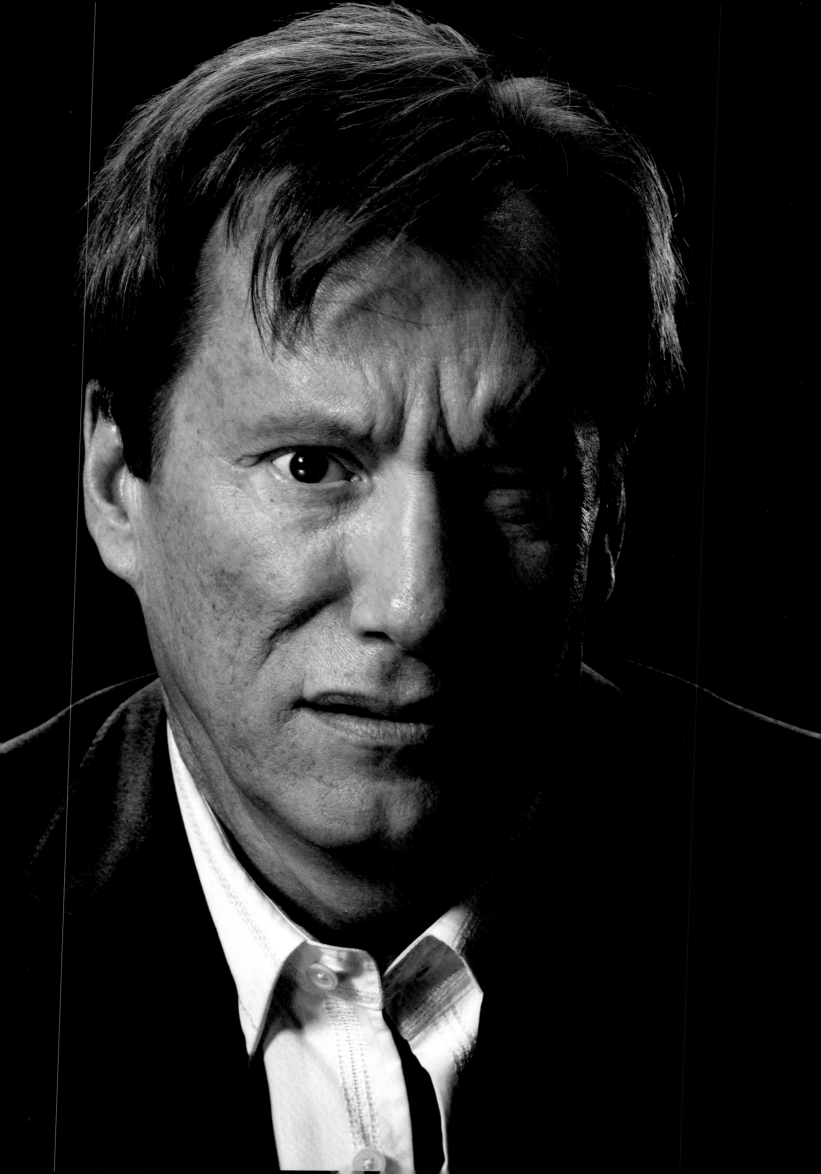

It takes a rare photographer like Olaf to get behind that mask, to reveal the vulnerable soul behind. I do not wish to give myself easily to the eye of a camera unless the person holding it is at risk too.

Sting

Photography is a radical art, because it reveals a moment in all its depth and complexity. As a musician I create an atmosphere over a certain period of time when I spin or compose a track. The photographer only has a single moment when everything has to be right. Olaf Heine is a true master at condensing different levels of perception within a photo into an inimitable atmosphere.

Paul van Dyk

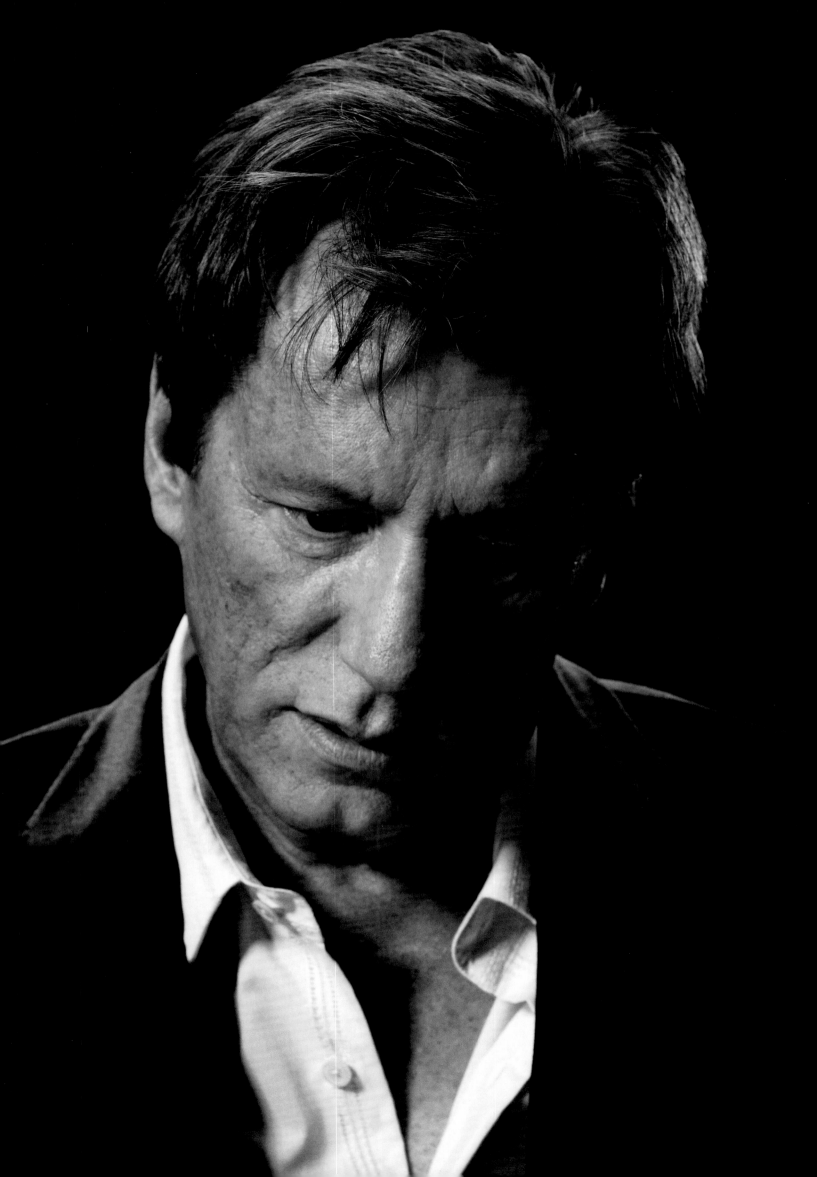

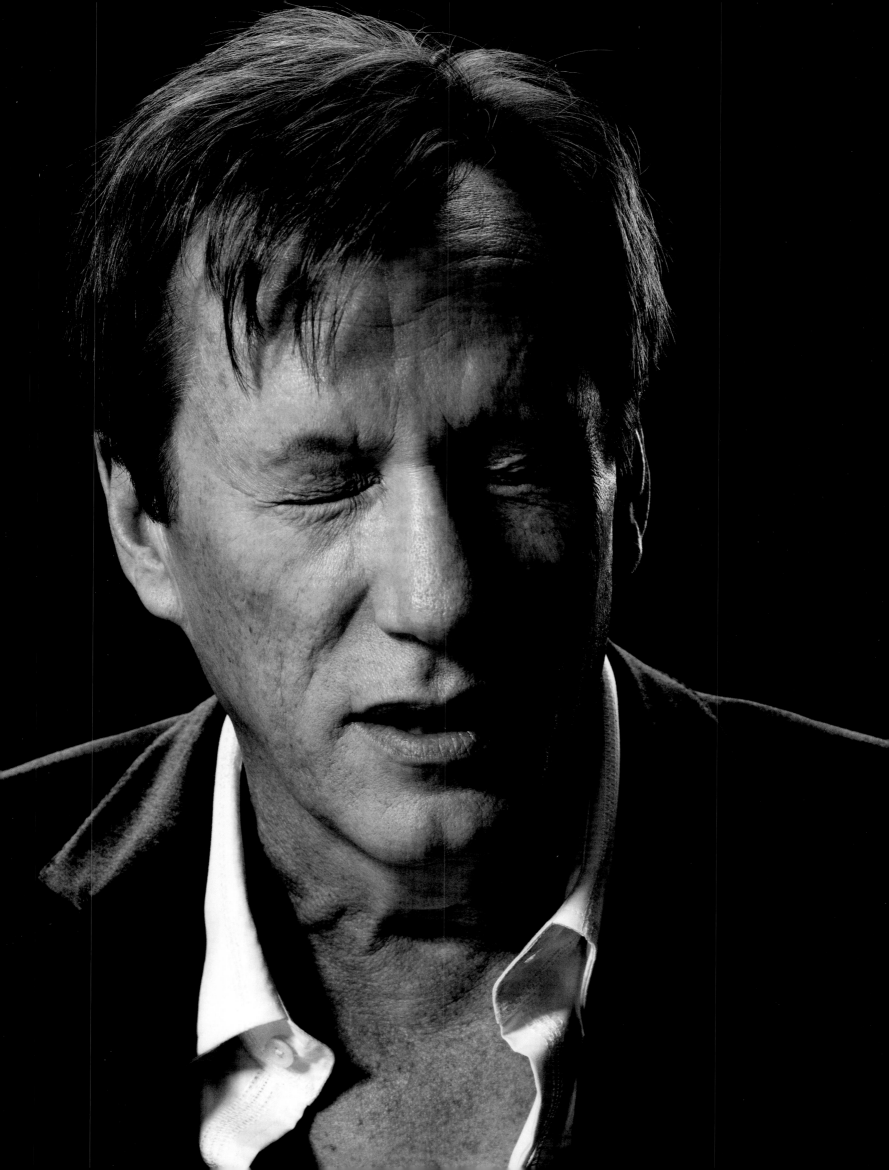

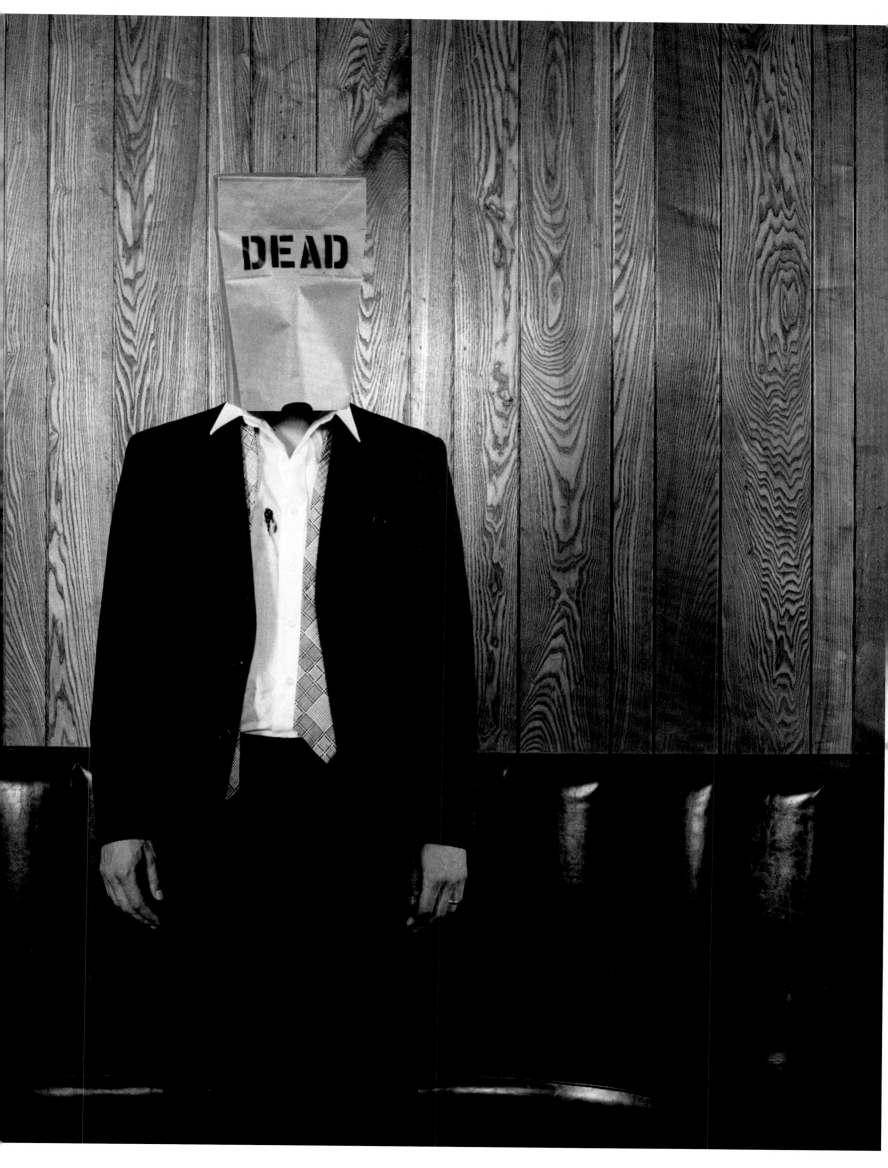

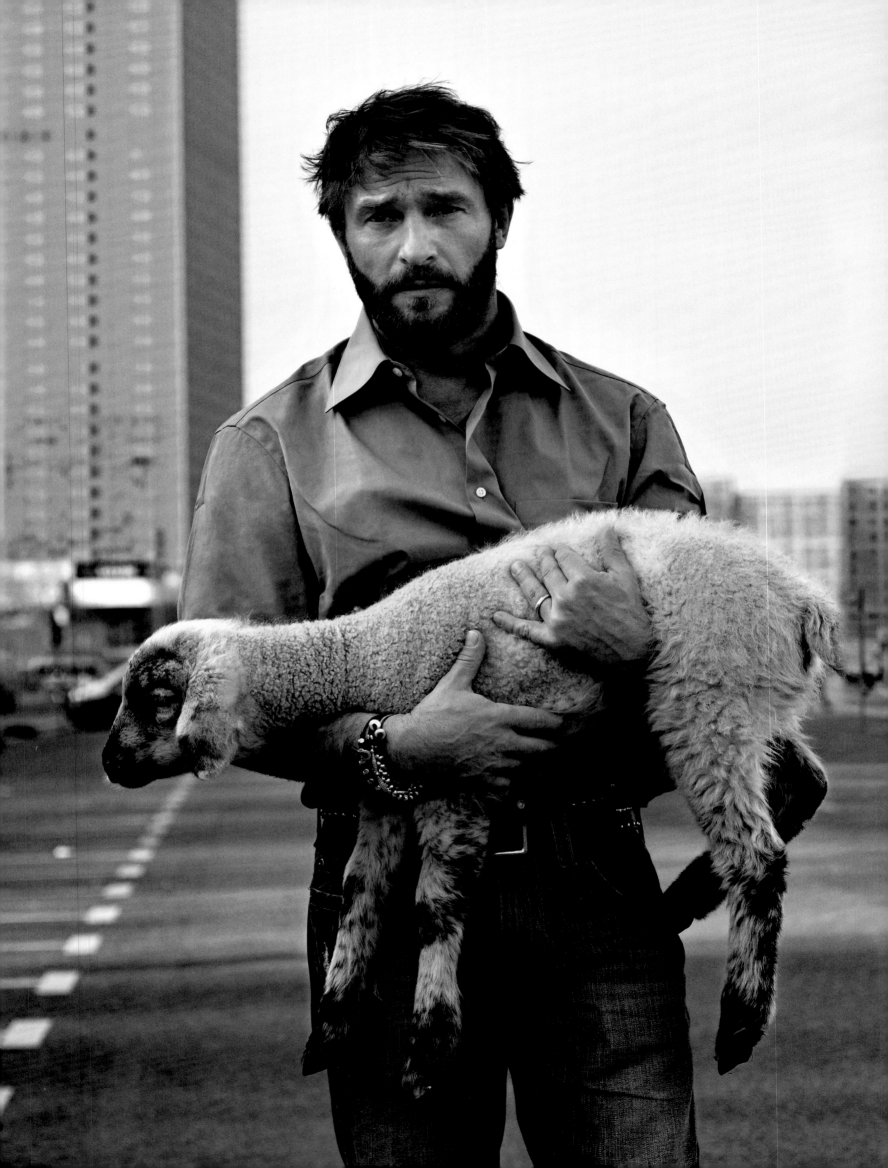

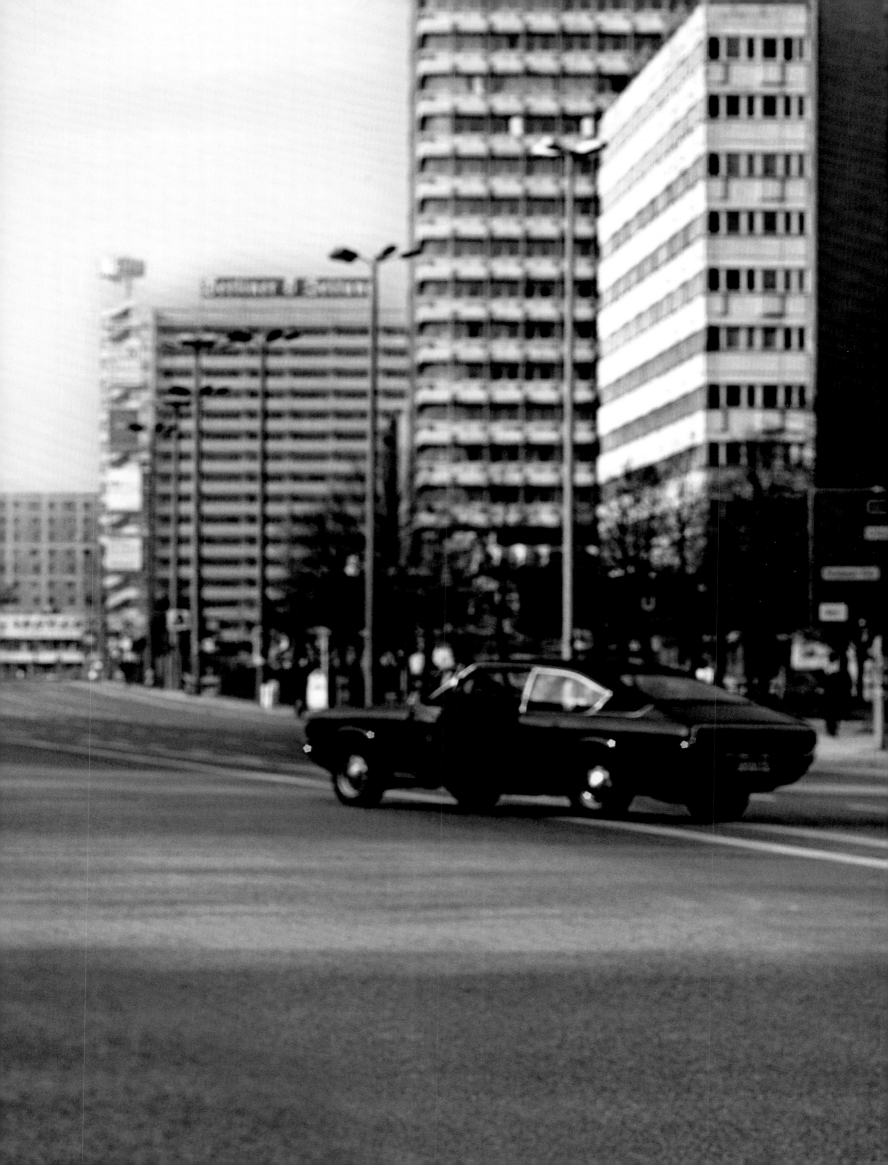

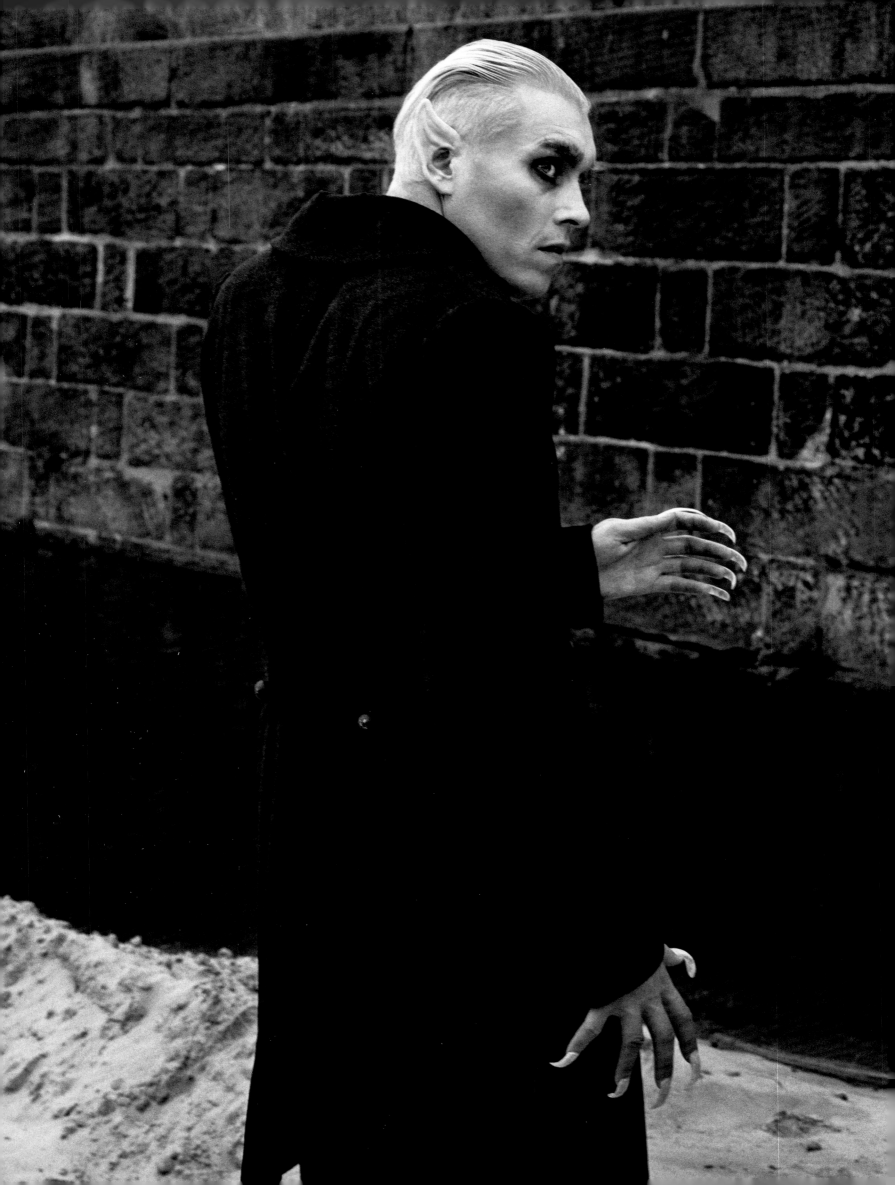

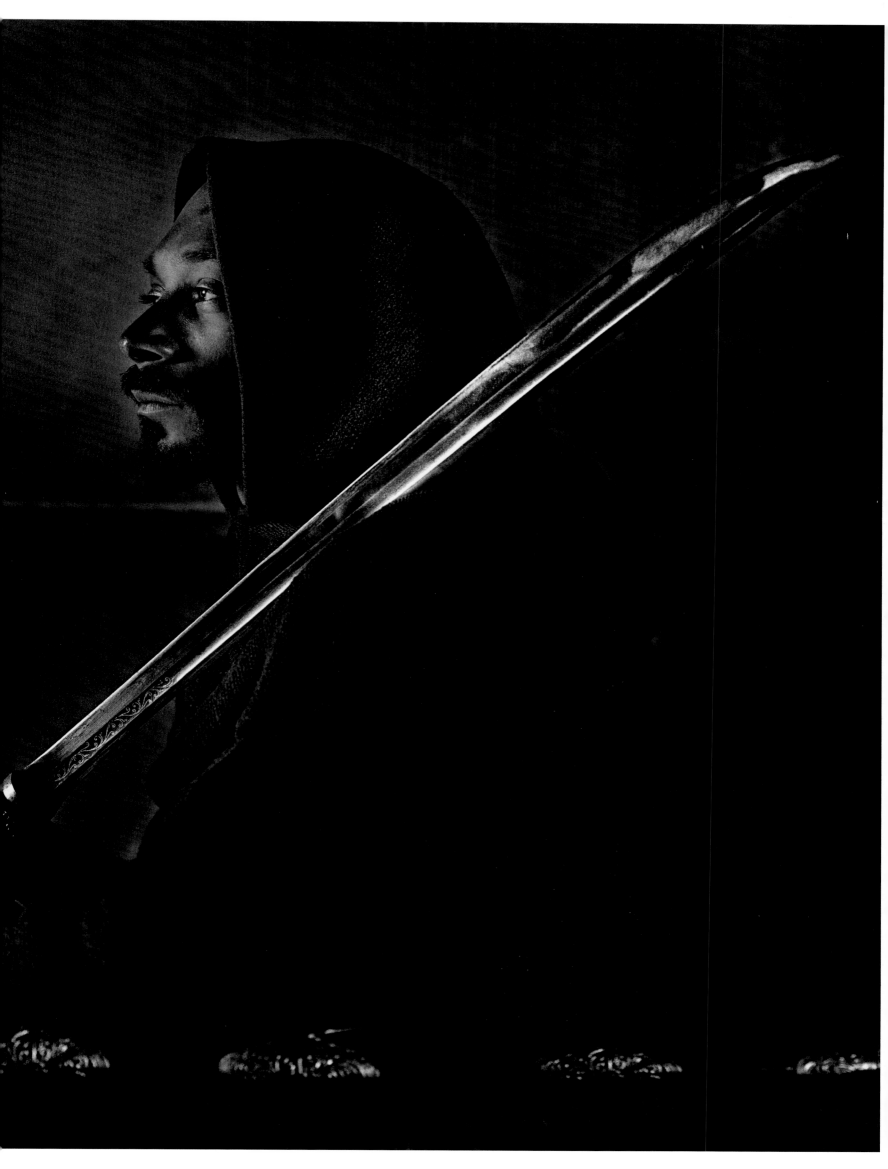

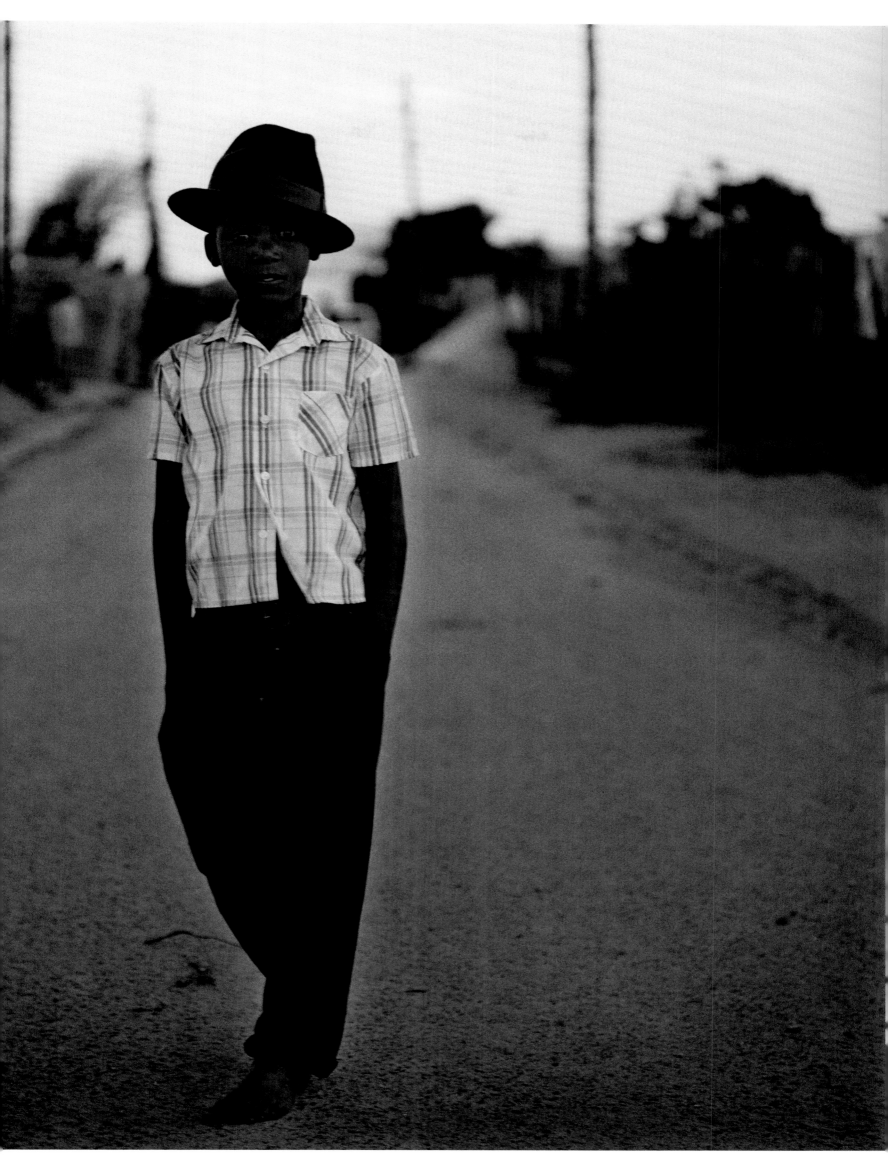

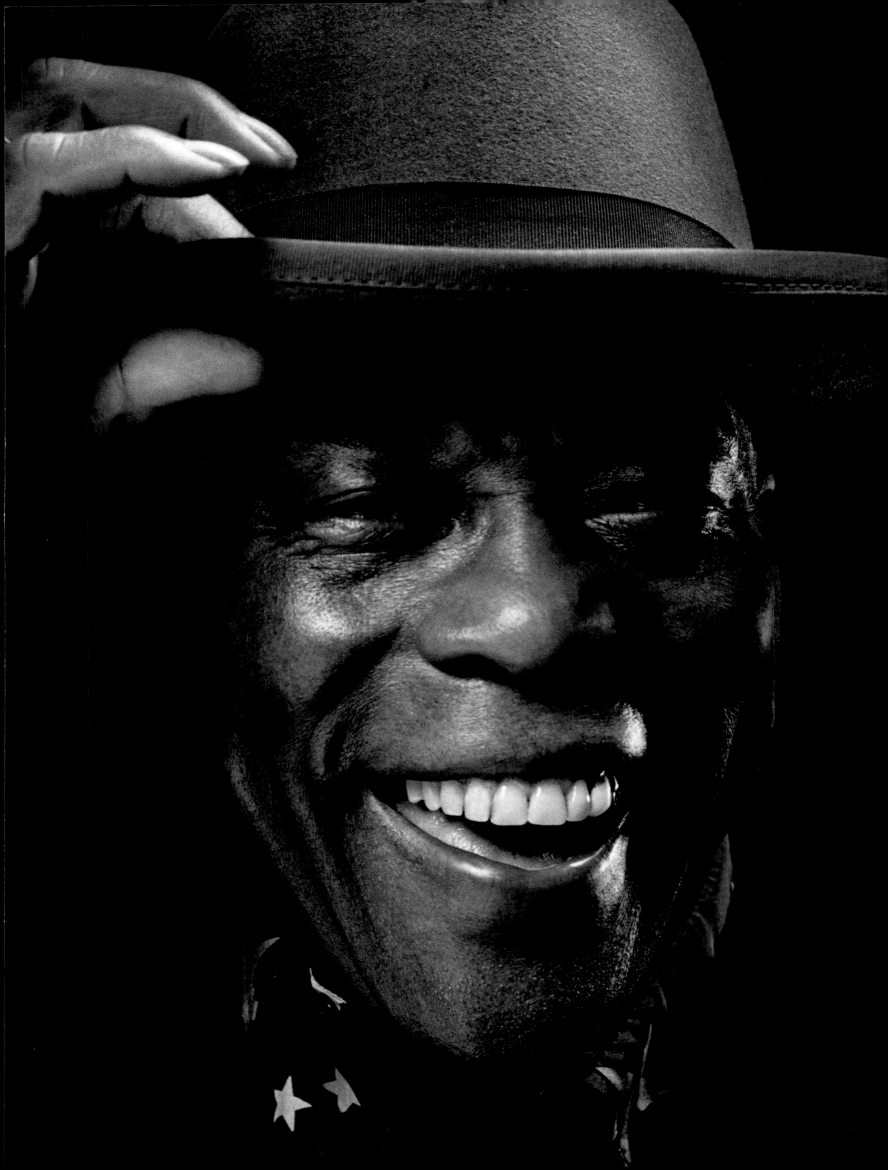

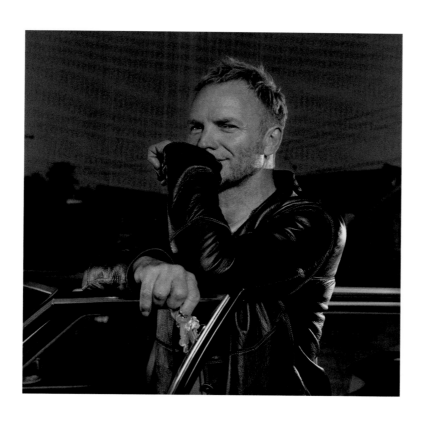

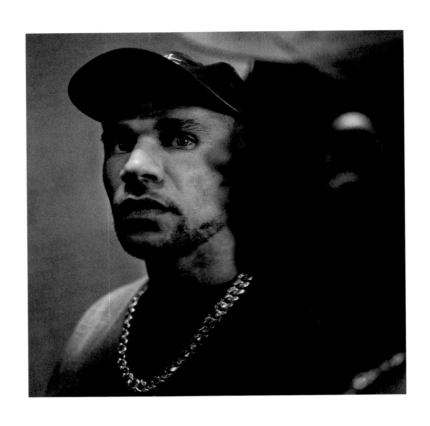

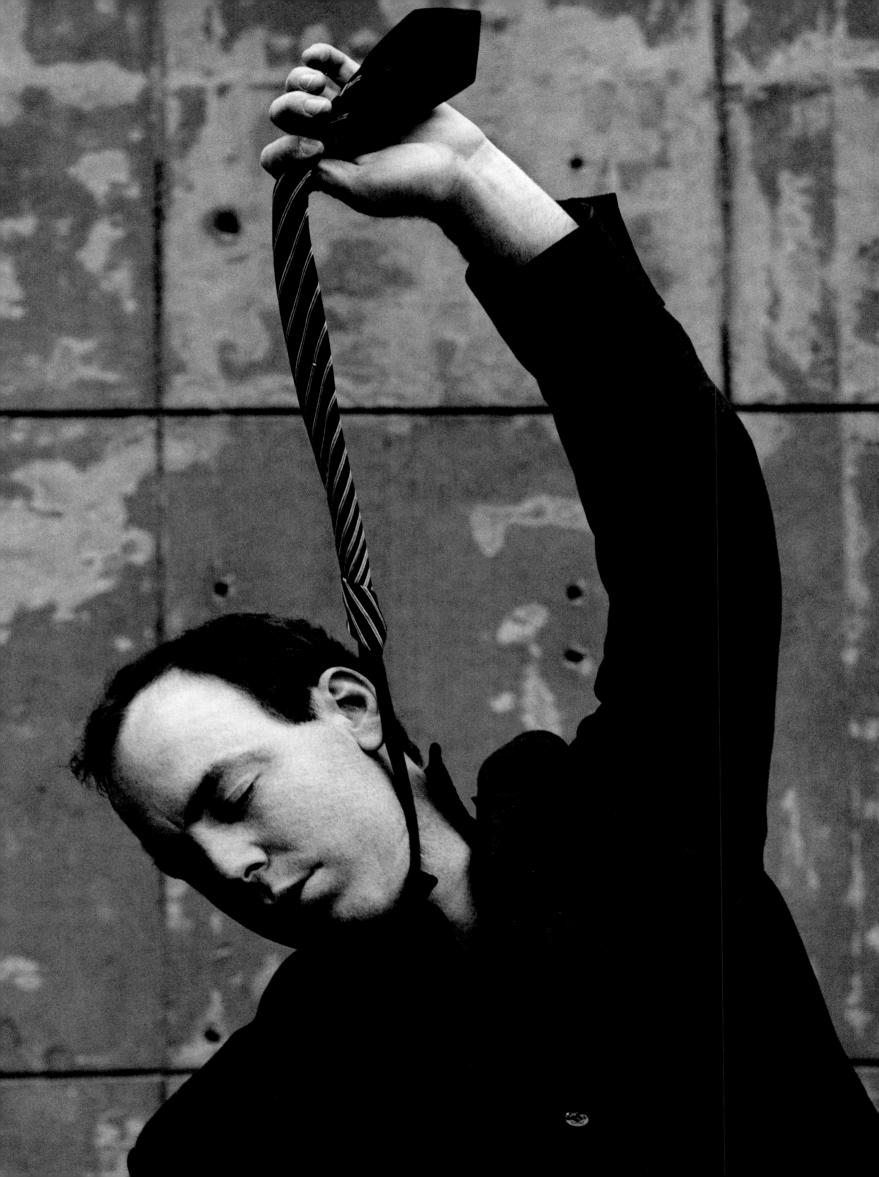

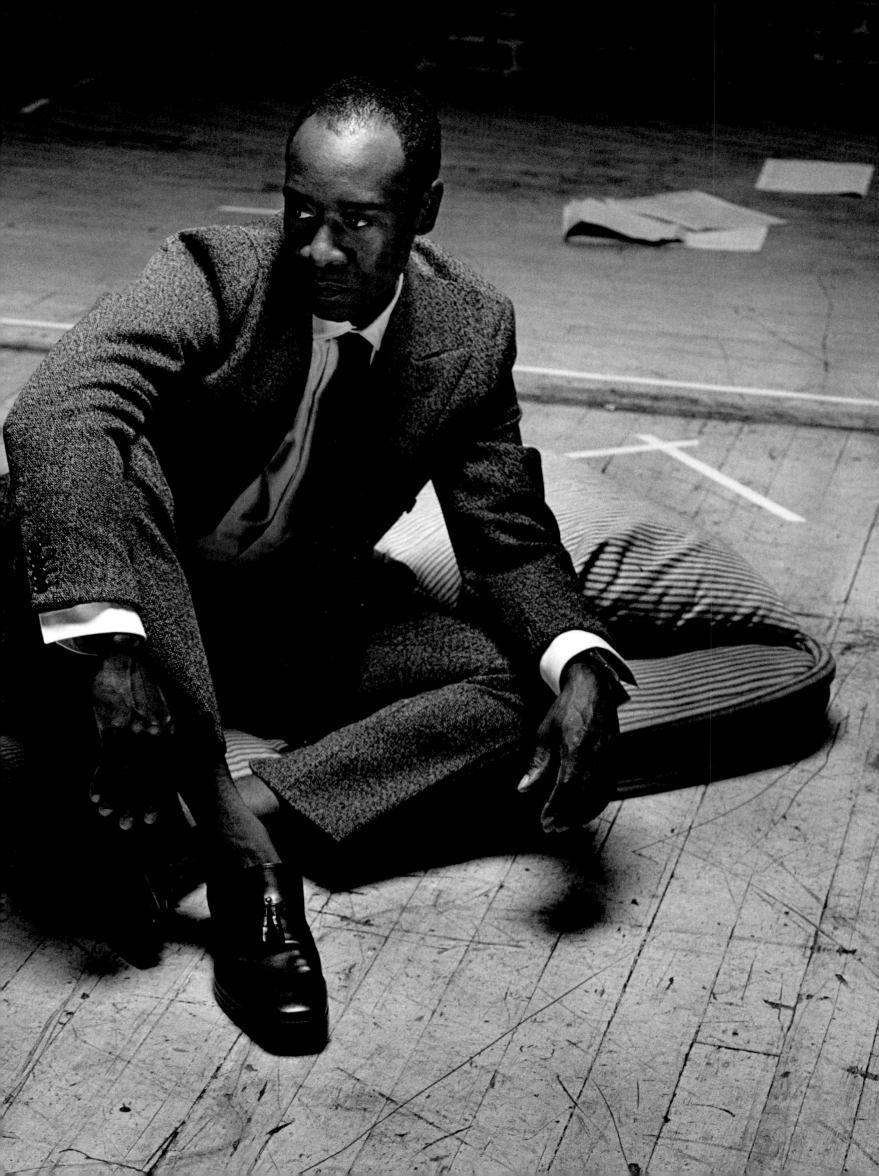

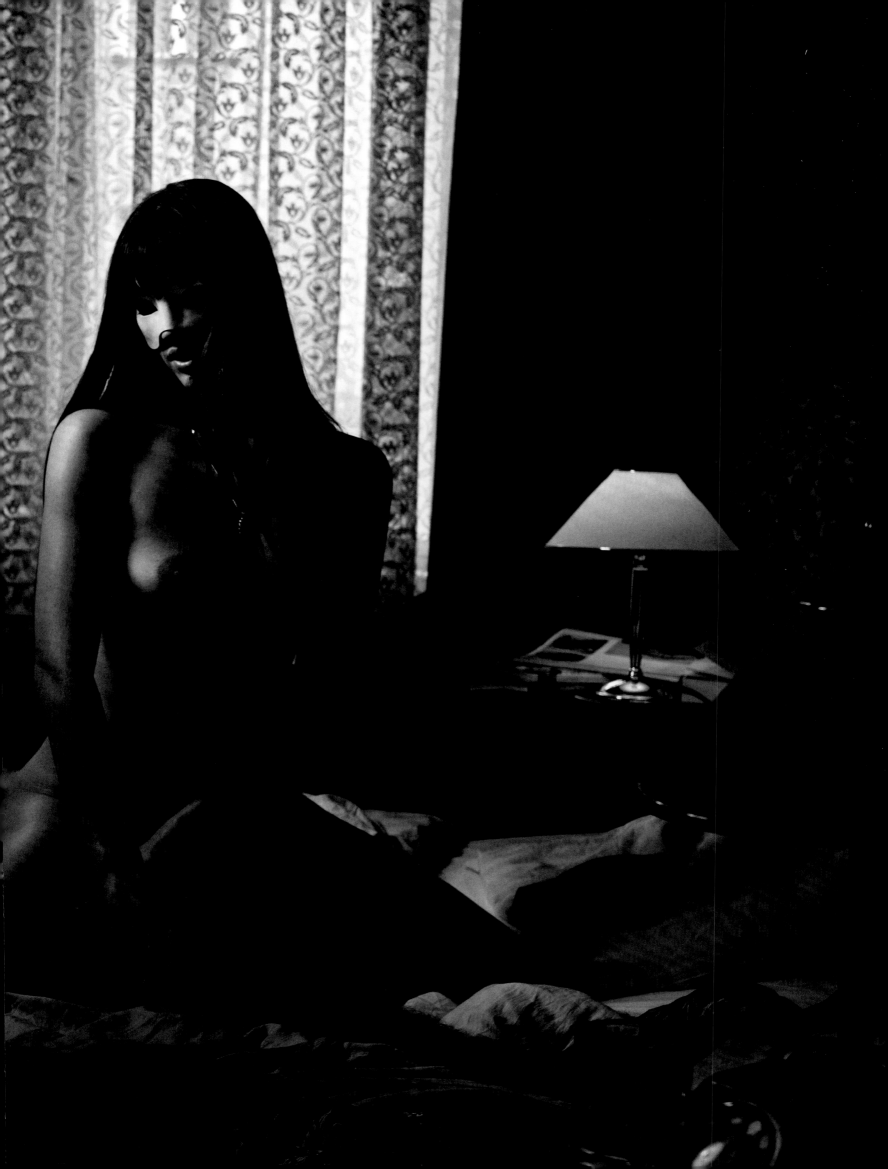

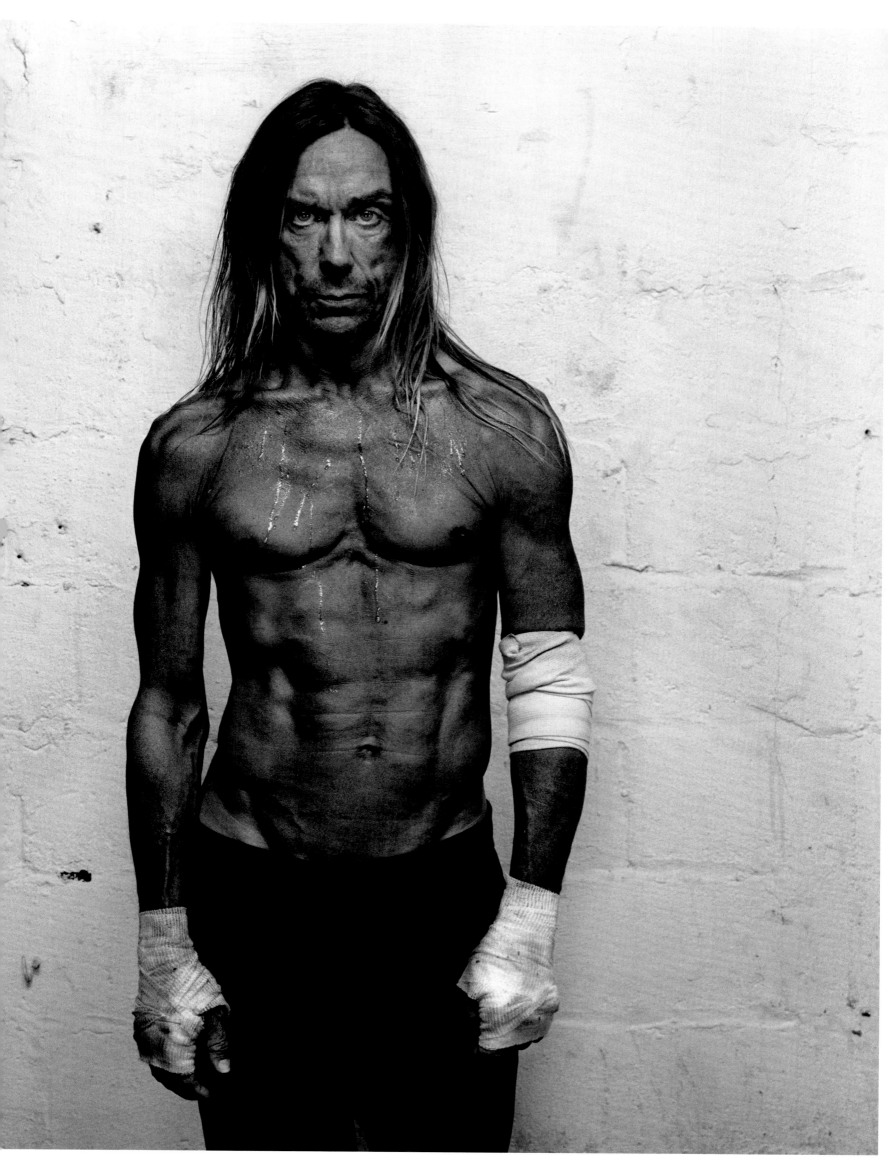

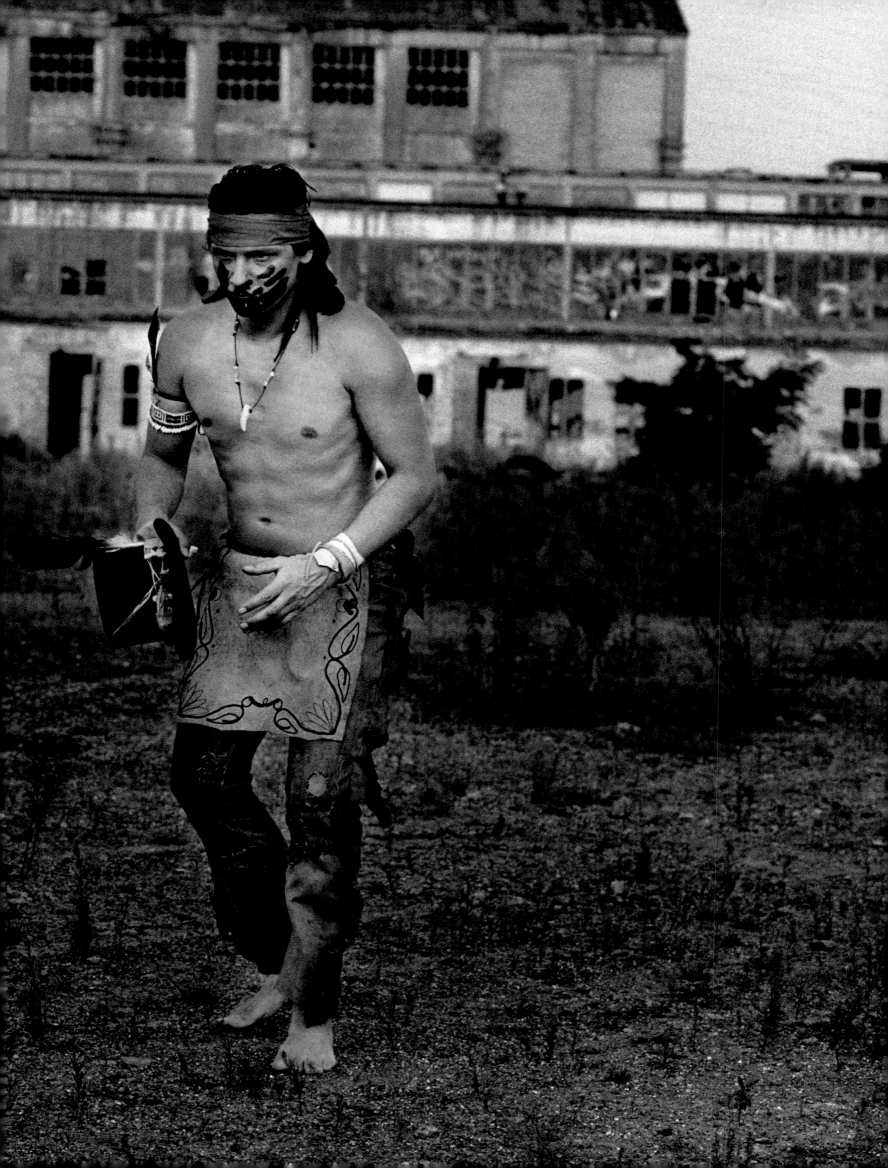

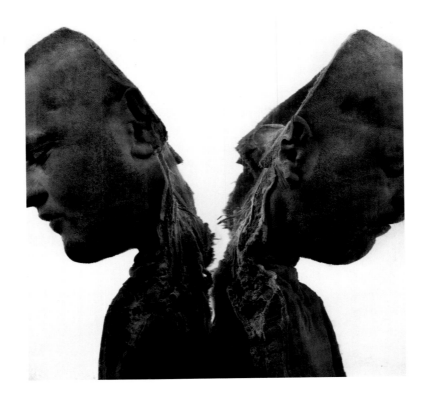

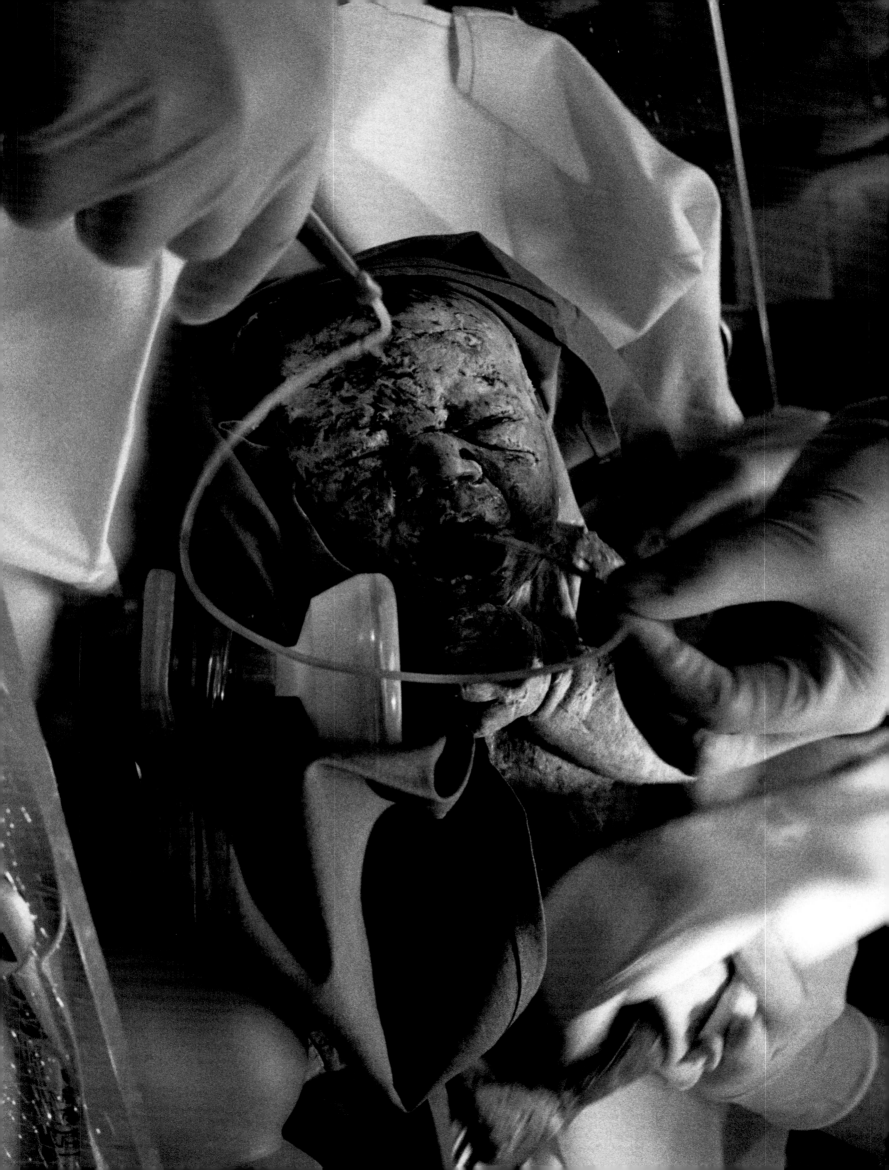

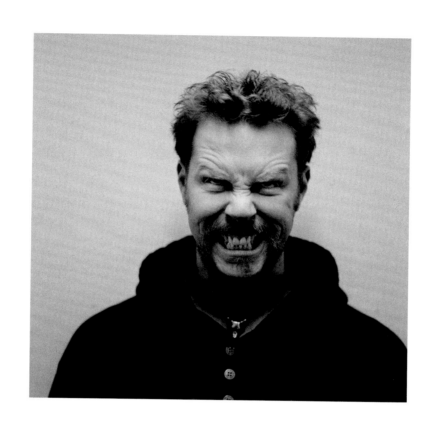

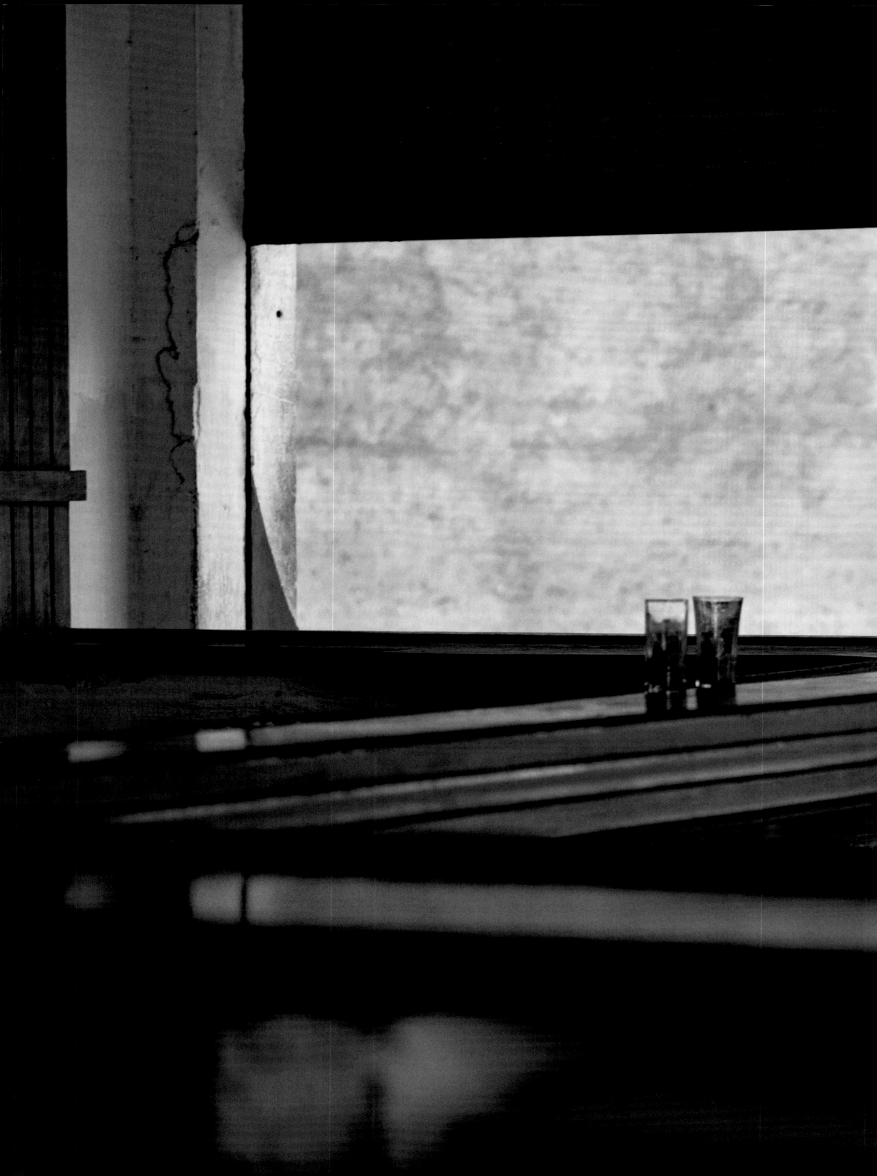

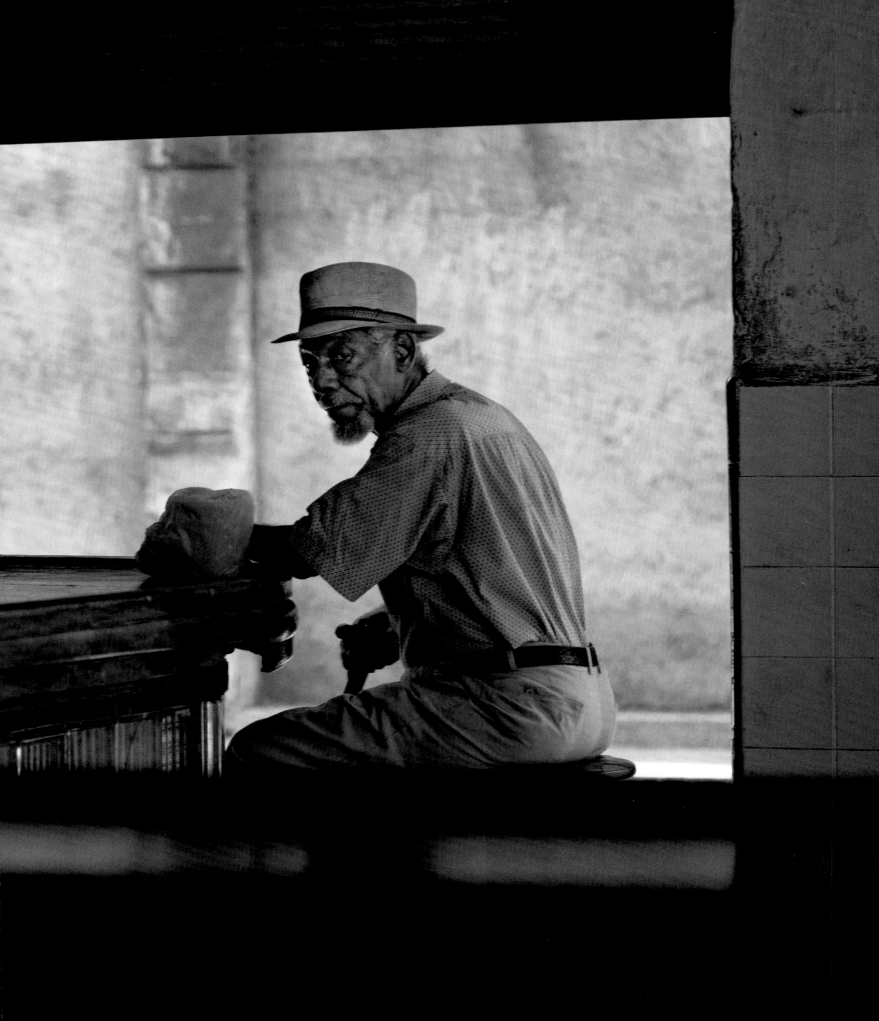

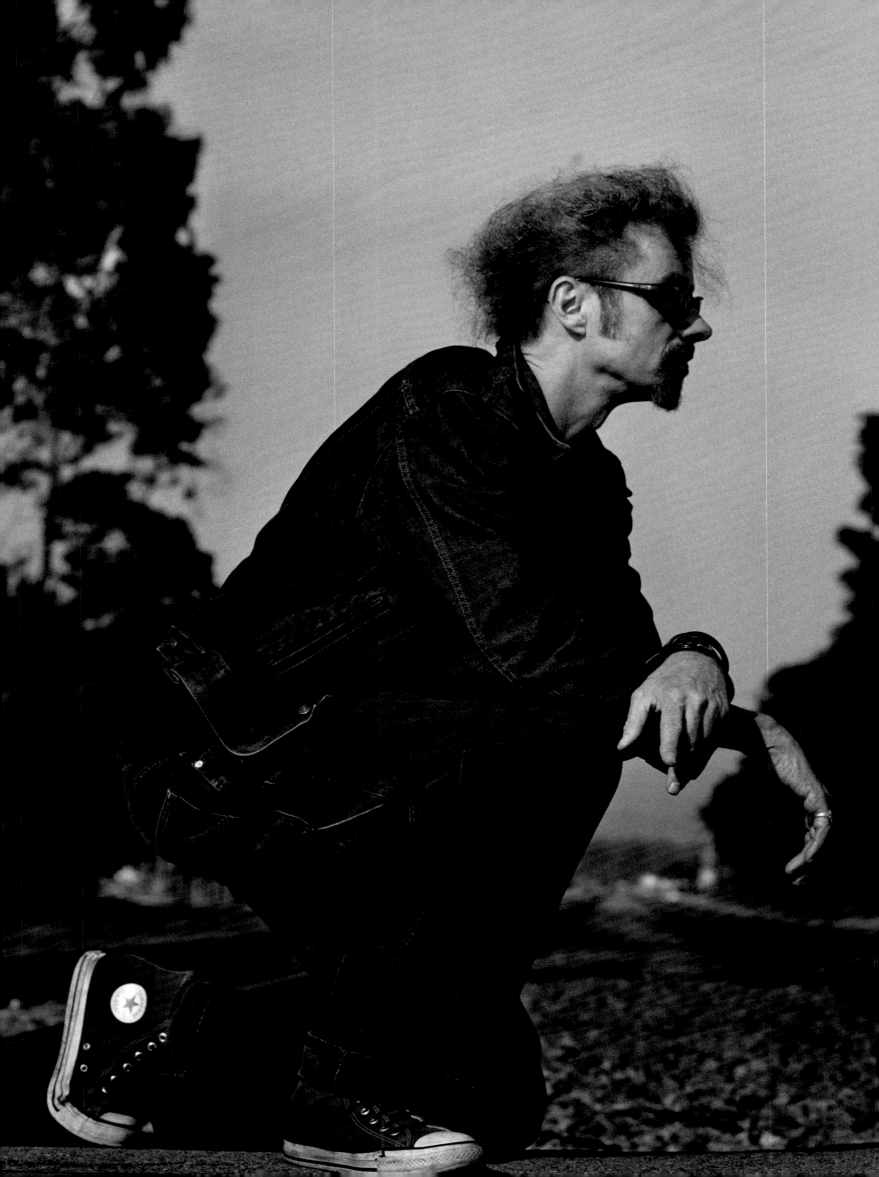

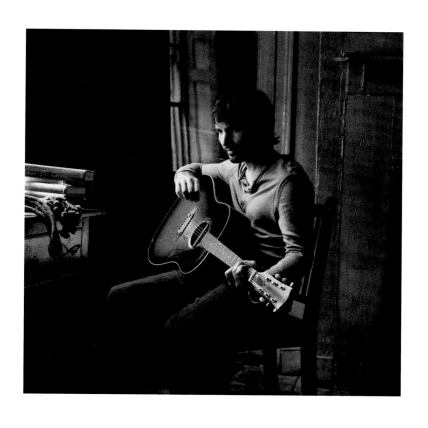

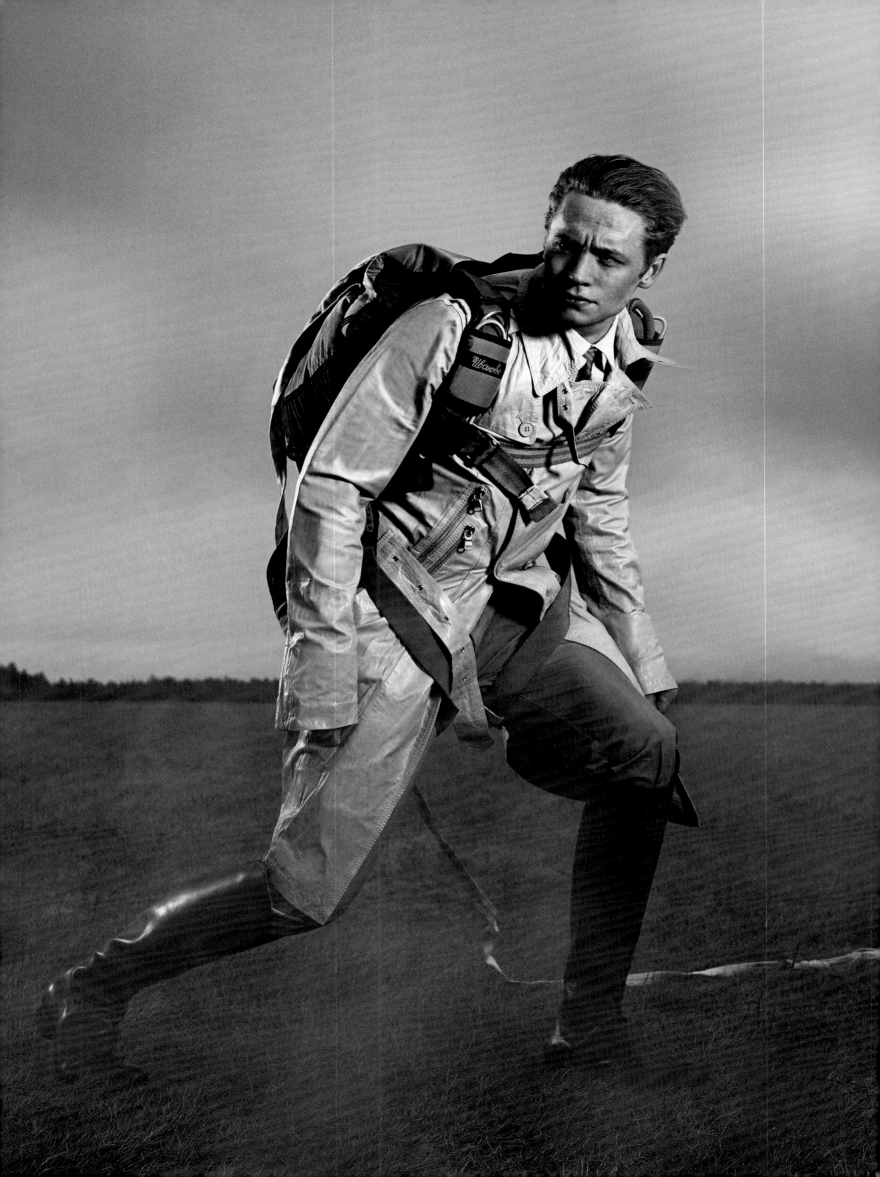

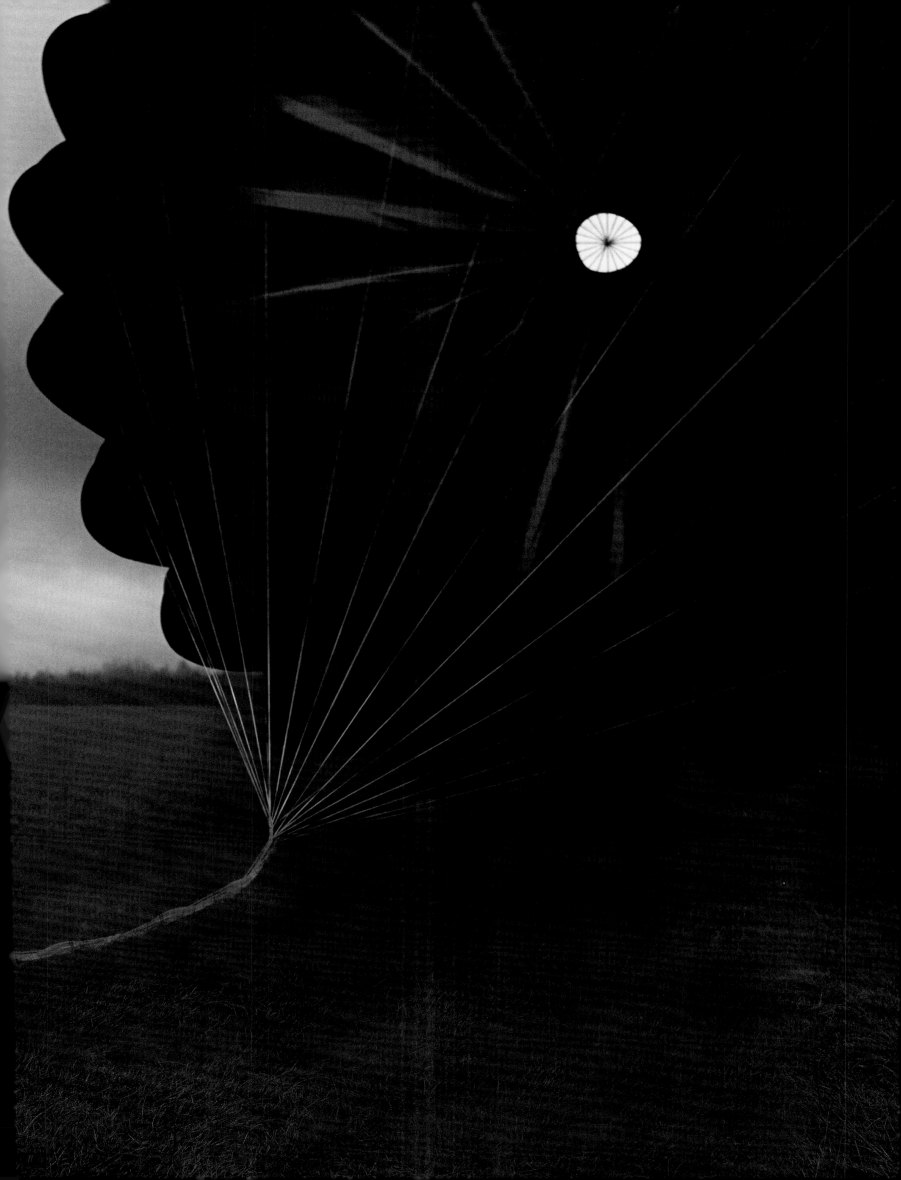

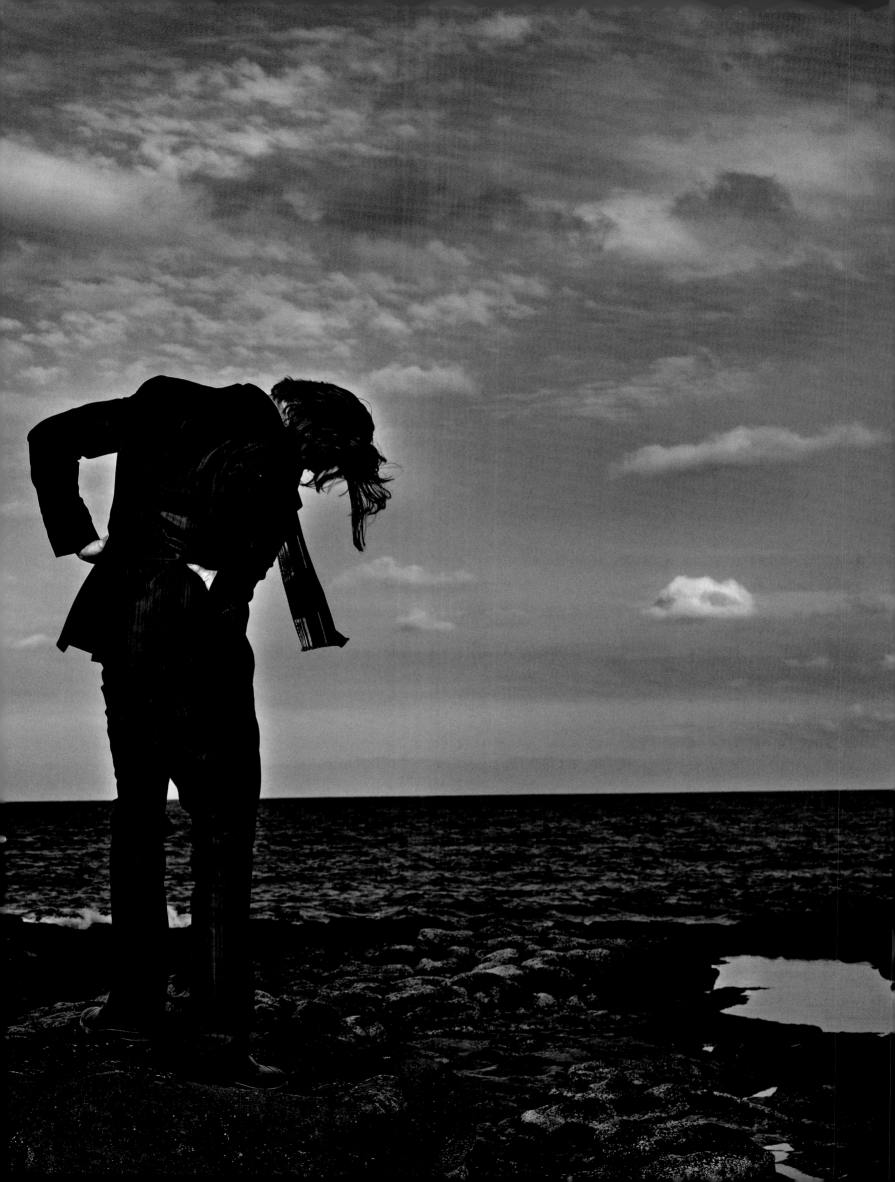

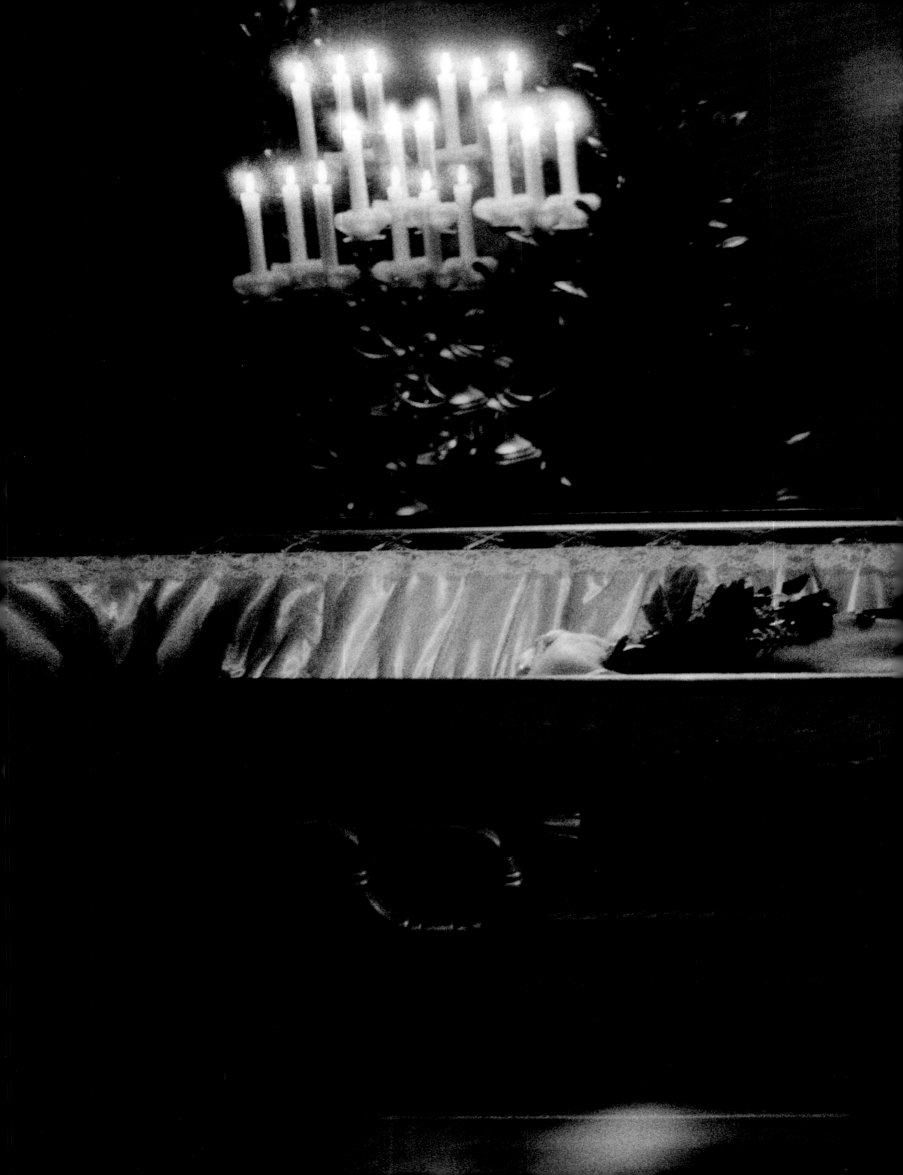

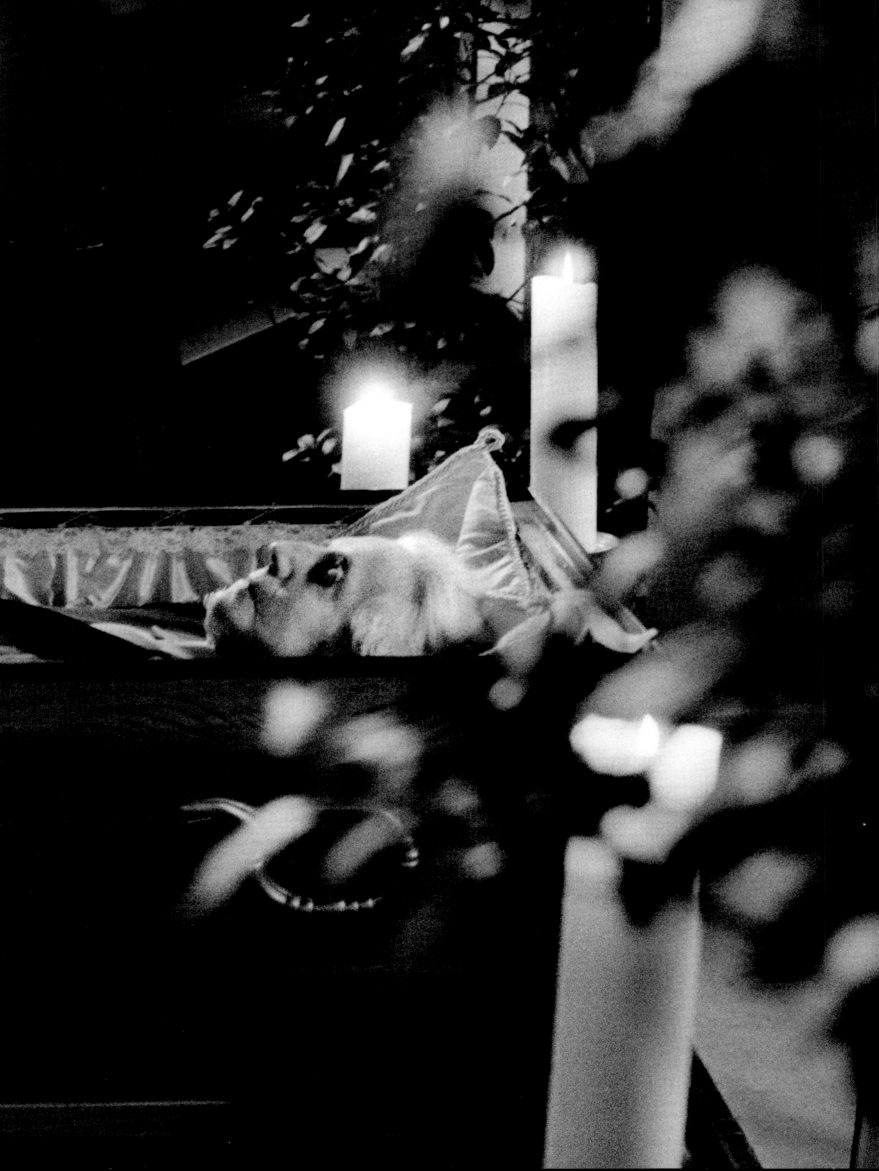

Index of Plates

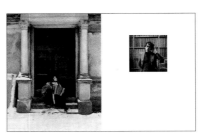

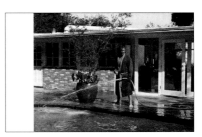

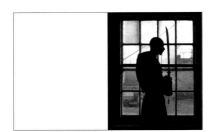

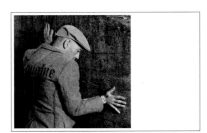

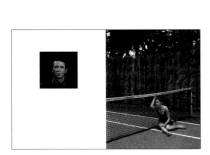

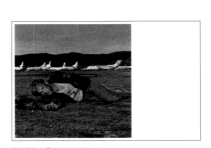

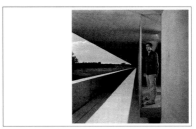

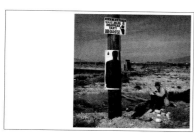

32–33 *Flake Loosing Some Pounds*
Shooting Range, Las Vegas, 1999

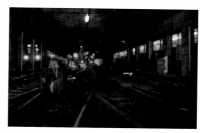

34–35 *(Still from) Edendale*
Short Film, Hamburg, 2002

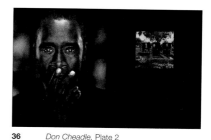

36 *Don Cheadle*, Plate 2
Los Angeles, 2002

37 *Faces*
Hollywood Forever, Los Angeles, 2003

38–39 *The Eagles*
Silurian Lake, Mojave Desert, 2007

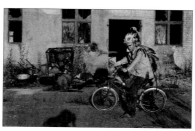

40–41 *Paul Riding a Bike*
Berlin, 2003

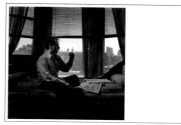
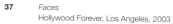

42–43 *Bret Easton Ellis*
Chelsea Hotel, New York City, 2005

44–45 *Til Schweiger*
Berlin, 2008

46 *Die Ärzte auf kontaminiertem Boden*
Nuremberg, 1995

47 *Paul Oakenfold*
Los Angeles, 2005

48–49 *Westernhagen Pointing Out*
Paris, 2000

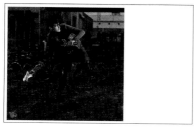

50–51 *Sam Endicott (The Bravery)*
Queens, New York City, 2004

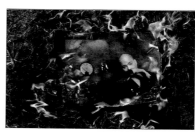

52–53 *Mark Spoon (R.I.P.)*
Frankfurt am Main/Mojave Desert, 1999/2007

54–55 *Black Lines*
Havana, Cuba, 2006

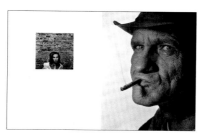

56 *Marilyn Manson*
New York City, 1998

57 *Calvin Russell*
Hanover, 1995

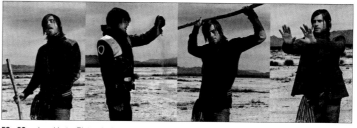

59–62 *Jared Leto*, Plates 1–4
Mojave Desert, 2005

185

64 *Blixa Bargeld Shooting Himself*
Berlin, 2004

65 *Blixa Bargeld (Screenshot)*
Berlin, 2004

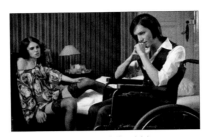

66–67 *Brian Molko (Placebo) and Jule*
Berlin, 2008

68–69 *Three of Die Fantastischen Vier*
Tenerife, 2004

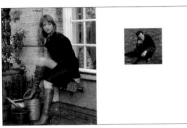

70 *Heike Makatsch Holding a Camera*
Berlin, 2005

71 *Joe Strummer Smelling Flowers*
Berlin, 2001

72–73 *Tape*
Lord's, London, 2006

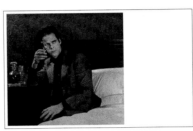

74–75 *Nick Cave*
London, 2000

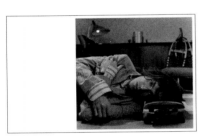

76–77 *Brandon Boyd (Incubus)*
Hamburg, 2002

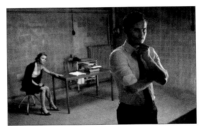

78–79 *Natalia Avelon and Clemens Schick*
Berlin, 2008

80 *Gero Drnek (Fury in the Slaughterhouse)*
El Cortijo, Spain, 1996

81 *Jessica Schwarz*
Berlin, 2007

82 *Sven Regener*
Hamburg, 1998

83 *La Luna*
Berlin, 1999

84–85 *Balthazar Getty*
Los Angeles, 2006

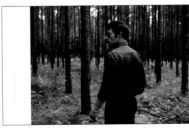

86–87 *Wayne Jackson*
Berlin, 2007

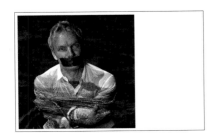

88–89 *Sting Tied Up*
Los Angeles, 2000

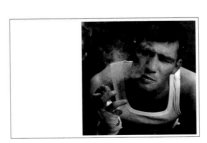

90–91 *Dariusz Michalczewski Smoking*
Hamburg, 2000

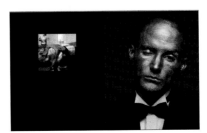

92 *Iggy Pop Lying on a Hotel Bed*
Hamburg, 1999

93 *Moby in Gold*
Munich, 1997

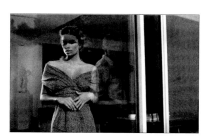

94–95 *Arielle Vandenberg*
Santa Monica, 2007

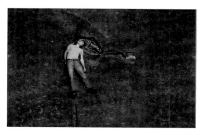

96–97 *Memento Mori (A Body in My Backyard)*
Unknown, 2002

98–99 *Ray Liotta*
Los Angeles, 2001

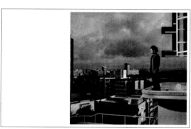

100–1 *Robby Rosa*
Santa Cruz, Puerto Rico, 2003

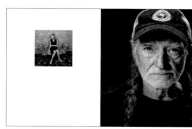

102 *Nina Persson (The Cardigans)*
Hamburg, 2000

103 *Willie Nelson*
Los Angeles, 2006

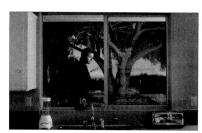

104–5 *Brandon Flowers (The Killers)*
Beverly Hills, 2006

187

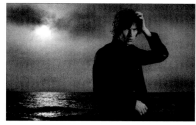

106–7 *Richard Ashcroft*
Los Angeles, 2002

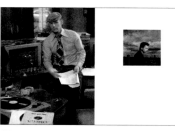

108 *Junkie XL*
Rotterdam, 2002

109 *Dave Gahan (Depeche Mode)*
Hamburg, 2003

110 *Campino Lying on a Beach*
Algarve, Portugal, 1999

111 *Squashed Frog*
Maui, Hawaii, 2001

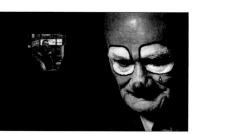

112 *Till Lindemann*
San Francisco, 2001

113 *Il Disperato*
Hannover, 1991

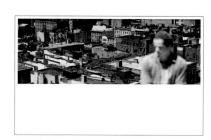

114–15 *Perau (Terry Hoax)*
New York City, 1994

116–17 *Heike Makatsch Laughing*
Berlin, 2005

118–19 *Coldplay*
London, 2003

120–21 *Chris Cornell*
Los Angeles, 2004

122 *Dolores O'Riordan (The Cranberries)*
Limerick, Ireland, 2000

123 *Q'Orianka Kilcher*
Malibu, 2005

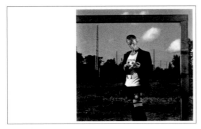

124–25 *DJ Hell*
Berlin, 2004

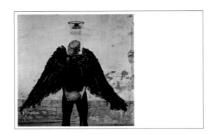

126–27 *Dirk Nowitzki's Wings*
Würzburg, 2004

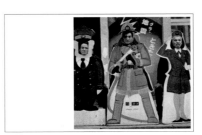

128–29 *Die Ärzte*
Shibuya, Tokyo, 1997

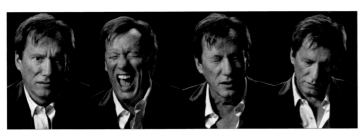

131–34 *James Woods,* Plates 1–4
Los Angeles, 2005

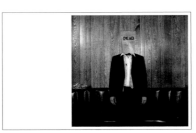

136–37 *Ken Andrews*
Los Angeles, 1999

188

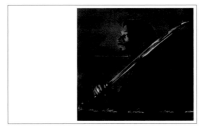

138–39 *Thomas Kretschmann*
Berlin, 2008

140–41 *Strausberger Platz*
Berlin, 2006

142 *Farin Urlaub*
Hamburg, 2001

143 *Nina Hagen*
Berlin, 2000

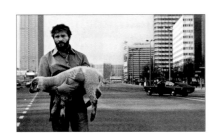

144–45 *Snoop Dogg*
Los Angeles, 2003

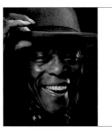

146–47 *Junge*
Cape Town, 2002

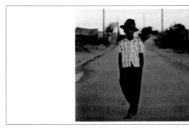

148 *Buddy Guy*
New York City, 2006

149 *Sting*
Malibu, 2003

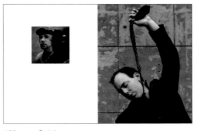

150 *Goldie*
Mojo Club, Hamburg, 1997

151 *Greg Graffin (Bad Religion)*
São Paulo, Brasil, 1999

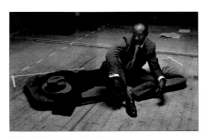

152–53 *Don Cheadle,* Plate 1
Los Angeles, 2004

154–55 *The Rabbit Hole*
Berlin, 2008

156–57 *El Matador*
Los Angeles, 2002

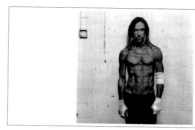

158–59 *Iggy Pop*
Miami, 2001

160–61 *Richard und Schneider tanzen*
Berlin, 2003

162 *A Man Called Malice*
Berlin, 1999

163 *Dave Grohl (Foo Fighters)*
Los Angeles, 2007

164 *Crying Baby after Birth (Caesarian)*
Hanover, 1992

165 *James Hetfield (Metallica)*
Cologne, 1996

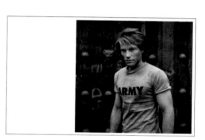

166–67 *Jon Bon Jovi*
Mexico City, 2000

168–69 *Chris Martin (Coldplay)*
London, 2003

170–71 *Barfly*
Havana , Cuba, 2006

172 *T.C. Boyle*
Santa Barbara, 2002

173 *Sheryl Crow at the Soho Grand*
New York, 1998

174 *Dave Stewart*
Hamburg, 1998

175 *Morten Harket (a-ha)*
Oslo, Norway, 2001

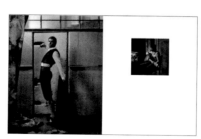

176 *Mario Gomez*
Stuttgart, 2008

177 *James Blunt*
London, 2007

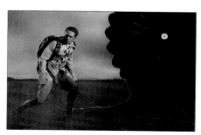

178–79 *Matthias Schweighöfer*
Berlin, 2008

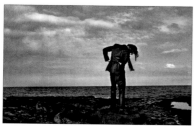

180–81 *Phillip Boa Down by the Water*
Tenerife, 2006

182–83 *Farewell*
Hanover, 1994

IM GRENZBEREICH

Ralf Grauel

In Olaf Heines Atelier gibt es eine Fotowand mit gerahmten Abzügen von Kollegen. Ein paar Originale von Heine sind auch dabei: In der Mitte hängt ein Selbstporträt aus der Zeit, als seine damalige Freundin sich gerade von ihm getrennt hatte. Heine steht verdreckt, möglicherweise verprügelt, mit rasiertem Kopf da, im schwarzen Anzug, das Jackett hat er geöffnet und an der Stelle seines Herzens ist eine Zielscheibe aus Blut auf seine Brust gemalt. »Ich hatte eigentlich vor, ein Triptychon zu machen«, erzählt Heine, »aber nach dem Foto war die Sache für mich durch. Ich war fertig, habe nichts mehr gefühlt.«

So wie Heine mit sich selbst umgeht, behandelt er auch viele der von ihm porträtierten Künstler. Für Heine war die Inszenierung eine Therapie; die fotografierten Künstler wachsen mit solchen Situationen. Blixa Bargeld beschrieb das folgendermaßen: »Je angreifbarer, je antastbarer man sich macht, umso unangreifbarer wird man tatsächlich. Du kannst die höchste und verletzlichste Fragilität zur Schau stellen – durch die Tatsache, dass du sie zur Schau stellst, wirst du immer unantastbarer.« *Leaving the Comfort Zone* zeigt solche Momente.

Olaf Heines Job ist es, einen auf Perfektion und Glamour versessenen Markt mit Bildern zu versorgen. Heine nimmt sich das Image der Künstler vor, studiert ihr Werk, liest Texte, sieht ihre Filme, hört ihre Musik und wartet auf Bilder, die ihm einfallen. Er denkt sich spielfilmähnliche Inszenierungen aus, organisiert Requisiten, Beleuchtung und gibt dann am Set Regieanweisungen. Meistens dreht Heine das Image des Künstlers ein wenig um: Der Porträtierte wird zum Schauspieler in der Rolle, sein eigenes Image neu zu interpretieren. Der Film aber ist ganz von Olaf Heine.

Die Stimmung am Set ist fast immer verspielt und locker. Am meisten spielt Heine. Aus Zufällen macht er Kunst, reagiert blitzschnell auf unerwartete Details und unterwirft sie seinem Zweck.

Seine intensive Vorarbeit erleichtert die Produktion. Sein Gegenüber fühlt sich sichtlich wohl – das Team, das bis zu diesem Punkt Blut und Wasser geschwitzt hat, nicht unbedingt.

Auffälligerweise führen Heines Filme oft in die Wüste. Sogar in Städten sucht er die Leere, über den Dächern. Die Inszenierungen spielen mit Architektur, Linien und Strukturen und folgen fast immer einem stark formalästhetischen und klaren Aufbau. Egal, wovon die vielen Geschichten um Heines Bilder herum handeln, die Ausschnitte zeigen oft Momente des Scheiterns. Es geht um Verlust, Einsamkeit und Leere. So platziert er Sting in einem Swimmingpool, fesselt ihn und verbindet ihm den Mund wie Troubadix, dem ungeliebten Barden aus *Asterix und Obelix* (Abb. S. 88/89).

Den britischen Sänger Brian Molko inszeniert Heine als in Gedanken versunkenen, möglicherweise impotenten Dandy im Rollstuhl, der sich von seiner Gespielin abwendet (Abb. S. 66/67). Ein schmerzhaftes Bild, denn seit ihrem Album *Meds* ist es tragisch still geworden um seine Band Placebo. Aber selbst wenn die Fotos nicht vor ganz so düsterem Hintergrund entstehen, gibt Heine ihnen die passende Wendung. So ist das Bild von Thomas Kretschmann während der Dreharbeiten für den *Seewolf* entstanden (Abb. S. 138/139). Der Schauspieler hatte Heine angerufen: »Ich habe einen Bart, lass uns Fotos machen.« Jeder Schauspieler weiß um den Wert eines neuen Looks im Portfolio, da nichts schlimmer ist, als nur ein einziger Typ zu sein. Olaf Heine blieb sich auch in dieser Situation treu, ließ eine Kreuzung auf der Berliner Karl-Marx-Allee sperren, besorgte ein Lamm und einen alten Ford. Die Regieanweisung lautete: »Stell dir vor, du hast alles in einem Feuer verloren. Frau, Kinder, Hof. Nur das Lamm konntest du retten.«

Vor Jahren fotografierte Olaf Heine Mark Spoon, den exzessiven Techno- und Dance-DJ, vor einem Druckkessel, dessen Zeiger auf null steht. Sieben Jahre später lief die Lebensuhr von Mark

Spoon wirklich ab, sein Herz war nicht mehr stark genug – 2006 starb Markus Löffel, so sein bürgerlicher Name, in Berlin. Heine war das alte, damals schon leere Bild nicht genug. Ein Jahr nach dem Tod Mark Spoons nahm er einen Abzug, legte ihn in die Wüste und verbrannte ihn nachträglich: Heines persönliche Form des Abschiednehmens (Abb. S. 52/53).

Und schließlich das Foto von Herbert Grönemeyer.* »Ich wollte ein Berlin-Bild machen«, erzählt Heine, »es sollte trist sein und etwas von Film Noir haben.« Heine fesselte Grönemeyer, verband ihm die Augen und inszenierte eine Hinrichtung. Als das Foto gemacht wurde, hatte Herbert Grönemeyer ein halbes Jahr zuvor seine Frau und seinen Bruder verloren. Dieses Bild von Herbert Grönemeyer darf nur in Ausstellungen und auf Olaf Heines Website gezeigt werden. Heine kann es nicht in Zeitschriften, auf Postern und schon gar nicht auf Werbeplakaten veröffentlichen. Dieses Bild darf nichts verkaufen, denn es zeigt viel zu deutlich den wahren Schmerz eines Menschen.

Man könnte nun die Skrupellosigkeit kritisieren, jemanden, der gerade Frau und Bruder verloren hat, als Hinrichtungsopfer zu inszenieren. Andererseits veröffentlichte Grönemeyer kurz zuvor mit *Mensch* sein mit Abstand erfolgreichstes Album, auf dem er selbst von seinem traurigen Kampf erzählt, einfach weiterzumachen. Ist es ein Unterschied, ob der Leidende selbst sein Leid verarbeitet, indem er es inszeniert, oder ob sein Leid die Grundlage für die Inszenierung eines Dritten bildet?

Man kann Heine tatsächlich Skrupellosigkeit vorwerfen. Man sollte aber auch seinen Mut und seine Kraft bewundern, sein Gegenüber so weit zu bringen. Denn es sind immer extrem starke Persönlichkeiten, die er inszeniert. Menschen, die so bekannt sind, dass sie in jedem Betrachter Assoziationen hervorrufen und an dieser Stelle Marken ähnlicher sind als echten Menschen; globalisierte öffentliche Figuren. Diese Personen sind es gewohnt,

mit ihrem Selbstbild zu spielen. Insofern sind sie nicht normal. Und ebenso unnormal und künstlich sind ihre Jobs. Olaf Heine hat die Kraft, diese Menschen, die fast alle ständig »Bestimmer« sind, auf seinem Weg mitzunehmen. Heine liebt die Reibung und das Gefühl, wenn jemand mitgeht. Das klappt nicht immer. Aber wenn, dann ist es ein euphorisierendes Erlebnis. Mit Schauspielern ist das einfach, für sie ist es alltäglich, in Rollen zu schlüpfen. Auch mit Fußballern, die in ihrer Kreativität noch formbar sind. Bei allen anderen aber ist es harte Arbeit. Dabei spielt es keine Rolle, ob es sich um eine Auftragsarbeit oder eine freie Arbeit handelt – am Ende zählt immer das eine Bild.

Wie tragisch die Vorgeschichten für seine Inszenierungen auch sein mögen, die entstandenen Momentaufnahmen sind einzigartig, archaisch und schön. An dieser Stelle, wo sich Archetypus und Perfektion treffen, entstehen Ikonen. Und natürlich sind die Fotos immer ein Gemeinschaftsprodukt: von Heine, der einen Weg zeigt, und dem Fotografierten, der ihn geht. Heine hat bei Herbert Grönemeyer eine Grenze überschritten. Aber die Inszenierung macht es uns mehr als jedes Porträtfoto möglich, den in der Öffentlichkeit stehenden Künstler Herbert Grönemeyer als Mensch zu betrachten. Genau das wollte der Künstler selbst mit seiner Platte, die er deswegen auch *Mensch* nannte.

Im Englischen gibt es das Wort »vicarious«; mit »stellvertretend« ist es nur unzulänglich übersetzt. »Vicarious lives« sind Leben, die Menschen stellvertretend für andere führen. Viele Reporter, Fotografen und Schauspieler erleben diese Momente tausendfach: Sie erleben sich durch fremde Figuren und erweitern so ihr Dasein.

Olaf Heines eigenes, persönliches Thema hat mit Leid zu tun und mit dem Tod. Es sind nicht nur die häufigen Regieanweisungen, bei denen er Schauspieler und Popstars zu Fall bringt und ihnen kleine Tode bereitet, von denen sie wieder auferstehen.

Heine selbst sucht den Tod, besucht ihn seit Jahren. Er geht in medizinhistorische Sammlungen, leiht sich Ausstellungsstücke, setzt Licht und fotografiert sie (Abb. S. 83 und 162). Er besucht Friedhöfe und findet in ihnen das Abbild des Lebens. Die Friedhöfe in Hawaii gleichen paradiesischen Palmengärten. Die Gräber von Hollywood sind kleine Celebrity-Schreine mit vergoldeten Künstlernamen (Abb. S. 37), während die engen, steinernen New Yorker Friedhöfe Straßenschluchten bilden. »Die Stätten der Toten spiegeln die Städte der Lebenden«, sagt Heine.

Autoren schreiben, wenn sie Dinge zu verarbeiten haben. Fotografen fotografieren. Vor vielen Jahren, als Olaf Heine noch nicht wusste, dass er einmal Fotograf wird, machte er Zivildienst in einem Krankenhaus. Er interessierte sich für die Geburten, war bei vielen dabei, auch bei einem Kaiserschnitt (Abb. S. 164). In dieser Zeit wurde Heines Neffe geboren, und sein Großvater starb. »Damals wurde ich erwachsen«, sagt er. Mit dem Bild seines aufgebahrten Großvaters endet dieses Buch. »Seltsam«, erzählt Heine, »im Gegensatz zur Geburt, die ja der Eintritt ins richtige Leben ist, habe ich damals den Tod als etwas sehr Ruhiges erlebt. Der Tod ist friedlich, die Geburt aber ist ein Kampf voller Schmerzen. Du wirst herausgerissen aus der Geborgenheit des Mutterleibs.« Aus dieser Sicht würde das Leben mit dem Verlassen dieser *Comfort Zone* beginnen, und es würde mit einer Heimkehr enden.

Olaf Heines Bilder sind tatsächlich dann am besten, wenn er die Menschen, die er fotografiert, an einen persönlichen Grenzbereich führt. »Meine Arbeit ist in den besten Momenten ein Mittel, mich mit archaischen Gefühlen auseinanderzusetzen. Dazu gehören Euphorie, Hilflosigkeit – und der Tod.«

Im Zivildienst hielt Heine die Hand einer alten Frau, die im Sterben lag. »Die Pflegerinnen sagten, ich soll Bescheid geben, wenn sie tot ist. Ich fragte, woran ich das erkenne. ›An der Schluckatmung,

die Intervalle werden länger‹, sagten sie und gingen raus.« Die Intervalle wurden länger, die Frau hat ihn mit den Augen fixiert und nicht losgelassen, berichtet Heine, »irgendwann spürte ich eine Hand auf meiner Schulter, der Oberarzt«. Es sei vorbei, sagte der Arzt, Heine solle jetzt erst einmal vor die Tür gehen.

Manche Menschen leben einfach vor sich hin. Andere finden über den Tod zum Leben. Olaf Heine ist ein solcher Mensch. Er findet über das Leid zu sich. Und zu anderen Menschen.

* Bedauerlicherweise hat Herbert Grönemeyer seine Einwilligung zum Abdruck des Fotos nicht gegeben. Es ist auf www.olafheine.com zu sehen.

LET THE MUSIC PLAY

Matthias Harder

»Ich fotografiere Prominente.« Mit dieser einfachen Aussage umschreibt Olaf Heine etwas, das sich in seinem Werk in vielfältiger Weise zeigt – ungewöhnliche Bilder einiger der bekanntesten Vertreter der internationalen Popmusikszene. So kommen uns seine Porträts vertraut vor – auch wenn viele der hier versammelten Aufnahmen bisher nicht publiziert wurden. Heine ist viel unterwegs und viel gebucht, auf allen Kontinenten entstehen seine inszenierten Bildgeschichten. Jedem Foto liegen Begegnungen zugrunde, mit Menschen oder Städten, erstmals oder zum wiederholten Male – meist arrangiert durch seine Agenturen. Voraussetzung für diese intensiven Bildnisse ist eine Begabung für Kommunikation und ein intuitives Gespür.

Heine pendelt zwischen Auftragsfotografie und freier Arbeit hin und her. Gute Fotografen sind in der Lage, beim Auftraggeber den eigenen Stil durchzusetzen, gewissermaßen mit einer Carte blanche zu agieren. Und Heine hat zweifellos einen eigenen Porträtstil entwickelt: klar und einfühlsam, ironisch und hintergründig. Manchmal scheinen wir die Musik durch die zweidimensionale Abbildung hindurch zu hören, etwa wenn er Musiker wie Lou Reed oder Nick Cave porträtiert (Abb. S. 26 und 74/75). Wie Filmstills ziehen die Bilder vor unserem inneren Auge vorbei, wenn er Schauspieler wie James Woods vor der Kamera hatte (Abb. S. 131–134). Los Angeles hat sich der Fotograf auch deswegen als Betätigungsfeld ausgesucht, da hier die Stars leben und arbeiten, für die sich die Auftraggeber in der Musik- oder Schauspielszene interessieren. Und so öffnet Heine auch uns Europäern die Tür zu dieser amerikanischen Welt. Doch die Branche verändert sich rasant; die Vertriebswege der Bilder werden immer schneller, die meisten Fotografien tauchen inzwischen ausschließlich im Internet auf – und nicht mehr in gedruckten Zeitschriften. Heine ist sich dieses Rezeptionswechsels bewusst und stellt die Weichen jetzt neu.

Die Menschen, die Heine porträtiert, wurden zuvor Tausende Male wissentlich oder unwissentlich fotografiert und sind zu medialen Profis geworden. Denn Celebrity-Porträts dienen Schauspielern und Musikern als mediale Transmitter, um sich ihren Fans über die millionenfache Verbreitung immer wieder neu zu präsentieren. Die Starporträts waren und sind visuelle Identifikationsangebote. Kann in dieser Medieninflation noch ein neues Bild entstehen?

Ziel der meisten Bildermacher – ob Paparazzo oder Auftragsfotograf – bleibt nicht das perfekte, sondern das ultimative, ikonische Bild, so auch für Heine; Aufnahmen, die ihn überdauern, wie er es ausdrückt. Das ist die alte, genuine Idee der Porträts seit der Pionierzeit der Fotografie. Das Herrscherbildnis, das Repräsentationsporträt entwickelte sich in der Verbürgerlichung der Gesellschaft zum Abbild all derer, die sich eine Porträtsitzung beim Fotografen leisten konnten, sowie der Stars des kulturellen Lebens. Ihre Porträts, häufig in Form von Autogrammkarten oder schlicht im Auftrag illustrierter Zeitungen, entstanden bereits im späten 19. Jahrhundert für die stetig wachsende Schar von Fans und deren unstillbaren Hunger nach Bildern ihrer Helden. Diese Tradition hat sich bis heute prinzipiell kaum geändert, allein die hohen Auflagenzahlen, die Distribution sowie der schnelle Interessenswandel und Personalwechsel sind neu.

Hugo Erfurth oder Stefan Moses haben in der ersten beziehungsweise zweiten Hälfte des 20. Jahrhunderts in Deutschland die jeweils aktuelle, heute fast vergessene Kulturszene fotografiert; ihre konservativ-bewahrende Bildidee mit Blick auf das eigene Land und seine Repräsentanten hat sich heute in eine sich rasant drehende, globale Aktualitäts- und Innovationsspirale verwandelt. Was zählt, ist das formal wie inhaltlich Neue, auch im Porträtfach. Gleichzeitig beginnen wir in unserer sich immer stärker ausdifferenzierenden Welt den Überblick zu verlieren. Wir können

nicht mehr jeden promoteten Musiker und Schauspieler kennen – zumal morgen schon wieder neue Namen auf den Zetteln der Castingagenturen und der Bildredakteure stehen. Wenn Figuren wie Madonna oder Mick Jagger über Jahrzehnte die Medienöffentlichkeit zu interessieren in der Lage sind, stecken – jenseits musikalischer Begabung – in erster Linie geniale PR-Konzepte dahinter.

Authentizität ist hinter der Medienfassade ein dehnbarer Begriff geworden. Olaf Heine interessiert sich für eine private Konstruktion hinter der Verkleidung. 2001 hat er Iggy Pop in Miami porträtiert, mit nacktem, durchtrainiertem Oberkörper, verbundenen Händen und Ellenbogen – wie ein Boxer nach dem Kampf tritt der Sänger vor uns (Abb. S. 158/159). Nur die Anzughose verrätselt die Bildwirkung. Dieses Bild, zugleich inhaltlich passendes Covermotiv von *Leaving the Comfort Zone,* wird sich zu einer Ikone des Musikerporträts entwickeln. Der direkte und kühle Blick in die Kamera ist untypisch in Heines Werk; meist sind es eher kontemplative oder emotionale Situationen, in die er die Menschen vor seiner Kamera zu versetzen weiß. Hier aber, in der Begegnung mit Iggy Pop, entstand eine konfrontative Spannung zwischen dem Star und dem Regisseur des fotografischen Bühnenexperiments. Den Rapper Snoop Dogg wiederum verwandelte Heine in einen Shaolin-Mönch mit Schwert (Abb. S. 15 und 144/145). Diese Metamorphose hatte es bislang nicht gegeben. Jenseits der martialischen Geste des Schwerttragens ist das Asketische, ja Spirituelle als formale Assoziation greifbar. Den deutschen Sänger Phillip Boa fotografierte Heine hingegen als Rückenfigur an der zerklüfteten Felsenküste von Teneriffa (Abb. S. 180/181). Leicht gebeugt, gegen den Wind und die anderen Elemente kämpfend, entstand eine außergewöhnliche Charakterstudie. Wie die Natur hier zur Kulisse wird, zeigt die Entwicklung weg vom romantischen Zitat eines Caspar David Friedrich hin zu den Prinzipien zeitgenössischer Modefotografie.

Das Drama entfaltet sich bis zu Stings Porträt, das den Sänger gefesselt, mit verklebtem Mund und halb unter Wasser zeigt (Abb. S. 88/89). Die Bildidee sorgt dafür, dass Sting sich weder bewegen noch singen kann. Doch das Stück ist so launig wie eine Komödie, denn in den Augen des Sängers spiegelt sich Heines unbekümmerte Inszenierungsidee mit den Theaterrequisiten wider. Der Fotograf findet unter den Prominenten – wie im Fall von Sting – immer wieder Verbündete, kreative Geister, die auf seine ungewöhnlichen Bildideen eingehen. Heine individualisiert sein Gegenüber, er gibt ihm ein privates Gesicht, das wir neu entdecken können. Dabei inszeniert Heine seine Aufnahmen in geschlossenen, ja selbst in öffentlichen Räumen häufig wie Bühnenstücke, nicht wie »echtes« Leben. Er verlässt die *Comfort Zone* zugunsten einer Stilisierung der Realität.

Manchmal studiert Heine vorhandene Bilder aus der fotografischen Vergangenheit seines Gegenübers, doch bewusst orientiert er sich nicht an ihnen. Denn die Ideen für das Shooting stellen sich gewissermaßen von alleine ein, so der Fotograf im Interview. Dennoch findet man die eine oder andere Annäherung an die Arbeit berühmter Kollegen im Buch, etwa beim Porträt von Sven Regener, den Heine ungewöhnlich nah an den linken Bildrand stellt und so die Figur anschneidet (Abb. S. 82). Der sichtbar gemachte Negativstreifen lässt uns an charakteristische Stilmerkmale Richard Avedons denken – eine bewusste Hommage an den 2004 verstorbenen New Yorker Fotografen.

Es gibt nicht viele Kollegen, die in diesem Feld auf gleichem Niveau arbeiten. Anton Corbijn ist einer von ihnen; jedoch fasst er den Bildausschnitt meist knapper als Heine und konzentriert sich eher auf die Fokussierung des Menschen. Doch bei Heine ist der räumliche Kontext interessant, in dem die Menschen agieren und den er mit genau so vielen Accessoires ausstattet, dass assoziative Beziehungen zwischen den Menschen und den Dingen entstehen können. Gleichzeitig bleibt Olaf Heine der

abbildenden Fotografie treu; radikale, formale Experimente und Abstraktionen lässt er in seinem Werk nicht zu. Seine Menschenbilder beruhen auf klaren Kompositionsprinzipien mit Linien, Flächen und Figuren – Ausdruck einer tiefen Verbundenheit mit der Architektur. Kurze Zeit hatte er dieses Fach studiert, bevor er sich auf die Fotografie konzentrierte; geblieben ist die Offenheit gegenüber anderen Künsten, die seine Bildsprache bereichern.

Heine ist Regisseur und Beobachter zugleich; meist entstehen die Bildideen zuvor im Kopf, so kann er dirigieren und reagieren. Im Dialog zwischen Kamera und Blick entstehen seine Aufnahmen manchmal intuitiv, bestimmte Bildideen werden ihm erst im Nachhinein bewusst, wie Heine selbst zugibt: so etwa beim Porträt von Thomas Kretschmann, der für das Bild ein Lamm in seinen Armen trägt (Abb. S. 138/139). Der Schauspieler ließ sich zum Zeitpunkt der Aufnahme, während der Berlinale 2008, für seine Rolle als »Seewolf« einen Vollbart wachsen und wird hier zum herumirrenden, verwirrten Schäfer oder – wenn man das junge Schaf religiös konnotiert – zum Christophorus, zum Christusträger. Es gibt viele mögliche Deutungen, und der Fotograf ist kein Didakt, er lässt den Betrachtern die Möglichkeit zu eigenen Lesarten. Egal für welche Interpretation wir uns entscheiden, sie bleibt durch die sonderbare urbane Situation zweideutig: Ein Auto steht mit offener Wagentür mitten auf der Straße, der Verkehr auf der mehrspurigen Strasse scheint tagsüber zum Erliegen gekommen zu sein. Alles steht still, wie nach einem nuklearen Angriff oder einem Initiationserlebnis.

Heine arbeitet zielstrebig und überlässt selten etwas dem Zufall; doch auch der Zufall einer unerwarteten Begegnung kann zu einer starken Aufnahme führen. So geschehen in Havanna, als Heine einen alten Mann in einer Bar sitzen sah, der gedankenversunken und doch ganz intensiv zurückblickte (Abb. S. 170/171). Besser kann man ein Bild nicht komponieren und dichter lässt sich die dortige Stimmung atmosphärisch-visuell kaum inszenieren.

Olaf Heine sieht sich selbst als Geschichtenerzähler. Er macht visuelle Angebote, etwa wenn er den Strausberger Platz in Berlin in Schwarz-Weiß fotografiert: Er bleibt durch den nach oben gerutschten Bildausschnitt menschenleer, da Heine hier den Himmel über Berlin fokussiert hat (Abb. S. 140/141). Dieser Blick ruft automatisch eine Erinnerung in uns wach, und sei es nur an Wim Wenders' Film.

Letztlich interessieren Heine die großen Themen wie Leben und Tod. Eine Aufnahme, eine authentische Szene mit dramatischem Hintergrund, bildet allerdings einen Sonderfall und wird innerhalb der Bildabfolge doch wieder zurückgeführt und eingeordnet. Ein junger Krimineller – von der Polizei in die Enge getriebenen – erschoss sich vor Jahren vor den Augen des Fotografen. Während andere Schutz unter Tischen und hinter Türen suchten, griff Olaf Heine intuitiv zu seiner Kamera, ging zum Fenster und fotografierte den Selbstmörder, der sich mit einem Kopfschuss das Leben nahm. Der Körper des Erschossenen liegt leicht verdreht auf dem Asphalt, und eine riesige Blutlache fließt in den Gulli direkt nebenan (Abb. S. 96/97). Die reale Situation wirkt alptraumhaft inszeniert und verfolgte Heine monatelang. Erst nach Jahren entwickelte er den Film und vergrößerte das Bild für dieses Buchprojekt – Leaving the Comfort Zone.

Das Buch, eine Bilanz, steht an einem Wendepunkt in Heines Leben und Werk, das häufig abseits vertrauten Terrains entstand. Es wird sich etwas ändern, auch wenn der Fotograf selbst nicht weiß, wohin die Reise geht – oder es nicht verraten will. Vielleicht wird der Sport eine größere Bedeutung bekommen, der bisher nur eine marginale Rolle in seinem Werk spielte. Heines Interesse an Sport ist aber gleichzeitig durch ein tiefes, persönliches Interesse fundiert. Wir könnten neue Darstellungsformen in der medialen Präsenz der Sportler durchaus gebrauchen.

Der Vielgereiste hält inne und erlebt die Geburt des eigenen Sohnes, dem dieses Buch unter anderen gewidmet ist. Heine legt Zeugnis von den vergangenen eineinhalb Jahrzehnten ab; dieses Buch erzählt seine Geschichte. Wir begegnen Menschen, die Olaf Heine in Deutschland, Amerika und anderswo begleitet hat und die auch ihn begleitet haben, fotografisch individuell eingefangen. Aus den Begegnungen wurden Bilder. »Man ist porös wie ein Schwamm und saugt Dinge auf – das ist der künstlerische Prozess«, so Heine im Interview.

Formal existieren unterschiedliche Repräsentationsformen des Menschen nebeneinander. Der inhaltliche Bogen ist gespannt zwischen der Geburt eines Kindes – bereits während seiner Zivildienstzeit in einem Krankenhaus fotografiert – und dem Tod des Großvaters am Ende des Buches (Abb. S. 164 und 182/183); der Schwerpunkt liegt gleichwohl auf den Musikerporträts. Doch das Existenzielle des Lebens zeigt sich oft, wenn wir bemerken, dass die Party gefeiert und die Welt bereist wurde. Heines intensiver Blick in und auf die Welt wird über diese Bildzusammenstellung zu einer ganz eigenen Autobiografie, zu einem vielstimmigen Selbst- und Werkporträt, das Charaktereigenschaften wie Kontemplation und Melancholie genauso beinhaltet wie Durchsetzungsvermögen und Aufbruch. »Das Wichtigste«, so Heine über seine Fotografie, bleibe dabei »der Dialog mit den Menschen«.

SUR LE FIL

Ralf Grauel

L'atelier d'Olaf Heine possède un mur entièrement recouvert de tirages photographiques encadrés de collègues. On y trouve aussi quelques-uns de ses originaux. Au centre, il a accroché un autoportrait de l'époque où sa compagne d'alors l'avait quitté. On le voit crasseux, apparemment amoché et le crâne rasé dans un costume noir dont il a laissé la veste ouverte. À l'emplacement du cœur, sur sa poitrine, il a peint une cible avec du sang. Heine raconte : « À l'origine, j'avais prévu de réaliser un triptyque, mais après la photo, c'était fini pour moi. J'étais à bout, je ne ressentais plus rien ».

Heine agit de la même façon avec lui-même qu'avec bon nombre d'artistes dont il fait les portraits. Pour lui, la mise en scène est une sorte de thérapie, les artistes photographiés sortent grandis de telles situations. Blixa Bargeld résume cette vision : « Plus on se montre vulnérable et faible, plus on devient en fait invulnérable. Tu peux afficher la plus grande fragilité qui soit ; par le fait de l'afficher, tu te rends intouchable ». *Leaving Comfort Zone* montre ces moments-là.

Le travail d'Olaf Heine consiste à approvisionner en images un marché avide de perfection et de glamour. Heine se penche sur l'image de marque des artistes, il étudie leur œuvre, lit des textes, regarde leurs films, écoute leur musique et attend que des idées de photo lui viennent. Il imagine des mises en scène de films, cherche des accessoires, des éclairages puis donne ses indications pour la réalisation. La plupart du temps, Heine transforme légèrement l'image de marque de l'artiste : celui qu'il photographie devient un comédien dont le rôle est de donner une nouvelle interprétation de son image. La pellicule reste, elle, signée entièrement Olaf Heine.

L'ambiance de la séance de pose est quasiment toujours joyeuse et détendue, en grande partie grâce à Heine. Il sait transformer des situations fortuites en art, réagir en un éclair aux détails

inattendus et se soumettre à son but. Le travail préparatoire qu'il mène intensément en amont facilite la production. On sent que la personne qu'il photographie est en confiance, ce qui n'est pas nécessairement le cas de l'équipe qui jusqu'ici a sué sang et eau.

On remarque que les films de Heine nous emmènent souvent dans le désert. Et même au cœur des villes, il semble chercher le vide, au-dessus des toits. Les mises en scène jouent avec l'architecture, les lignes et les structures et suivent presque toujours une organisation claire et fortement marquée par une esthétique formelle. On se moque de savoir de quoi parlent les nombreuses histoires qui gravitent autour des images de Heine, les clichés, eux, montrent souvent des situations d'échec. Il s'agit de perte, de solitude et de vide. C'est ce qui le mène à placer Sting dans une piscine, à l'attacher et à lui bâillonner la bouche comme Assurancetourix, le barde dans *Astérix et Obélix* (ill. p. 88–89).

Heine met en scène le chanteur britannique Brian Molko, tel un dandy impotent en fauteuil roulant, perdu dans ses pensées et se détournant de sa compagne de jeux (ill. p. 66–67). Une image d'autant plus douloureuse lorsque l'on sait que son groupe Placebo n'a plus fait parler de lui depuis l'album *Meds.* Cependant, même lorsque les photos ne s'inscrivent pas dans un contexte aussi glauque, Heine sait leur donner la tournure adéquate. C'est notamment le cas concernant la photo de Thomas Kretschmann, prise lors du tournage de son dernier film *Der Seewolf* (ill. p. 138–139). Rien n'étant plus handicapant pour un acteur que de ne correspondre qu'à un seul look, Kretschmann avait profité de ce rôle pour se présenter sous un nouvel aspect dans son book et avait appelé Heine en lui disant : « Je porte la barbe en ce moment, viens prendre des photos ». Olaf Heine ne dérogea pas à ses principes et resta là encore fidèle à lui-même : il fit bloquer un carrefour sur la très large Karl-Marx-Allee à Berlin et se procura un agneau et une ancienne Ford. La directive de

mise en scène était la suivante : « Imagine-toi avoir tout perdu dans un incendie : femme, enfants, maison. Tu n'as pu sauver que l'agneau ».

Il y a plusieurs années, Olaf Heine avait photographié Mark Spoon, DJ de musique techno et dance réputé pour ses comportements excessifs, devant un caisson de décompression, l'aiguille bloquée sur zéro. Sept ans plus tard, l'aiguille s'arrêta aussi sur zéro pour Mark Spoon, son cœur ne tenant plus : en 2006, Markus Löffel de son vrai nom est mort à Berlin. La photo, pourtant déjà vide, ne suffit pas à Heine. Un an après la mort de Mark Spoon, il prit une épreuve de la photo qu'il emmena dans le désert et l'incinéra : ce fut sa façon à lui de dire adieu (ill. p. 52–53).

Enfin, la photo du chanteur allemand Herbert Grönemeyer.* Heine raconte : « Je voulais faire une photo de Berlin, morne et évoquant un film noir ». Heine attacha Grönemeyer, lui banda les yeux et mit une exécution en scène. Lorsque la photo fut prise, cela faisait six mois que Herbert Grönemeyer avait perdu son frère et sa femme. Cette photo ne peut être montrée que lors d'expositions et sur la page web d'Olaf Heine. Heine n'a pas le droit de la publier ni dans des magazines, ni sur des posters ni pour des affiches publicitaires. Il est impossible que cette photo puisse faire vendre quelque chose car elle est l'expression trop criante de la véritable douleur d'un homme.

On pourrait certes critiquer le manque de scrupules dont fait preuve Heine en photographiant en condamné à mort quelqu'un qui vient de perdre sa femme et son frère. Cependant, peu avant, Grönemeyer avait sorti *Mensch,* incontestablement son album le plus réussi, dans lequel il évoque son triste combat pour essayer simplement de continuer à vivre. Doit-on faire une différence entre une souffrance mise en scène par la personne concernée pour essayer de la digérer et la souffrance utilisée comme matériau pour la mise en scène d'un tiers ?

On peut effectivement reprocher à Heine d'être sans scrupules. Mais on doit aussi admirer le courage et la force avec lesquels il parvient à pousser aussi loin dans ses retranchements la personne qu'il photographie. Car il met toujours en scène de très fortes personnalités. Des hommes qui sont connus au point de pouvoir évoquer chez chaque observateur des associations et qui sont davantage considérés comme des marques que comme de vrais hommes : des personnages publics de la globalisation. Ces personnes sont habituées à jouer avec leur image. Ce qui leur donne une dimension anormale, aussi anormale et superficielle qu'est leur travail. Olaf Heine a le pouvoir d'entraîner ces gens, pourtant presque tous des « décideurs », dans la direction qu'il a choisie. Heine aime ce sentiment d'émulation lorsque quelqu'un le suit. Cela ne marche pas à chaque fois. Mais lorsque c'est le cas, il s'agit alors d'une expérience euphorisante. C'est souvent plus facile avec les acteurs qui sont, eux, habitués à se glisser quotidiennement dans d'autres rôles. De même pour les footballeurs qui restent malléables dans leur créativité. Mais chez tous les autres, la tâche est difficile. Et cela n'a aucune importance s'il s'agit d'une commande ou d'un travail réalisé sans thème imposé, au bout du compte il ne reste qu'une seule image.

Quel que soit le degré de tragique présent dans le vécu qu'il utilise pour ses mises en scène, les instantanés qui en résultent sont uniques, originaux et beaux. À l'endroit même où se rencontrent l'archétype et la perfection naissent des icônes. Et ces images sont toujours un résultat commun du travail de Heine, qui indique le chemin à suivre et de celui du photographié qui se plie à cette direction. Chez Herbert Grönemeyer, Heine a dépassé une certaine limite. Mais cette photo-là nous permet plus que tout autre portrait de considérer l'artiste public qu'est Herbert Grönemeyer comme un homme. Et c'est exactement ce que souhaitait l'artiste avec son album intitulé *Mensch* (Homme).

On utilise en anglais le mot « vicarious » que l'on peut traduire en français par « par procuration ». « Vicarious lives » sont des vies que des hommes vivent pour d'autres, par procuration. De nombreux reporters, photographes et acteurs connaissent ces moments des milliers de fois : ils vivent au travers de personnages étrangers et élargissent ainsi l'horizon de leur existence.

Le seul thème personnel d'Olaf Heine a à voir avec la souffrance et la mort. Il ne s'agit pas uniquement des directives fréquentes grâce auxquelles il fait choir des acteurs et des stars de la scène pop et leur prépare de petites morts desquelles ils ressuscitent. Heine lui-même cherche la mort et semble lui rendre visite depuis des années. Il va dans des collections d'œuvres sur l'histoire de la médecine, emprunte des pièces d'exposition, les met en valeur et les photographie (ill. p. 83 et 162). Il va dans des cimetières et y trouve le portrait de la vie. Les cimetières d'Hawaï ressemblent à des palmeraies paradisiaques. Les tombes d'Hollywood sont autant de petits reliquaires de célébrités aux noms d'artistes gravés en lettres d'or (ill. p. 37) et les étroits cimetières en pierre de New York ressemblent à des rues encaissées. Pour Heine, « les cités des morts reflètent les villes des vivants ».

Les auteurs écrivent pour faire un travail sur une expérience vécue. Les photographes font des photos. Il y a de nombreuses années, lorsqu'Olaf Heine ne savait pas encore qu'il allait devenir photographe, il fit son service civil dans un hôpital. Il s'intéressait particulièrement aux naissances et put assister plusieurs fois à des accouchements, notamment à une césarienne (ill. p. 164). C'est à cette époque que naquit le neveu de Heine et que son grand-père décéda. Il déclare : « C'est alors que je devins adulte ». Le livre se termine sur une photo du corps embaumé de son grand-père. « C'est étrange, dit Heine, mais à l'inverse d'une naissance qui est l'entrée dans la vraie vie, j'ai alors ressenti la mort comme quelque chose de très calme. La mort est paisible,

la naissance en revanche, un combat plein de souffrances. Tu es arraché de la quiétude du sein de la mère ». Dans cette perspective, la vie débuterait en quittant cette *Comfort Zone* et se terminerait en y retournant.

Les meilleures photos d'Olaf Heine sont celles où il pousse ceux qu'il photographie à leurs limites. « Dans les meilleurs moments, mon travail est un moyen de me confronter à des sentiments archaïques dont font partie l'euphorie, la détresse – et la mort ».

Lors de son service civil, Heine a tenu la main d'une vieille dame en train de mourir. « Les infirmières m'avaient dit de les prévenir dès qu'elle serait morte. Je leur avais demandé à quels signes je pourrai m'en rendre compte. Ce à quoi elles m'avaient répondu : "À la respiration, les intervalles s'espacent" et étaient sorties ». Heine raconte comment les intervalles s'espacèrent, comment le regard de la dame le fixa mais sans qu'elle ne lui lâche la main. Au bout d'un moment, il sentit une main sur son épaule, celle du médecin en chef. Il lui dit que c'était fini et qu'il devait maintenant sortir de la chambre.

Certaines personnes vivent au jour le jour, d'autres trouvent un moyen d'exister par la mort. Olaf Heine fait partie de ces dernières. Il trouve sa voie à travers la douleur. Et la voie qui le mène vers les autres.

*Malheureusement, Herbert Grönemeyer n'a pas souhaité donner son accord pour la publication de son portrait dans cet ouvrage. Il est néanmoins possible de le voir sur www.olafheine.com.

LET THE MUSIC PLAY

Matthias Harder

« Je photographie des célébrités ». Par ces quelques mots, Olaf Heine décrit ce que l'on voit dans son œuvre sous de multiples formes : des tableaux insolites de quelques-uns des plus célèbres représentants de la scène musicale pop internationale. C'est la raison pour laquelle ses portraits nous semblent familiers, bien que la plupart des photos rassemblées ici n'aient encore jamais été publiées. Heine est très souvent en voyage et très demandé, ses mises en scène ont lieu sur tous les continents. Chaque photo est liée à des rencontres, uniques ou répétées, avec des hommes ou avec des villes – le plus souvent organisées par son agence. La réalisation de ces portraits intenses nécessite un don pour la communication et une grande intuition.

Heine oscille constamment entre commandes et travaux sans thème imposé. Les bons photographes sont capables d'imposer leur propre style à leur commanditaire et de bénéficier en quelque sorte d'une carte blanche. Il ne fait aucun doute que Heine a su développer son propre style de portraits : clair et empathique, ironique et profond. Il nous semble parfois, lorsqu'il photographie des personnages tels que Lou Reed ou Nick Cave (ill. p. 26 et 74–75), entendre la musique à travers ses représentations en deux dimensions. De même on croit voir défiler des prises de films lorsqu'il fait poser des acteurs comme James Woods (ill. p. 131–134). C'est pour cela que le photographe a choisi Los Angeles comme lieu d'activité : les stars qui intéressent les commanditaires de la scène artistique, qu'il s'agisse de musique ou de cinéma, y vivent et y travaillent. Ainsi, Heine nous ouvre à nous, Européens, les portes du monde américain. Mais cette scène évolue à une vitesse fulgurante et les moyens de diffusion deviennent toujours plus rapides, la plupart des photos finissent par n'apparaître plus qu'exclusivement sur Internet et non plus dans des magazines imprimés. Heine est conscient de ce changement de réception et pose de nouveaux jalons.

Les personnes dont Heine fait le portrait ont déjà été photographiées des milliers de fois de façon plus ou moins scientifique et sont devenues des professionnels des médias. Ces portraits de célébrités sont des transmetteurs médiatiques que les acteurs et les musiciens utilisent pour diffuser à l'infini une image d'eux toujours renouvelée auprès de leurs fans. Les portraits des stars étaient et demeurent des possibilités d'identification visuelle. Mais est-il possible de faire exister une nouvelle image dans toute cette inflation médiatique ?

Le but de la plupart des photographes – qu'il s'agisse de photographes travaillant sur commande ou de paparazzo –, et y compris de Heine, n'est pas la photo parfaite mais l'ultime photo ayant valeur d'icône, les photos qui, selon lui, survivront à leur créateur. Il s'agit là de l'idée ancienne et originelle du portrait, évoquée par les pionniers de la photographie. Le portrait de souverain, le portrait de représentation s'est développé dans une société embourgeoisée dans laquelle tous ceux qui pouvaient se le permettre s'offraient une séance de portrait chez le photographe, et notamment les célébrités de la vie culturelle. Leurs portraits, souvent publiés sous forme de cartes postales signées ou tout simplement dans des journaux illustrés, apparaissent dès la fin du XIX^e pour répondre aux attentes d'une masse d'admirateurs toujours plus nombreuse et combler leur besoin insatiable d'images de leurs héros. Cette tradition a peu changé jusqu'à aujourd'hui, les seules nouveautés résidant dans des tirages bien plus élevés, dans la diffusion ainsi que dans la vitesse à laquelle les intérêts et les personnes changent.

Hugo Erfurth, pour la première moitié du XX^e siècle, ou Stefan Moses, pour la seconde moitié, ont photographié la scène culturelle allemande d'alors, aujourd'hui presque oubliée bien que toujours actuelle. L'image imprégnée de conservatisme qu'ils donnent de leur propre pays et de ses représentants s'est transformée aujourd'hui en une tornade effrénée de l'actualité et de

l'innovation de la globalisation. Ce qui importe, c'est la nouveauté, qu'elle touche le fond ou la forme. Parallèlement, nous commençons à perdre une vue d'ensemble sur notre monde toujours plus contrasté. Il n'est plus possible de connaître les noms de tous les musiciens et de tous les acteurs à la mode sachant que de nouveaux noms apparaissent chaque jour dans les agences de casting et dans les rédactions. Le fait que des personnalités comme Madonna ou Mick Jagger soient capables d'intéresser les médias pendant plusieurs décennies est le résultat, en-dehors de tous talents musicaux, de concepts géniaux dans le domaine des relations publiques.

Derrière la façade médiatique, l'authenticité est devenue un concept malléable. Olaf Heine se penche sur la construction privée dissimulée sous le masque qui apparaît au public. En 2001, il a photographié Iggy Pop à Miami, son torse musclé nu, les mains et les coudes bandés à la manière d'un boxeur après le combat (ill. p. 158–159). Seul le pantalon de costume rétablit la vérité. Cette photo, reprise pour la couverture de *Leaving Comfort Zone,* est devenue une icône du portrait du musicien. Ce regard direct et froid est inhabituel dans l'œuvre de Heine qui met davantage en scène des ambiances de contemplation et d'émotion dans lesquelles le photographe parvient à plonger ceux qui posent pour lui. À l'inverse, cette rencontre entre Iggy Pop et Olaf Heine exprime une impression de confrontation entre les deux protagonistes de cette expérience photographique. Chose encore jamais faite, Heine a métamorphosé le rappeur Snoop Dogg en un moine Shaolin armé de son épée (ill. p. 15 et 144–145). Au-delà de l'attitude martiale, on saisit ici également l'association avec une dimension esthétique et spirituelle. Inversement, Heine a photographié le chanteur allemand Phillip Boa de dos, au bord des falaises escarpées de Ténériffe (ill. p. 180–181). Légèrement courbé et semblant se battre contre le vent et les autres éléments, le photographe obtient ici une étude de caractère hors du commun. La nature reléguée au rang de coulisse montre bien à quel point les principes de la photographie de mode contemporaine se sont éloignés de ceux du romantisme évoqués notamment par Caspar David Friedrich.

L'aspect dramatique des photos atteint son apogée dans le portrait de Sting sur lequel on le voit à moitié sous l'eau, attaché et la bouche bâillonnée (ill. p. 88–89). Cette représentation laisse supposer que Sting ne peut ni bouger ni chanter. Pourtant, l'impression générale prend des allures de comédie car dans les yeux du chanteur se reflète la volonté d'une mise en scène réalisée avec une certaine légèreté dans le choix des accessoires. Le photographe réussit à choisir, parmi les célébrités qu'il fait poser, celles – comme c'est le cas chez Sting – qui réagiront comme des alliés faisant preuve d'esprit créatif face à ses idées insolites. La personne que Heine photographie devient un individu, il lui donne un visage intime auquel il nous donne accès. Pour ce faire, Heine met souvent ses photos en scène, que ce soit dans des lieux privés ou publics, comme s'il s'agissait d'une pièce de théâtre et non de la « vraie » vie. Il quitte la *Comfort Zone* au profit d'une réalité stylisée.

Parfois, Heine étudie des images déjà existantes dans le passé photographique de celui qu'il photographie mais il refuse consciemment de s'en inspirer. En effet, le disant lui-même lors d'une interview, les idées s'imposent d'elles-mêmes pendant la séance de pose. Il est cependant possible de faire des rapprochements avec le travail de certains de ses congénères célèbres. C'est le cas notamment pour le portrait de Sven Regener, reproduit dans ce livre (ill. p. 82) et dont le cadrage est si décalé vers la gauche qu'il semble manquer une partie de la photo. La bande du négatif laissée visible n'est pas sans rappeler les photos de Richard Avedon et est un indiscutable hommage au photographe new-yorkais décédé en 2004.

Heine a peu de collègues qui travaillent sur le même niveau que lui dans ce domaine. Anton Corbijn est l'un d'eux mais il réduit

cependant le cadre de l'image et se concentre davantage sur l'homme. C'est ce contexte spatial qui est intéressant chez Heine : il laisse le personnage y agir et l'équipe soigneusement de tant d'accessoires qu'il parvient à créer des associations entre l'homme et les choses. Cependant, Olaf Heine reste fidèle au principe de la photographie de reproduction. Il refuse toute expérience radicale et toute abstraction. Ses portraits reposent sur des principes de composition simples jouant sur les lignes, les surfaces et les silhouettes et exprimant un lien indissociable avec l'architecture, discipline qu'il a étudiée quelque temps avant de se consacrer à la photographie. Il en a gardé cette ouverture d'esprit sur les autres formes d'art qui enrichit sa palette photographique.

Heine est simultanément réalisateur et observateur. La plupart du temps, il imagine des tableaux qui lui permettent ensuite de diriger et de réagir. Dans ce dialogue entre le regard et l'appareil, ses photos naissent parfois de façon intuitive. D'autres fois il n'en prend conscience qu'après coup. Il reconnaît lui-même que c'est le cas pour le portrait de Thomas Kretschmann portant un agneau dans ses bras (ill. p. 138–139). À l'époque où la photo fut prise, pendant la Berlinale de 2008, l'acteur s'était laissé pousser la barbe pour son rôle dans *Der Seewolf* et apparaît ici soit comme un berger errant et troublé soit, si l'on considère l'agneau avec sa symbolique religieuse, comme saint Christophe portant le Christ. Il y a de nombreuses interprétations possibles et le photographe ne veut en imposer aucune. Il laisse à l'observateur la possibilité d'avoir sa propre lecture de l'image. Quelle que soit l'interprétation pour laquelle nous optons, le cadre urbain particulier donne une dimension ambiguë : la voiture est stationnée au milieu de la rue, la portière ouverte, la circulation semble avoir été suspendue en pleine journée sur la large artère à plusieurs voies. Tout semble calme comme après une attaque nucléaire ou une expérience initiatique.

Heine travaille avec un but précis et laisse rarement les choses au hasard sauf lorsque le hasard d'une rencontre inattendue aboutit à une photo d'une grande intensité. C'est ce qui se passa à la Havane lorsque Heine vit un vieil homme dans un bar qui, bien que perdu dans ses pensées fixait intensément l'objectif (ill. p. 170–171). Il est difficile de réaliser une meilleure photo et l'atmosphère ambiante n'aurait pu s'exprimer avec une plus grande intensité visuelle.

Olaf Heine se considère lui-même comme un conteur d'histoires. Il fait des propositions visuelles comme lorsqu'il photographie en noir et blanc la Strausberger Platz à Berlin. Il la montre vide, sans présence humaine, en décentrant la photo vers le haut et montrant ainsi le ciel de Berlin (ill. p. 140–141). Cette image nous évoque immanquablement un souvenir, celui du film de Wim Wenders *Les Ailes du désir*.

Enfin, Heine s'intéresse aux vastes thèmes que sont la vie et la mort. Une photo, une scène authentique dans un cadre dramatique constitue une exception mais est réintroduite et replacée au cœur d'une série de photos. Il y a quelques années, un jeune criminel, pris au piège par la police s'était donné la mort sous les yeux du photographe. Pendant que d'autres cherchaient un abri sous les tables et derrière les portes, Olaf Heine eut le réflexe d'attraper son appareil, se mit à la fenêtre et le photographia en train de se tirer une balle dans la tête. Le corps gît légèrement tordu sur l'asphalte, une énorme flaque de sang coule dans la bouche d'égout toute proche (ill. p. 96–97). Cette situation nous apparaît cauchemardesque. Elle poursuivit Heine et c'est seulement plusieurs années plus tard qu'il développa le négatif et agrandit la photo pour *Leaving the Comfort Zone*.

Ce livre est un bilan à un tournant de la vie et de l'œuvre de Heine, souvent située au-delà de tout terrain connu. À présent, quelque chose va changer même si le photographe lui-même ne sait pas

encore ou ne veut pas encore dévoiler la nouvelle direction que va prendre l'aventure. Il se peut qu'il accorde une importance plus grande au sport, domaine auquel il n'a attribué jusqu'alors qu'un rôle marginal dans son œuvre. L'intérêt de Heine pour le sport repose également sur un profond intérêt personnel : nous pourrions tout à fait avoir recours à de nouvelles formes de représentation de la présence des sportifs dans les médias.

Celui qui a tant voyagé se pose un peu et se consacre à une nouvelle expérience : la naissance de son fils à qui est dédié cet ouvrage, entre autres. Heine livre un témoignage de ces quinze dernières années et raconte son histoire personnelle. Nous rencontrons, capturés un par un dans des photos, des hommes et des femmes qu'Olaf Heine a accompagnés, comme eux aussi l'ont accompagné, en Allemagne, en Amérique et dans d'autres contrées. De ces rencontres sont nées ces photos. Comme Heine l'évoquait dans une interview : « On s'imbibe de choses, comme une éponge, puis on les absorbe. C'est cela le processus artistique ».

Plusieurs formes de représentations se côtoient ici. Le contenu de ce livre s'étend de la naissance d'un enfant, photographiée à l'époque où Heine effectuait son service civil dans un hôpital, à la mort de son grand-père (ill. p. 164 et 182–183). Toutefois, l'accent est aussi mis sur les portraits de musiciens. Et pourtant, la part essentielle de la vie ne se montre souvent qu'une fois que l'on remarque que la fête est finie et le monde parcouru. Le regard intense que Heine porte sur et à l'intérieur du monde, rassemblé dans ses photos, devient une autobiographie, un autoportrait polyphonique du photographe et de son œuvre dans lequel on retrouve les différents traits de caractère qui sont les siens : la contemplation et la mélancolie voisinant avec sa force de conviction et un désir de renouveau. « Le plus important restant », d'après les mots de Heine sur sa photographie, « le dialogue avec les hommes ».

BIBLIOGRAPHY

EDITORIAL WORK

2008

Brachmann, Jan. "Das singende Ausrufezeichen." *Vanity Fair* (Germany, March), pp. 96–99.

Eibl, Ralf. "Schnittigkeit mit gutem Gewissen." *AD* (February), pp. 90–93.

Garcia, Jorge. "The Lost Star Imagines Finding Himself in the Hereafter." *Maxim* (February), p. 40.

Müntefering, Marcus. "Zwei Typen starten durch." *Vanity Fair* (Germany, April), pp. 105–15.

Prato, Alison. "Icon: Dave Grohl." *Maxim* (January), pp. 74–75.

Wichert, Silke. "Mamma Mia, Toni." *Vanity Fair* (Germany, April), cover and pp. 36–43.

Willenborg, Caroline. "In jedem Fall Sommer." *Best Life* (Germany), no. 2, cover and pp. 96–107.

Wurm, Oliver. "Gut gehalten." *Vanity Fair* (Germany, January), pp. 62–67.

2007

Ackermann, Birgit. "Frauen an die Front." *Player* (June), pp. 102–09.

Editorial Best Life. "Lässig und elegant." *Best Life* (Germany), no. 7, cover.

Dreßlein, Detlef, and Tim Gutke. "Hitler war einer von uns." *Playboy* (Germany, January), pp. 56–63.

——. "Fernsehen macht uns alle doof." *Playboy* (Germany, March), pp. 56–60.

Fischer, Marc. "Big Mälzer." *Vanity Fair* (Germany, November), pp. 58–64.

Hellmuth, Iris. "Mit Ecken und Kanten." *Stern*, no. 37 (September 6), pp. 160–68.

Koischwitz, Christine. "Wir sehen Schwarz." *Park Avenue* (December), p. 23.

Lindemann, Christoph. "Was bleibt, sind nur die Melodien." *Musikexpress* (March), cover and pp. 40–47.

O'Brien, Basil (ed.). *The World's Greatest Black & White Photography No. 1.* London, p. 37.

Wichert, Silke. "Für Pferde hatte er wenig übrig." *Vanity Fair* (Germany, May) pp. 148–49.

Wilms, Jan. "Die Kraft der Vorstellung." *Bücher* (June), pp. 70–75.

2006

Bilmes, Alex. "Heeeere's Ricky!" *GQ* (UK, May), pp. 88–97.

Blasberg, Anita. "Tod eines DJs." *DIE ZEIT*, no. 14 (March 30), p. 68.

Chalmers, Robert. "Is This America's Most Depraved Man?" *GQ* (UK, February), pp. 80–87.

Hofmann, Frank. "Unser guter Bösewicht." *BestLife* (January), cover and pp. 40–46.

Klickstein, Mathew. "Danielle Panabaker." *AP* (October), p. 112.

Kotler, Steven. "The Many Moods of James Woods." Maxim (USA, October), pp. 110–11.

Lössel, Ulrich. "Til Schweiger." *Penthouse* (November), pp. 18–22.

Méjanès, Stéphane. "Femmes d'exception." *Sport Model* (April), pp. 14–15.

MINI: The Book. Hamburg, pp. 44–45.

Peschke, Marc. "8/2006." *30 Jahre Photographie* (Special edition *Photographie*), p. 43.

Petereit, Isa. "Die neue S-Klasse." *Men's Health* (Germany, January), pp. 97–109.

Raschke, Rudi, and Mario Vigl. "Super, so zu sterben." *Playboy* (Germany, June), pp. 166–69.

Sanai, Darius. "Trust Us, You Want Their Lives." *GQ* (UK, March), pp. 192–97.

Scholz, Martin. "Ich habe einen Traum." *DIE ZEIT*, no. 43 (October 19), p. 78.

Zimmerman, Mike. "Succeed Like This Joker." *Men's Health* (USA, October), pp. 164–67.

2005

Bilmes, Alex. "Is This Man for Real?" *GQ* (UK, November), pp. 286–93.

Blasberg, Anita. "Purer Sex in der Stimme." *Stern*, no. 45 (May), pp. 214–16.

Breuer, Wolfgang. "Hart... Aber herzlich." *Best Life* (Germany, March), cover and pp. 32–36.

Edwards, Gavin. "Lost Boy." *Rolling Stone* (USA, February), p. 45.

Hedegaard, Erik. "Snoop's Higher Vision." *Rolling Stone* (Germany, January), p. 46.

——. "Der Highlander." *Rolling Stone* (Germany, February), pp. 76–81.

Jones, Dylan. "Inspiration Burt Bacharach." *GQ* (UK, October), pp. 303–06.

"Die Männer des Jahres." *GQ* (Germany, December), cover.

Morant, Uli, and Verena Volkhausen. "Glücksmomente." *Jolie* (May), pp. 86–89.

Müller, Falko, and Mirko Heinemann. "Ein paar Sachen habe ich schon kapiert." *Zitty*, no. 2 (May), cover and pp. 16–21.

Neumayer, Ingo. "Dave Gahan: Ich will nicht mehr der Außenseiter sein." *Galore* (May), pp. 40–44.

Rich, Joshua. "The Players." *Look* (December), pp. 35–38.

Schlüter, Jörn. "Die Stille vor dem Sturm." *Rolling Stone* (Germany, June), pp. 20–22.

Stenglein, Markus. "Herr der Lüfte." *Men's Health* (Germany, March), cover and pp. 78–82.

Strauss, Neil. "Big Top Metal." *Rolling Stone* (USA, June), pp. 60–61.

Wiederhorn, Jon. "Slave to the Music." *Stuff Magazine* (October), pp. 92–93.

2004

Bissinger, Manfred. "Versuch, Dich zu Erinnern," in Marius Müller-Westernhagen. *Versuch, Dich zu erinnern.* Munich, pp. 98, 107.

Boyle, T.C., and Gerd Burger. "Mein neuer M3." *BMW Magazin* (February), pp. 82–90.

Ehlers, Fiona. "Das duale System." *Kultur Spiegel* (September), pp. 20–25.

Editorial Flaunt. "L. A. Story." *Flaunt* (February), pp. 150–57.

Schipprack, Annette. "Dream Team." *Max* (September), pp. 146–52.

Schöttelndreier, Holger. "Rammstein: Das Diktat der Kinder." *WOM Magazin* (September), cover and pp. 16–18.

Thilo, Andrea. "Ich habe einen Traum." *DIE ZEIT*, no. 26 (June 17), p. 66.

Tschernek, Michael. "Papa Cave." *netspotting* (November), pp. 36–39.

Zahn, Thorsten. "Weltreisende." *Metal Hammer* (September), cover and pp. 32–37.

2003

Fuß, Birgit. "Der alte Affe Angst." *Rolling Stone* (Germany, June), cover and pp. 38–43.

——. "Glaube, Liebe, Hoffnung." *Rolling Stone* (Germany, September), pp. 26–27.

Helmore, Edward. "The British Invaders." *Vanity Fair* (USA, November), p. 345.

Sting. "I Held the Record for Being Caned." *The Daily Telegraph*, October 29, p. 19.

——. "My Trip of a Lifetime." *Men's Journal* (US, November), cover.

——. "This Stupid Name Is Starting to Stick." *The Daily Telegraph*, October 30, p. 25.

2002

Ewig währt am längsten: Die Toten Hosen in Farbe und Schwarz-Weiss. Düsseldorf, pp. 36, 37, 71, 98, 125.

Fuß, Birgit. "Im Headquarter der Toten Hosen." *Rolling Stone* (Germany, February), cover and pp. 44–50.

——. "In a Rocker's Style." *Rolling Stone* (Germany, April), pp. 74–76 .

Fuss, Holger. "Alles ganz geheimnisvolle Dinge." *Stern*, no. 13 (March 21), pp. 244–46.

Hertel, Wolfgang. "Punks, Piraten, Paranoia." *Musikexpress* (February), cover and pp. 20–23.

Schwarz, Markus. "Ein Satz Heiße Ohren." *WOM Journal* (May), cover and pp. 18–19.

2001

Doebeling, Wolfgang. "Die vier Aufrechten." *Rolling Stone* (Germany, June), pp. 48–53.

Hirshey, Gerri. "Sting: Die Reifeprüfung." *Rolling Stone* (Germany, July), pp. 52–57.

Hoersch, Teddy, and Ralph Päckers. "Denk mal." *Musikexpress* (January), cover and pp. 20–24.

Hof, Gert. *Rammstein.* Berlin, passim.

Karg, Markus. *Die Ärzte: Ein überdimensionales Meerschwein frisst die Erde auf.* Berlin, passim.

Kletzin, Andreas. "Energie hoch zwei." *Musikexpress* (October), cover and pp. 20–25.

Lorenz, Flake. "Greetings from L. A." *Rolling Stone* (Germany, September), pp. 48–53.

Wagner, Peter. "Mutter ist die Beste." *WOM Journal* (April), cover and pp. 20–21.

Weilacher, Michael. "Mother's Finest." *Musikexpress* (March), p. 10.

Willander, Arne. "Citizen Cave." *Rolling Stone* (Germany, March), pp. 50–55.

2000

Hirshey, Gerri. "New Day Rising." *Rolling Stone* (US, November), pp. 66–70.

Kürthy, Ildikó von. "Der Alkohol hatte alles kaputt gemacht." *Stern*, no. 44 (October 26), pp. 306–14.

Lürzer, Walter. "Self-Promotional." *Lürzer's Archive*, pp. 182–83.

Luik, Arno. "Das Leben ist erbarmungslos. Es deformiert." *Stern*, no. 30 (July 20), pp. 40–48.

Weilacher, Michael. "Fragen sie ihren Arzt..." *Musikexpress* (November), cover and pp. 20–24.

1999

Albrecht, Falk. "Image ist nichts, Musik ist alles." *VISIONS* (May), cover and pp. 30–37.

Bernuth, Christa von. "Pia im Lundaland." *ELLE* (June), p. 60.

Mortag, Christine. "Irischer Frühling." *Petra* (May), pp. 26–30.

Renner, Kai-Hinrich. "Münchener G'schichten." *MAX* (November), pp. 150–157.

Ross, Hannes, and Stéfan Picker-Dressel. "Rammstein for America." *MAX* (March), pp. 76–80.

Schild, Stefanie. "Heike Makatsch." *ELLE* (January), pp. 36–38.

Seidl, Christian. "Man singt deutsch." *Stern*, no. 34 (August 19), pp. 44–56.

Editorial Stern TV Magazin. "Männerpension." *Stern TV Magazin*, no. 8 (February 18), cover.

Weitholz, Arezu. "Donna musste sechzig Mal stöhnen." *Spiegel Special* (April), pp. 100–03.

1998

Bartsch, W. "Heiße Gefechte um die wilde Lara." *Focus*, no. 20 (May 11), p. 92

Becker, Christoph. "Punk-Direktoren." *Die Woche* (July 31), p. 37.

Brückmann, Monika. "Bin ich schön?" *JOY* (October), p. 25.

Cloat, Gerold. "Mutter in Moll." *Musikexpress* (November), pp. 40–42.

Gill, Chris. "Battering Ramm." *Guitar World* (June), pp. 66–70.

Hertel, W. "Zwei vom selben Schlag." *Musikexpress* (December), pp. 40–42

Kelly, Christina. "Marilyn Manson Finds God." *JANE* (USA, November), pp. 134–37.

Krüger, Sascha. "Ein Alien in Hollywood." *VISIONS* (October), cover and pp. 20–25.

Liebing, Hagen. "Geil, diese Ärsche, Ärzte." *MAX* (September), cover and pp. 59–74.

Lockstein, Caroline and Susanne Faust. "Auf der Suche nach Mr. Right." *WOM Journal* (October), pp. 18–19.

Male, Andrew. "A Little Fright Music." *Details* (February), p. 30.

Mohr, Reinhard. "Aber lieb sind sie doch." *Der Spiegel,* no. 24 (June 8), p. 82–85.

Nieradzik, Andrea. "Rammstein Goes America!" *Hammer* (February), cover and pp. 20–23.

Stahl, Peter von. "Freudentränen in der Villa Hate." *WOM Journal* (February), cover and pp. 22–23.

Weilacher, Michael. "Moby." *Musikexpress* (February), p. 42.

Winkler, Josef. "Wir sind Popstars." *Musikexpress* (May), cover and pp. 22–26.

Zahn, Thorsten. "Bad Religion." *VISIONS* (April), cover.

1997

Lindemann, Till. "Fegefeuer der Grausamkeiten." *WOM Journal* (September), cover and pp. 24–25.

Oehmke, Philipp. "Was macht ihr denn da?" *Prinz* (September), pp. 28–31.

Päckers, Ralph, and Fury in the Slaughterhouse. *Fury in the Slaughterhouse: Scheiß Rock'n'Roll,* Hanover, passim.

Petersen, Martina. "Wenn nicht dann nicht." *Young Miss* (September), p. 142.

Pfeifer, David. "Der Beat der Nacht." *Prinz* (October), cover.

Stahl, Peter von. "Stefan Raab." *Musikexpress* (November), pp. 34–37.

Weilacher, Michael. "Mein Name ist Moby." *Musikexpress* (December), cover and pp. 22–26.

—— . "Mit Chris Cornell hinter den Kulissen." *Musikexpress* (February), pp. 26–29.

—— . "Tage des Donners." *Musikexpress* (August), pp. 30–31.

—— . "The Wallflowers." *Musikexpress* (July), p. 75.

Wingenfelde, Kai. "Für eine Handvoll Hits mehr." *Rolling Stone* (Germany, March), pp. 28–29.

Wlodark, Eva. "Geschwister sind von Natur aus Rivalen." *Brigitte,* no. 20 (September 17), pp. 108–14.

1996

Mellmann, Bernd. "Portfolio Olaf Heine." *Photographie* (January), pp. 67–70.

Schmidt, Bibi. "So gehen die Sozis." *Schädelspalter* (February), pp. 20–22.

Weilacher, Michael. "Religionsgemeinschaft." *Musikexpress* (May), pp. 24–25.

Hermann, Karl. "Behaart aber herzlich." *Tip,* no. 12 (May 30), cover and pp. 22–25.

1995

Gülden, Jörg. "Marius? Herbert? Udo?—Stoppok!" *Rolling Stone* (Germany, May), cover.

Neumann, Olaf. "Wichtig, laut, schön…" *Schädelspalter* (November), pp. 64–67.

Pütz, Uwe. "Fury in the Slaughterhouse." *Musikexpress* (February), pp. 38–39.

Stollberg, Christian. "Vom Aufsteiger zum Favoriten." *WOM Journal* (April), cover and pp. 12–13.

Weilacher, Michael. "Me Galerie." *Musikexpress Special: Das Jahrbuch,* pp. 87 and 89.

Wimmer, Martina. "Band on the Run." *Rolling Stone* (Germany, March), pp. 64–67.

1993

Fury in the Slaughterhouse. *Mono* [Songbook]. Munich, pp. 2–60.

ARTWORKS AND SLEEVES

2008

Junkie XL. *Booming Back at You.* RCA.

Max Raabe. *Heute Nacht oder nie.* SPV.

2007

Aqualung. *Memory Man.* Sony Music.

James Blunt. *All the Lost Souls.* Atlantic Records.

Phillip Boa. *Faking to Blend In.* Motor Music.

Paul van Dyk. *In Between.* Universal Music.

The Eagles. *Long Road out of Eden.* Polydor.

Jerry Lee Lewis. *Last Man Standing Live.* Sony Music.

Reamonn. *Wish.* Universal Music.

Stanfour. *Wild Life.* Universal Music.

Tokio Hotel. *Schrei.* Universal Music.

2006

Junkie XL. *Today.* Roadrunner Records.

Nick Lachey. *What's Left of Me.* Zomba Records.

Reamonn. *Wish.* Universal Music.

Sasha. *Greatest Hits.* Warner Music.

Silbermond. *Laut gedacht.* Sony Music.

2005

A-ha. *The Singles 1984–2004.* Warner Music.

Burt Bacharach. *At This Time.* Sony Music.

Phillip Boa. *Decadence & Isolation.* Motor Music.

Bon Jovi. *Have a Nice Day.* Island/Def Jam.

Michael Bublé. *It's Time.* Warner Music.

Conjure One. *Extraordinary Ways.* Nettwerk.

Paul van Dyk. *The Politics of Dancing 2.* Universal Music.

Fat Joe. *All or Nothing.* Atlantic.

Iggy Pop. *Million In Prizes: The Anthology.* Virgin Records.

Kane. *Fearless.* BMG.

Vanessa Petruo. *Mama Lila Would.* Universal Music.

30 Seconds to Mars. *Beautiful Lie.* Virgin Music.

Yonderboi. *Splendid Isolation.* Mole.

2004

ATB. *DJ in the Mix.* Kontor.

Instruction. *God Doesn't Care.* Geffen.

Jam and Spoon. *Tripomatic Fairytales.* Sony Music.

William Joseph. *Within.* Reprise Records.

Living Color. *Collidoscope.* Sanctuary.

Papa Roach. *Getting Away With Murder.* Geffen Records.

Rammstein. *Reise, Reise.* Universal Music.

Sting. *Sacred Love,* special edition. Geffen Records.

2003

Apocalyptica. *Reflections.* Universal Music.

Cold. *Year of the Spider.* Geffen.

Paul van Dyk. *Reflections.* Universal Music.

Josh Groban. *Closer.* Warner Music.

Itchycoo. *Itchycoo.* EMI.

Kane. *My Best Wasn't Good Enough.* BMG.

Kane. *What If.* BMG.

Paradise Lost. *Symbol of Life.* BMG.

Roselyn Sanchez. *Borinquena.* BMG.

2002

A-ha. *Lifelines.* Warner Music.

Apoptygma Berzerk. *Harmonizer.* Warner Music.

ATB. *Addicted to Music.* Kontor.

The Calling. *Camino Palmero.* Warner Music.

Conjure One. *Conjure One.* Nettwerk.

Chris Rea. *Stony Road.* Warner Music.

2001

Bon Jovi. *One Wild Night.* Island/Def Jam.

Boy George. *Essential Mix.* I.

BT. *Still Life in Motion.* Sony Music.

The Calling. *Camino Palmero.* Atlantic.

Paul van Dyk. *Politics of Dancing.* Universal Music.

Iggy Pop. *Beat Em Up.* Virgin.

Sasha. *Surfin On a Backbeat.* Warner Music.

Die Toten Hosen. *Unsterblich.* JKP.

Westernhagen. *So weit.* Warner Music.

2000

ATB. *Two Worlds.* Kontor Records.

Bad Religion. *New America.* Sony.

Blank and Jones. *DJ Culture.* Universal Music.

Phillip Boa. *My Private War.* BMG.

Bon Jovi. *Crush.* Island/Def Jam.

Boondock Saints. *Release the Hounds.* Atlantic.

Paul van Dyk. *Out There and Back.* Universal Music.

Die Fantastischen Vier. *Unplugged.* Four Music.

The Moffatts. *Just Another Phase.* Universal Music.

On. *Shifting Skin.* Sony.

Such a Surge. *Der Surge Effekt.* Warner Music.

1999

Götz Alsmann. *Zuckersüß.* Universal Music.

Be. *Orange.* EMI.

Jeff Beck. *Who Else.* Sony Music.

Till Broenner. *Love.* Universal Music.

Chris Cornell. *Euphoria Morning.* Interscope.

Paul van Dyk. *Another Way.* Universal Music.

Die Fantastischen Vier. *4:99.* Four Music.

On. *Soluble Words.* Sony.

Rammstein. *Live aus Berlin.* Universal Music.

The Scorpions. *Eye II Eye.* East West.

Sting. *Brand New Day.* Interscope.

Tocotronic. *K.O.O.K.* Motor Musik.

1998

Die Ärzte. *13.* Hot Action Records.

Phillip Boa. *Lord Garbage.* Motor Musik.

Tab Two. *Between Us.* Polydor.

1997

Bad Religion. *Tested.* Epic.

Fury in the Slaughterhouse. *Brilliant Thieves.* EMI.

Rammstein. *Engel.* Motor Musik.

1996

Die Ärzte. *Le Frisur.* Polygramm.

Be. *Bold.* EMI.

1995

Fury in the Slaughterhouse. *The Hearing and the Sense of Balance.* SPV.

Terry Hoax. *Den Kindern geht es gut und sie lassen grüßen.* Metronome.

1994

Die Ärzte. *Planet Punk.* Metronome.

Big Light. *Pop 2000.* SPV.

1993

Fury in the Slaughterhouse. *Mono.* SPV.

1992

Terry Hoax. *Freedom Circus.* Metronome.

ARTICLES AND INTERVIEWS

Hohenlohe, Hubertus von. "Sie haben 15 Minuten." *Hubertus von Hohenlohes 500 Very Special Hotels* (2006/2007), pp. 60–65.

SEA. "Giganten." *Photographie* (November 2006), pp. 102–09.

Editorial Bant. "Olaf Heine." *Bant,* no. 14 (2005), pp. 28–33.

Spilker, Heiko. "Songs in Schwarzweiß." *Prinz* (December 2004), p. 120.

Miekusem, Krzysztofem. "Olaf Heine." *Pozytyw* (September 2004), pp. 96–104.

Editorial Foto Spiegel. "Stars." *Foto Spiegel,* no. 115 (2004), cover and pp. 7–12.

Wieseler, Michael. "Wir haben alle Chancen." *Teneriffa Nachrichten,* no. 29 (2004), p. 1.

Beister, Yvonne. "Der Fotograf der Superstars." *Neue Presse,* no. 67 (2003), p. 17.

Editorial Vision. "Camera Obscura." *Vision* (April 2002), pp. 54–64.

Hess, H.-E. "Der Mann für die Stars der Szene." *Photo Technik International* (February 2002), cover and pp. 6–15.

Editorial Brigitte. "Olaf Heine." *Brigitte Spezial* (March 1999), p. 7.

Editorial Photographie. "Portfolio Olaf Heine." *Photographie* (October 1998), pp. 64–69.

Editorial Musikexpress. "Pop in Schwarzweiß." *Musikexpress* (October 1998), pp. 28–30.

Editorial Lux. "Ich bin aus liebe zur Musik zu diesem Job gekommen." *LUX* (August 1997), cover and pp. 86–97.

Hess, Hans-Eberhard. "Für die Show mit Biss." *Photo Technik International* (March 1997), pp. 68–75.

Ubrig, Sarah. "Momente der Ruhe." *Subway* (July 1996), p. 13.

Schmitt, Sascha. "Heine: Ein Fotomärchen." *Prinz* (January 1996), pp. 68–69.

Mellmann, Bernd. "Portfolio Olaf Heine." *Photographie* (January 1996), pp. 67–70.

Acknowledgments

206

My deepest appreciation and love is owed to Marion for supporting all my ambitions, encouraging me in the darkest hours and for keeping me sane. Without you this book would not have been possible.

A very special thanks to my family for their continuous support: Lennon, Lia, Elisabet Heine, Wolfgang Heine, Miriam Heine, Reinhard Meyer, Torben Meyer, and Hedwig Meyer. Your contribution is immeasurable.

To all of my friends: Sebastian Rasche, Kristina Kutsch, Stefan Sasse, Brian and Shea Bowen-Smith, Jason Thompson, Gabi Bartolomeo, Jan Hora, Lars Grewe, Tom Jermann, Torben and Tanja Ferkau, Fabian Heine, Georg Miros, Benjamin de Wolff, Joe and Rea Garvey, Natascha and Paul van Dyk, Emu Fialik, Michiel Groeneveld, Tom Holkenborg, Rhys Fulber, Carmen Rizzo, Dinand Westhoeff, Chrissie Juelich, Nikolai Kinski, Nanette Klieber, Meike Meier, Ralf Kotowski, Steffi Zoll, Strachi, Uli Kuppel, Rene Renner, Kirsten Roschlaub, Sharon McGinnis, Franka Potente, Oliver Perau, Thorsten and Kai Wingenfelder, Olaf Hauschulz, Christian McLaughlin, Oliver Coke, Bulle Berndt, Diana Späth, Michi Beck, Richard Kruspe, Kristian Draude, Alex Richter, Matthias Krüger, Jörg Strohmann, Alexander Schierl, Thomas Hanreich, Toby and Lynn Hyndman, and Hallie Sirota, I will always be grateful for all your help and encouragement.

I would like to thank all of my teachers, my role models and sources of inspiration, without whom I never would have taken this life path: Wolfgang Gorski, Uwe Mensing, Ursula Stegen, Karsten Seifert, Erk Bratke, Jim Rakete, Joe Mama Nitzberg, and Robert Frank.

Photography is a collaborative process and so I would like to thank everyone who has ever worked with me, assisted and supported me above and beyond the call of duty: Ole Brömme, Ben Fuchs, Boris Breuer, Jörg Kyas, Sven Sindt, Nela König, Sonja Tobias, Johanna Pagels, Paul Kusserow, Matt Kanji, Pia Möglich, Madjit Moussavi, Eric Axene, Chris Sorensen, Jeff Henrikson, Drew Schwartz, Evan Clanford, Johanna Pagels, Holger Geffken, Scott Clinton, Veronique Robin, Elena Rott, Michel Schüler, Sebastian Pötter, Toby Hudson, Muriel Liebmann, John Maxwell, Ben Franken, Gerhard Nelson, Todd Weaver, Vanessa Fuentes, Edwin Jimenez, and Ty Watkins.

To the beauty crew with all their dedication and sensitivity: Ara Decker, Sally Hirshberger, Henrike Kessler, Carola Gonzalez, Melanie Schöne, Gina Brook, Iris Jäger, Lorena Lopez, Melanie Clark, Denise O'Brian, C.I.S.E.L., Vivian Koller, Alexander Weber, Henriette Höft, Eric Ferrell, Tom Ludwig, Diana Schmidtke, Astrid Glänzel, Mira Hyde, Catrin Kreyss, Ilka Jännicke, Stephanie Bach, Dominic Stark, Romy Meier, Amy Chance, Kristina Gutsche, Nicole Artmont, Karla Neff, Karina Kozber, and Robert Metford, thanks a lot.

A warm thank you to all the contributors that added so much style with all their imagination and creativity: Samja Schröder, Niki Pauls, Jewels and Johnny, Eric Berg, Dyanne Beekman, Melissa Orndorff, Renee Ben-Shmuel, Lynn Bugai, Thom Wagner, Julia Freitag, Heike Stemmler, Donald McInnes, Dana Marasca, Tini Rathe, Samantha McMillen, Dee Anderson, Caroline Willenborg, Sue Dietz, Sabrina Hilbig, Lena Hoffmann, Svenja Brecht, Katharina Nitzpon, Bruce Hamilton, Sascha Gaugel, Kata, BJ Papas, Jenny Ricker, and Stephanie Canisius.

All my respect and gratitude to my fellow artists for always helping me to find and create the perfect setting: Luca Ognibene, Brody, David Ross, Andreas Lüdke, Steve Wingfield, Judith Schönstein, Simone Arndt, Phillip von Döring, everybody at Nowadays, and Karin Haase-Sehr.

I would like to offer my heartfelt thanks to Janet Botaish, Frank Küppers, Kirsten Roschlaub, Rhea Rachevsky, David Lyons, Carrie Ferriter, Vonetta Baldwin, Kimberly Feldman-Ayl, Helga Schierke, Susana Shaker, Stefanie Solar, Julia Waldmann, Margot Klingsporn, Cristina Steingräber, Clemens von Lucius, Matthias Harder, Ralf Grauel, and Verena Gerlach for always supporting and challenging my creativity and keeping calm throughout the storm.

Much gratitude to all of you who contributed in the making of these images. Your presence is greatly felt and deeply appreciated: Jeff Ayeroff, Anne Berning, Sybille Breitbach, Prof. Hans-Joachim Berndt, Ute Shaw, JP Robinson, Jen Littleton, Volker Steinmetz, Frank Engel, Axel Heise, Deb Dragon, Jodi Peckman, Louis Marino, Jackie Murphy, Olli Czok, Dirk Rudolph, Nicole Frantz, Dave Holmes, Dennis Marx, Alexander Maurus, Sven Sturm, Petra Husemann, Tim Renner, Stephan Schaefer, Boris Schade, Kathy Schenker, Ulf Wenderlich, Axel Schulz, Patrick Orth, Robert Blatchford, Michael Smilgies, Mirja Müller-Pentz, Kelly McCall, Michael McClellan, Cathrin Bauendahl, Andreas Doria, Christian Mai, Helge Bias, Malte Behrens, Suzann Brantner, Anja Bruchschmidt, Khodr Cherri, Grit Brüggemann, Gabi Dörr, Jenny Ferron, Boris Löhe, Ulli Glantz, Daniel Simon, Stefan Holwe, Andrea Gothe, Stefan Gruener, Sven Betz, Ulrike Schülecke, Jana Hallberg, Rüdiger Heinrich, Frank Harkins, Sven Hasenjäger, Heiner Hauck, Jeri Heiden, Gert Hof, Ulysses Hueppauf, Christian Jerger, Johannes Strachwitz, Sven Kilthau-Lander, Joachim Kirchstein, Thorsten König, Christian Stollberg and all at Musikexpress, Markus Kühn and all at Nowadays, Lawrence Rachmel, NHB Studios, Pixelgrain, Gabo, Ellen Wakayame, Arne Weingart, Ute Zahn, Peter Rochel, and Silke Lauffs.

And last but not least a big thank you to all of you creative souls out there for sharing moments and inspiring lifetimes: Terry Hoax, Bela B, Farin Urlaub, and Rodrigo, Be, Sting, Bon Jovi, Anke Engelke, Bobo, Chris Cornell, Coldplay, Jared Leto, Jam & Spoon, Antje Roloff, Thomas Kretschmann, Silbermond, Till and Rammstein, Ben Blümel, Phillip Boa, Brandon Boyd, Paul Oakenfold, Campino and die Toten Hosen, Marius Müller-Westernhagen, Kane, Sasha, Die Fantastischen Vier, Sven Regener, Wayne Jackson, Iggy Pop, Heike Makatsch, Michael Mittermeier, Mousse T, Vanessa Petruo, Yonderboi, Fury in the Slaughterhouse, Josh Groban, Reamonn, The Eagles, Max Raabe, Jessica Schwarz, Natalia Avelon, Clemens Schick, Linda Sundblad, Andre Tanneberger, Franziska van Almsick, Mario Gomez, and Sheryl Crow.

In Memory of Karl Meyer.

Published by
Hatje Cantz Verlag
Zeppelinstrasse 32
73760 Ostfildern
Germany
Tel. +49 711 4405-200
Fax +49 711 4405-220
www.hatjecantz.com

A Collector's Edition is available with a signed and numbered print by the
artist in an edition of 20 + 5 a.p.: *Barfly*, Havana, Cuba, 2006 (illustrated on
pp. 170–71)
Giclée Print on Somerset Velvet paper, 16 x 20 in.
Please contact Hatje Cantz for more information.

Hatje Cantz books are available internationally at selected bookstores. For
more information about our distribution partners please visit our homepage
at www.hatjecantz.com.

ISBN 978-3-7757-2218-6

Printed in Germany

Page 5: *Kurt Cobain*, Tanzbrunnen, Cologne, 1991

Quote on page 5: from *Teenage Kicks* by The Undertones

Cover illustrations:
Front: *Iggy Pop*, Miami, 2001 (pp. 158–59)
Back: *Black Lines*, Havana, Cuba, 2006 (pp. 54–55)

Back flap: photo by Brian Bowen-Smith

Copyediting: Clemens von Lucius, Kirsten Weiss, Marie-Liesse Zambeaux

Translations: Laura Schleussner, Marie-Liesse Zambeaux

Concept and layout: Olaf Heine

Production: Christine Emter

Typesetting: Karoline Haasters

Scans: Ole Brömme

Postproduction: Olaf Heine and Elektronische Schönheit

Typeface: Helvetica

Paper: Galaxi Supermat, 170 g/m²

Binding: Conzella Verlagsbuchbinderei, Urban Meister GmbH,
Aschheim-Dornach

Reproductions and printing: Dr. Cantz'sche Druckerei, Ostfildern